Leonardo

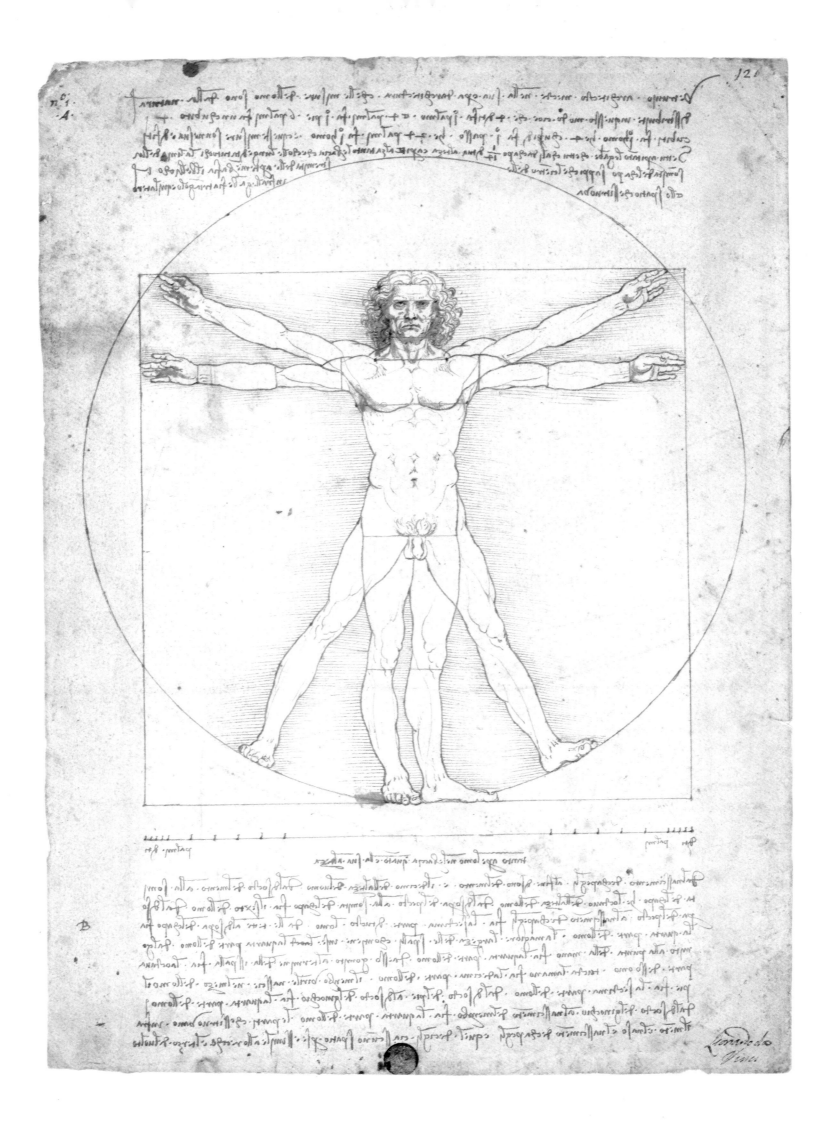

Peter Hohenstatt

Leonardo
da Vinci

1452–1519

KÖNEMANN

1 (frontispiece)
Vitruvian Man, ca. 1490
Pen, ink and metalpoint on paper, 34.3 x 24.5 cm
Gallerie dell'Accademia, Inv. 228, Venice

© 1998 Könemann Verlagsgesellschaft mbH
Bonner Str. 126, D-50968 Köln

Art Director: Peter Feierabend
Project Manager and Editor: Sally Bald
Assistant: Susanne Kassung
German Editor: Ute E. Hammer
Assistant: Jeannette Fentroß
Translation from the German: Fiona Hulse
Contributing Editor: Susan James
Production Director: Detlev Schaper
Assistant: Nicola Leurs
Production: Mark Voges
Layout: Wilhelm Schäfer
Typesetting: Greiner & Reichel, Cologne
Reproductions: CDN Pressing, Verona
Printing and Binding: Neue Stalling, Oldenburg
Printed in Germany

ISBN 3-8290-0251-3
10 9 8 7 6 5 4 3 2 1

Contents

LEONARDO DA VINCI –
THE MAKING OF A LEGEND

Leonardo da Vinci – this name has become a legend in
Western cultural history. It stands for a universal spirit
who distinguished himself by his extraordinary abilities
and corresponded more closely than anyone else to the
ideal image of a Renaissance man. Leonardo excelled in
almost all the fields of the arts and sciences: in physics,
mechanics, engineering, mathematics and geometry, in
anatomy, geology, botany and geography, equally in
music, architecture, sculpture and, last but not least,
painting. He was capable of grasping the different worlds
of art and science and achieving new insights in whatever
field he turned his attention to. The broad spectrum of
his abilities is reflected by a letter he wrote to the duke
of Milan, Ludovico Sforza (ill. 3), in which he offered
his abilities, the experience he had gathered and his
diverse experiments: in ten points he presented himself
as a designer and inventor of war machines – of movable
bridges, battering rams, scaling ladders, mines, explosive
devices, cannon and guns, naval arms, tunnels, armored
vehicles, catapults, projectiles and other things – as well
as an architect of public and private buildings and water
pipes. Finally he extolled his work as a painter and
sculptor. "Also I can carry out sculpture in marble,
bronze or clay, and also I can do in painting whatever
can be done, as well as any other, be he who may."

Nowadays, Leonardo's artistic biography can be
reconstructed from hundreds of manuscript pages,
numerous drawings and a variety of paintings. In
contrast, our information about the private Leonardo is
sparse. While there are various entries such as shopping
lists, inventories of his purchased books and short
allusions to his pupils in his notebooks, they do not
allow us to make any further deductions about his
character. Only the statements and descriptions of
contemporaries, which were collected by the painter
and author Giorgio Vasari (1511–1574) to produce a
characterization of Leonardo in his "Lives of the
Most Excellent Architects, Sculptors and Painters"
(1550–1568), convey to us an image of the person he
was which has remained definitive to this day.

Leonardo was born on 15 April 1452, the illegitimate
son of the notary Ser Piero di Antonio and the farmer's
daughter Catarina. Leonardo spent his childhood in the
small town of Vinci, not far from Empoli, until in about

1469 he began his apprenticeship in the famous
Florentine artists' workshop belonging to Andrea del
Verrocchio (1435–1488). Although he was admitted to
the painters' guild of St. Luke as early as 1472, he stayed
there for at least another four years. Following his first
independent commissions, he moved from Medici
Florence to Milan in 1482. It is likely that the duke of
Milan, Ludovico Sforza, had invited the artist to create
a gigantic equestrian statue in honor of his father
Francesco. Here, at the culturally up-and-coming court
of the Sforzas, Leonardo was able to develop his diverse
interests and inclinations, which would enable him to
become the *uomo universale* of Western cultural history.

Ludovico Sforza was a generous patron for whom he
undertook a number of tasks. As court artist, he not only
worked as a painter and sculptor, but also devoted
himself to military and architectural projects. For
example, he busied himself producing architectural
designs that contain ideal townscapes still valid today.
As an engineer, he examined the mechanization of work
processes, and attempted to increase the effectiveness of
military arms. In addition, the duke of Milan used
Leonardo's manifold talents for his own prestigious
purposes. He was entrusted with the most diverse
artistic tasks, such as designs for stage sets for theatrical
productions, or scenery for feasts and weddings. In the
fertile intellectual climate of Milan, Leonardo became
a scientist who extended his knowledge by studying
books and ancient treatises and took up the pen himself
in order to record his own thoughts on art theory.
His curiosity was aroused by intensive observations
of nature, the growth of plants as well as a direct
examination of the question of the creation of the Earth.
Despite it being strictly forbidden by the Church, his
enormous thirst for knowledge was such that he did not
shy away from autopsies in order to carry out anatomical
investigations. His extensive scientific studies also had
their effect on his paintings which he – as shown by the
Last Supper (ill. 72) – conceived as a sort of synopsis of
his findings.

When the French troops occupied Milan in 1499,
Leonardo left the city and after short stays in other
northern Italian cities – at the d'Este court in Mantua,
in Venice and Vaprio (near Milan) – he returned to

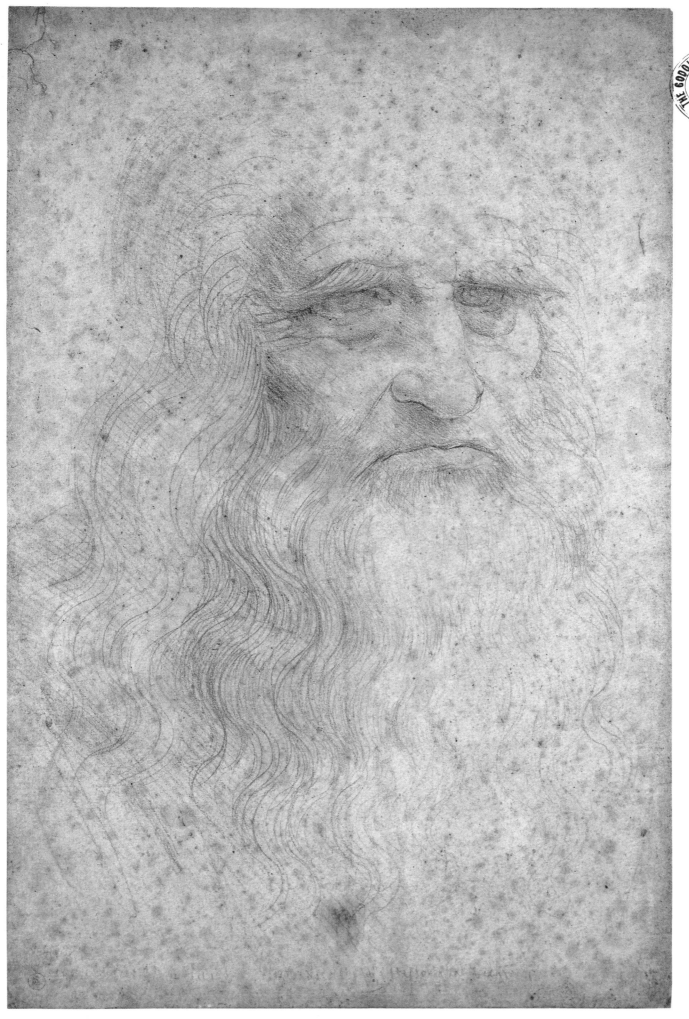

3 Letter to Ludovico Sforza
Pen and ink on paper
Biblioteca Ambrosiana, Codex Atlanticus, fol. 391a,
Milan

While the letter to the duke of Milan is not in Leonardo's
own hand, there is no doubt as to its authenticity.

Most illustrious Lord!

Having now sufficiently seen and considered the proofs of
all those who count themselves masters and inventors of
instruments of war, and finding that the invention and
working of the said instruments do not differ in any
respect from those in common use, I shall endeavor
without prejudice to anyone else to explain myself to your
Excellency, showing your Lordship my secrets, and then
offering at your pleasure to work with effect at convenient
times on all those things which are in part briefly
recorded below:

1. I have plans of bridges, very light and strong and
suitable for carrying very easily, and with them you may
pursue, and at times flee from, the enemy; and others
secure and indestructible by fire and battle, easy and
convenient to lift and to place in position; and plans for
burning and destroying those of the enemy.

2. When a place is besieged, I know how to remove the
water from the trenches, and how to construct an infinite
number of bridges, battering rams and ladders and other
instruments having to do with such expeditions.

3. Also if a place cannot be reduced by the method of
bombardment either owing to the height of its banks or
to its strength of position, I have plans for destroying
every fortress or other stronghold, unless it were founded
on rock.

4. I have also plans of mortars most convenient and easy
to carry with which to hurl small stones in the manner
almost of a storm; and with the smoke of this cause great
terror to the enemy and great loss and confusion.

5. Also I have means of arriving at a fixed spot by caves
and secret and winding passages, made without any noise
even though it may be necessary to pass underneath
trenches or a river.

6. Also I will make covered cars, safe and unassailable,
which will enter among the enemy with their artillery,
and there is no company of men at arms so great that they
will not break it. And behind these the infantry will be
able to follow quite unharmed and without any
hindrance.

7. Also, if need shall arise, I can make cannon, mortars,
and light ordnance of very useful and beautiful shapes,
different from those in common use.

8. Where the operation of bombardment fails, I shall
contrive catapults, mangonels, *trabocchi*, and other
engines of wonderful efficacy and not in general use. In
short, to meet the variety of circumstances, I shall
contrive various and endless means of attack and defense.

9. And if it should happen that the fight was at sea I have
plans for many engines most efficient for both attack and
defense, and vessels which will resist the fire of the largest
cannon, and powder and smoke.

10. In time of peace I believe I can give perfect
satisfaction, equal to that of any other, in architecture and
the construction of buildings both private and public, and
in conducting water from one place to another.

Also I can carry out sculpture in marble, bronze or clay,
and also I can do in painting whatever can be done, as
well as any other, be he who may.

Moreover, the bronze horse may be taken in hand, which shall
endue with immortal glory and eternal honor the happy memory
of the Prince your father and of the illustrious house of Sforza.

And if any of the aforesaid things should seem impossible or
impracticable to anyone I offer myself as most ready to make the
trial of them in your park, or in whatever place may please your
Excellency, to whom I commend myself with all possible humility.

Florence in 1500. Since the death of Lorenzo de' Medici in 1492 and the revolution of 1494, the city had, however, changed completely. In the place of the humanist regime of the Medicis there was now a republican oligarchy. Leonardo did not spend long in Florence, though, but briefly entered the service of Cesare Borgia, the son of Pope Alexander VI, as a military advisor during the summer of 1502. After his return in April 1503, he was commissioned to produce a large fresco for the Sala del Gran Consiglio in the Palazzo Vecchio (*Battle of Anghiari*, ill. 89).

From his return to Milan in 1506, where he stayed for nearly seven years with only brief interruptions, he increasingly dedicated his time to his research and experiments. In addition to various commissions such as the equestrian statue of Marshal Trivulzio, architectural projects and projects of a technical hydraulic nature, he was planning a definitive treatise on anatomy. In this year he presumably started work on the *Mona Lisa* (ill. 119) – probably the most famous work in European art history. But the uncertain political situation caused him to leave the city in 1513 and enter the service of Giuliano de' Medici, the brother of Pope Leo X (Giovanni de' Medici, died in 1521), who had been elected on 11 March of the same year, and go to Rome with him. He spent just three years working for Giuliano on a variety of projects, outside Rome as well, before the latter died in 1516. Thereupon, Leonardo accepted the invitation of the new French king, Francis I (1494–1547), and became his first painter, engineer and architect. In 1519, he died at the age of 67, in the French royal residence of Clos-Lucé near Amboise.

While Leonardo's biographical dates are unambiguous, the picture of his character is ambivalent. If on the one hand he was granted physical beauty, power, dexterity, intelligence, eloquence, magnanimity and generosity, on the other hand there were also complaints about his capriciousness, moodiness and eccentric nature. He is said to have started many things and never completed them. For example, Pope Leo X was so annoyed with Leonardo that he apparently exclaimed: "Alas, this man will never get anything done, for he is thinking about the end before he begins." In addition, Leonardo's appearance was unconventional. In contrast to his contemporaries, who were dressed in long garments in sober colors, he wore a short jerkin and tight trousers made of blue or crimson velvet and silver brocade. In his presumed self-portrait (ill. 2), he depicted himself with a long beard and melancholy expression – attributes which corresponded to the Renaissance ideal of a philosopher. "Leonardo's hair and beard were so long, and his eyebrows were so bushy, that he appeared to be the sheer idea of noble wisdom," the artist and author Gianpaolo Lomazzo wrote in the late 16th century. Leonardo is also said to have had an unhappy childhood and to have been homosexual. He is said to have inflated animal stomachs, filling the entire room with them and forcing the guests into a corner, and he even filled his own father with terror with a painted monster, as Vasari tells us. And he is said to have sinned against God at night by dissecting corpses, while

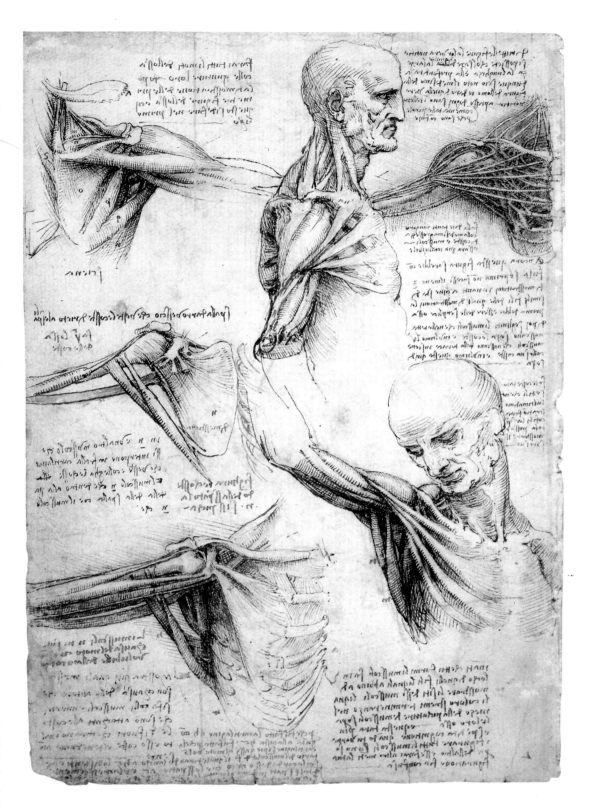

4 *Anatomical studies of the shoulder*, ca. 1510/1511
Black chalk, pen and ink on paper, 28.9 x 19.9 cm
Royal Library, RL 19003v, Windsor

"Leonardo then applied himself, even more assiduously, to the study of human anatomy, … [and] he did meticulous drawings in red chalk and pen of bodies he had dissected himself. He showed all the bone structure, adding in order all the sinews

and covering them with the muscles: the first attached to the skeleton, the second that hold it firm and the third that move it. In the various sections he wrote his observations in puzzling characters (written in reverse with the left hand)…" (Vasari).

At the top right is a diagram of the right shoulder in which Leonardo has reduced the muscles to a cord representing the direction of force of each muscle. He thus made it clear how the muscle system works in a way that cannot be seen in nature.

5 (right) Francesco Melzi (1492–1570)
"Treatise on Painting", ca. 1520–1550
Vaticano, Biblioteca Vaticana, Codex Vaticanus Urbinas
lat. 1270, ff. 330v/331r, Rome

Leonardo's student and workshop heir Francesco Melzi is
the person we have to thank for the fact that Leonardo da
Vinci's so-called "Treatise on Painting" was compiled – as
can be seen when compared to the original – in a
conscientious manner without personal comments. On
this page he lists Leonardo's books, from which he drew
about 950 individual longer or shorter passages in order
to arrange them thematically. For reasons unknown, the
compilation was never published as had been planned. All
that exist are excerpts that circulated mainly in Florence
and Rome in the 16th century.

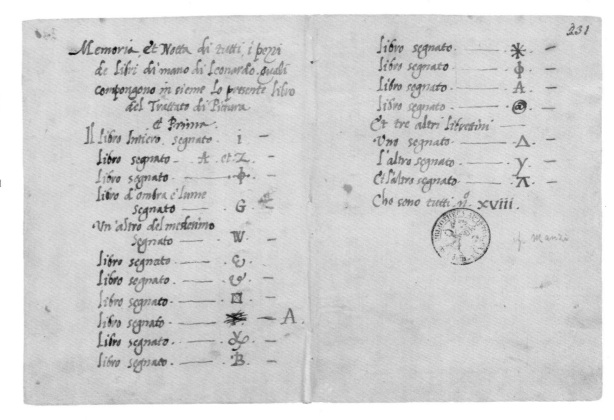

6 (below) Printed edition of Leonardo's "Treatise on
Painting"
With illustrations by Nicolas Poussin, 1651
Bibliothèque Nationale, Paris

When the first printed edition of the "Treatise on
Painting" appeared in Paris in 1651, it was not known
that it was incomplete. Not until the original manuscript
was discovered shortly before 1800 was it revealed that
the first chapter of the treatise had remained unknown.
However, even the first edition with its descriptive title
"Paragone" (Competition of the Arts) shows that
Leonardo's delimination of painting against the other
artistic genres had been interpreted one-sidedly. For
particularly from the mid-16th century onwards, the
theme of the predominance of one artistic genre over
the others had become increasingly important to Italian
humanists and artists. Leonardo's own comments on
painting were frequently pushed into the background.

by day he would shine at court as a gallant entertainer
and musician.

However, the universal quality of Leonardo appears
to be so incomprehensible that even Vasari was not able
to explain this phenomenon except by referring to
divine influences: "… everything he does clearly comes
from God rather than from human art." It appears all
the more astonishing given his miserable upbringing, his
lack of education as he called it himself, which he
complained about all his life. Growing up in his father's
house, he received the usual elementary education of his
age, learned the manual and technical possibilities in
Verrocchio's workshop and broadened his theoretical
knowledge. But he could probably only read difficult
Latin texts with the aid of his humanist friends and
could not understand Greek. This is the background
against which we need to see the display of strength of
a person who has entered history as a universal genius.

Leonardo was an artist, inventor and researcher at the
same time; he saw no conflict between these fields and
combined the various disciplines with each other in a
unique manner. In all the topics he investigated, he
attempted to achieve what was possible in his time and,
by exercising his imagination, realize the impossible.
Leonardo is less well known nowadays as an architect
and sculptor, but various manuscripts mention a series
of important projects. Many remaining sources attest to
the high esteem in which he was held for producing the
decorations for feasts and designing theatrical sets at
court. He served the rulers well as an engineer by
developing military equipment and overseeing several
building projects for turning rivers into canals. He
devoted himself to cartography, horology and music.

Above all, however, he is famous as a natural scientist
because of his studies in the fields of mechanics, botany,
the flight of birds, water, anatomy (ills. 4, 112–118) and
optics. The center of his activities was painting, though,
and for him it was not only a craft, it was also a science
and the highest one at that. In his "Treatise on Painting"
(ills. 5, 6), which was published posthumously, he laid
down his position clearly: in it he required that a painter
should not only master his craft but should also have
extensive knowledge of the nature of things. Just as a
poet must first know what he wants to write before he
can note it down with hand and pen, a painter must first
have understood the object that he wants to paint before
he can execute it with hand and brush. A painter cannot
simply depict nature like a 'dumb' mirror if he wants to
imitate it in a deceptively real manner. He must transfer
the three-dimensional world onto the two-dimensional
surface in such a way that it appears three-dimensional.
In order to achieve this, it is vital that a painter should
study nature and the laws of optics, and hence also be a
natural scientist.

To this day, Leonardo is quite rightly considered to be
one of the most fascinating and diverse artists and
thinkers of the Renaissance. His reputation as a painter
has always been undisputed. "No-one had ever shed
such luster on the art of painting" was Vasari's judgment.
And this despite the fact that Leonardo probably created
fewer than 40 paintings. Nowadays we are in fact
familiar with only about 20 original paintings, though
these include two of the most famous in the history of
painting – the Milan Last Supper (ill. 72) and the Mona
Lisa (ill. 119) in the Louvre in Paris. Nevertheless, Vasari
was not the first to praise him highly – even with respect

to those works that were unfinished. During his own lifetime, important figures, both men and women, sought his presence. Thus, he worked for the Medicis, Sforzas and the pope in Rome, was asked by Isabella d'Este to produce a portrait and enjoyed the admiration and friendship of King Francis I of France.

In addition to other things, it is Vasari's biography, written after the artist's death, which has had a particular effect on shaping our image of Leonardo. Vasari's "Lives" (1550–1568) is a highly-regarded literary masterpiece which is at the same time one of the most important sources for understanding Renaissance art. Vasari made it his task to narrate how the problem of the unrealistic art of the Middle Ages had, since the 14th century, been overcome by Tuscan artists, to honor the commendable ruling house of the Medicis, and to celebrate the work of Michelangelo, still alive when the "Lives" were written, and whom he considered to have reached the pinnacle of development in painting, sculpture and architecture.

Vasari, himself a painter and architect, was an understanding interpreter of his predecessors, and he arranged a convincing chronological series of character studies, in order to demonstrate how the arts had developed from artist to artist in the Golden Age of

the Renaissance. Leonardo occupied a key position in his work, as at the turn of the 16th century he had raised painting to new heights, so that all Raphael (1483–1520) and Michelangelo (1475–1564) had to do was add some refinements. In order to present this line of development, Vasari had to work out the precise artistic qualities of Leonardo and, at the same time, emphasize his imperfection compared with Raphael and Michelangelo. He found the latter in Leonardo's already famed, but more critically viewed versatility, which Vasari used to explain the fact that just about all the important Florentine commissions that Leonardo was given remained unfinished. Leonardo "protested that he had offended God and mankind by not working at his art as he should have done," according to Vasari, and elsewhere he wrote that "the truth, however, is surely that Leonardo's profound and discerning mind was so ambitious that this was itself an impediment; and the reason he failed was because he endeavored to add excellence to excellence and perfection to perfection." This comparison makes it clear that Vasari was already surrounding Leonardo – in contrast with Raphael and Michelangelo – with an aura of mystery and the superhuman, which led to his becoming a legend.

"Leonardo da Vinci [was] an artist of outstanding

7 Netherlandish master (?)
Head of Medusa, 16th century
Oil on panel, 49 x 74 cm
Galleria degli Uffizi, Florence

From an early point, museums endeavored to add the name of Leonardo to their collections. As early as 1782, this panel in the museum's depository was linked to a head of Medusa by the artist which Vasari mentions. It is likely, though, that a well-read Netherlandish artist had read the biographer's description of the monster that is said to have frightened Leonardo's father, and amalgamated it and an independent head of Medusa to produce this painting.

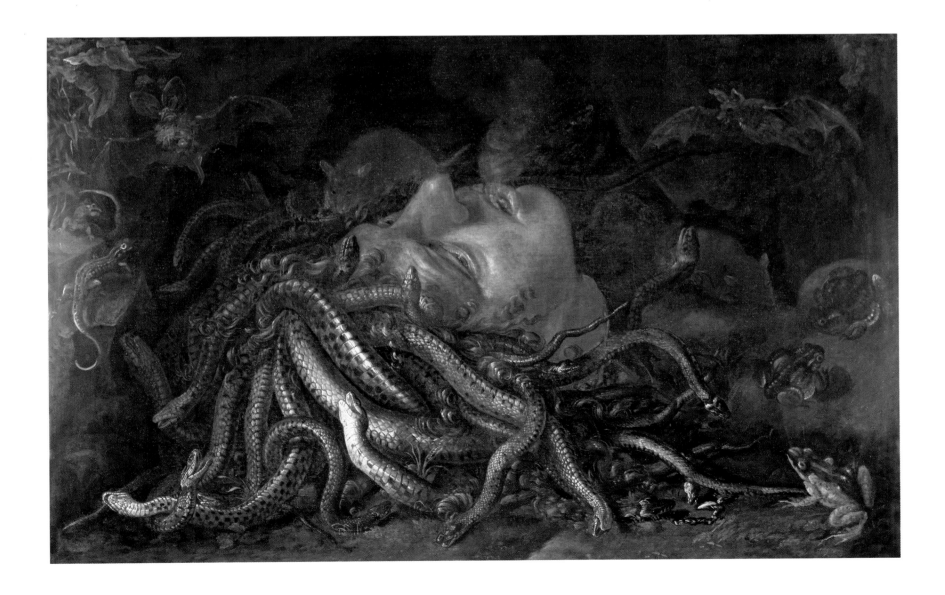

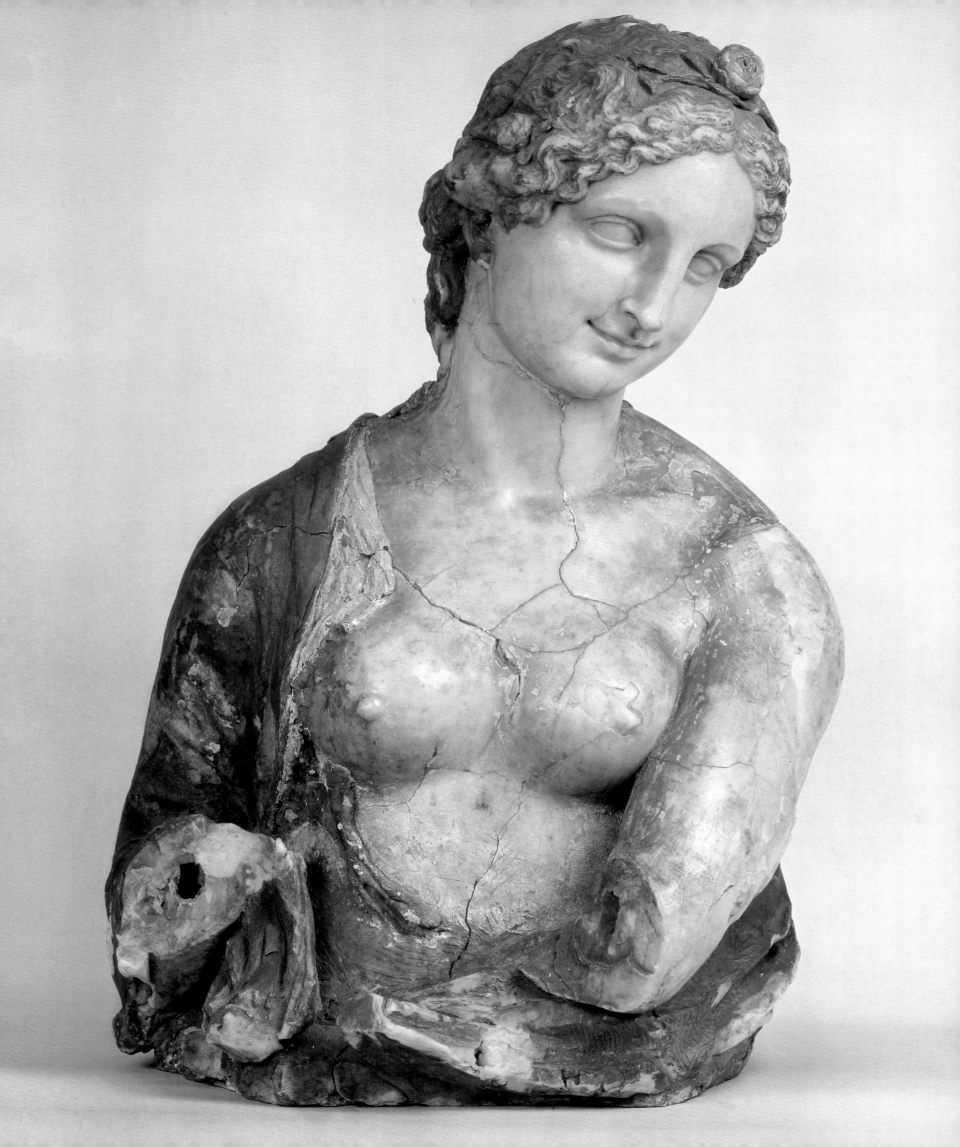

physical beauty who displayed infinite grace in everything he did and who cultivated his genius so brilliantly that all problems he studied he solved with ease. He possessed great strength and dexterity; he was a man of regal spirit and tremendous breadth of mind; and his name became so famous that not only was he esteemed during his lifetime but his reputation endured and became even greater after his death." Vasari's judgment has lost none of its validity to this day. Numerous scholars who greatly admired Leonardo's mental and artistic greatness have studied the paintings, drawings, sketches and designs of this extraordinary person. Their assessment always depended on the intellectual trends of their time, but never varied in their estimation of his quality.

The development of writing on art in the 18th century led to the poet becoming the interpreter of painting, due to his artistic imagination and his affinity in creative matters. Descriptions of pictures were produced in which the poet recreated the works of art in question with words, brought them to life that way and thus emphasized an essential nature of art that was independent of space and time.

Goethe's description of Leonardo's *Last Supper* (ill. 72) is one of the most famous examples of this reception of art: "Peter has, in the meantime, grasped the right shoulder of John, who is leaning against him, with his left hand, pointing at Christ and at the same time urging the most beloved disciple to ask who the traitor is. He involuntarily happens to press the handle of his knife against Judas' ribs, causing the latter by a happy chance to jump forward in fright, even knocking over a saltcellar. This group can be considered the first in the picture to have been conceived, and it is the most perfect."

In 1857, Théophile Gautier wrote the following comment on Leonardo's figures in the Paris journal "L'Artiste": "They seem to know what men do not know, people say that they have lived in higher and unknown spheres before they came to be reflected on canvas; their gazes are as mysterious as they are profound, penetrating, wise, disquieting while they also give delight and breed fear and love at the same time." Interpretations such as this raised the question of which artist could have produced such works and what sort of person he must have been. Thus, in the 19th century, the multilayered character of Leonardo was the principal subject for investigation. During the period when people were becoming increasingly interested in the inner life and soul of man, Leonardo's works seemed precisely suited to such analyses. From this developed the picture of an artist whose character appeared to be just as unfathomable and mysterious as that of his paintings.

In "Leonardo da Vinci: A Psychosexual Study of an Infantile Reminiscence" (1910), Sigmund Freud attempted to solve the riddle of his character from a psychoanalytical point of view. Starting with Vasari's interpretation that Leonardo's variety of interests had caused many of his works to remain unfinished, he referred to his experiences during his early childhood. His separation from his natural mother, the initial distance of the father and finally the pampering affection of his stepmother had been the foundations of his homosexuality which he had not, however, practiced, instead suppressing it and sublimating his libido into a thirst after knowledge. This point of view evoked violent objections at the time and does not stand up to our present knowledge of the historical Leonardo.

The development of the modern scientific approach to art, which started to base itself on facts drawn from sources and documents, and created comprehensible criteria by which to assess attributions, finally demystified the legend of Leonardo. While the rise of public museums founded in the 19th century and their need for original paintings by Leonardo led to a wave of incorrect attributions (ills. 7, 8), the early 20th century saw the start of a critical scientific examination of the universal genius. The first editions of Leonardo's remaining manuscripts and drawings were produced, revealing the artist's entire range as an engineer and natural scientist.

Bibliographies and volumes of sources were created in which the known documents relating to the artist were collected. In 1919, Luca Beltrami published them in chronological order for the first time. This was followed, in 1925, by Gerolamo Calvi's trendsetting study on the chronology of the manuscripts. Wilhelm Suida's work "Leonardo und sein Kreis" (Leonardo and his Circle; 1929) became the standard work on Leonardo's circle. Sir Kenneth Clark published the huge collection of Leonardo drawings from the Royal Library in Windsor Castle. Not until 1998 was the immense project of producing a facsimile edition of all Leonardo's known manuscripts completed. This is all the more important given that the numerous documents – which are mainly to be found in two places, Milan and Paris – provide us with the most important information about the historical Leonardo. Although the facts needed to reconstruct Leonardo's creative life are available within them, the mystery of his art is far from solved. His interpreters now face the task of acquiring the knowledge which Leonardo, the *uomo universale*, had possessed in such a diverse range of fields.

8 Leonardo's circle (?)
Bust of Flora, 16th century
Wax, height 67.5 cm
Staatliche Museen zu Berlin – Preußischer Kulturbesitz, Inv. no. 5951, Berlin

The bust of Flora, the Roman goddess of flowers and gardens, was bought from a London art dealer by the chairman of the Berlin museums, Wilhelm von Bode (1845–1929), who was a renowned Berlin expert on the Renaissance. By making comparisons with stylistically related paintings of Flora in the school of Leonardo, it was possible to reconstruct the missing flowers. However, the genuineness of the bust is still dubious, for an Englishman pronounced under oath that his father was commissioned by an art dealer to produce this work in the first half of the 19th century as a copy of a painting.

9 (below) *Comparison of scalp skin and onion*
Pen and ink on paper, 20.3 x 15.2 cm
Royal Library, RL 12603v, Windsor

Leonardo always attempted to record his analyses of what he saw and his experimental observations by connecting words and drawings, creating an encyclopedia of knowledge in the most diverse fields: optics, mechanics, biology, cosmology, mathematics, anatomy, geology. Here he compares the layers of the human scalp with those of an onion.

"In the normal course of events many men and women are born with various remarkable qualities and talents; but occasionally, in a way that transcends nature, a single person is marvellously endowed by heaven with beauty, grace and talent in such abundance that he leaves other men far behind, all his actions seem inspired, and indeed everything he does clearly comes from God rather than from human art." These words, which vividly describe the concept of the *uomo universale*, are the ones that Giorgio Vasari uses to introduce the biography of that artist who had already become the very symbol of such a universal man for his contemporaries: Leonardo da Vinci.

The image of the *uomo universale*, the man who knows everything, does everything, can undertake and is everything, was formed at that time of radical change whose very name, Renaissance, indicates its being a "new beginning." At the beginning of the 15th century, driven by a desire to cause the classical world to rise again, the Italian humanists began a revival of culture and education, thus creating a new image of man. The basis of every upbringing was not to be a specialized education such as the ones striven for at the universities, but to enrich and fortify the spirit as a whole before going into individual disciplines in more depth. This included the study of the classical languages, the medieval masterpieces, the great works of the sciences and philosophy as well as physical exercises. The new ideal upbringing was closely related to the concept of the citizen, who had to be enabled by an all-embracing education to also take on responsibilities in matters of state. In "Della Famiglia" (1433–1443), Leon Battista Alberti demanded that man should improve his mind in its entirety, not only in order to be suitable for everything, but in order, as far as possible, to *be* everything, so that he did not have to give up any of his possibilities. He had to be a citizen, but also a scientist, artist, engineer and man of the world. While Alberti's concept of the universal man reflects the political requirements during the last flowering of the Italian republics and describes the citizen of a democratic city state, the political ideal types written about by the diplomat and poet Baldassare Castiglione and the politician and historian Niccolò Macchiavelli corresponded to courtly society in the 16th century. While Macchiavelli's "Principe" (The Prince, 1513) introduces the concept of the tyrannical ruler who takes the place of rival parties, Castiglione created the civil opposite. In "Il Cortegiano" (The Courtier, 1514–1518), he describes the ideal courtier as excelling in all fields.

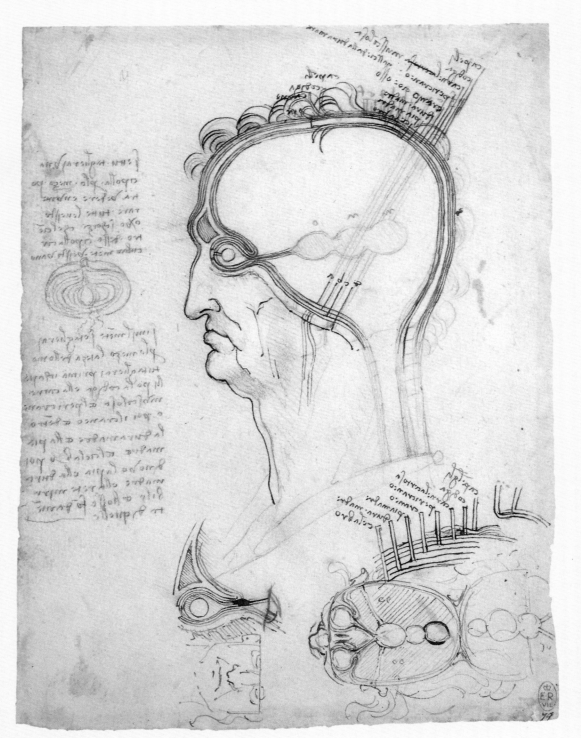

10 (opposite) Raphael (1483–1520)
Portrait of Baldassare Castiglione, ca. 1514–1516
Oil on canvas stretched on panel, 82 x 67 cm
Musée du Louvre, Paris

In "Il Cortegiano" (The Courtier, 1514–1518), Castiglione conceived the ideal courtier who excelled in all fields: talented and from a respectable family, handsome and with an endearing appearance, skillful in the use of weapons and a good storyteller, well-read in literature and experienced in business matters, a courtier also had to be a musician and painter, poet and philosopher, soldier and politician.

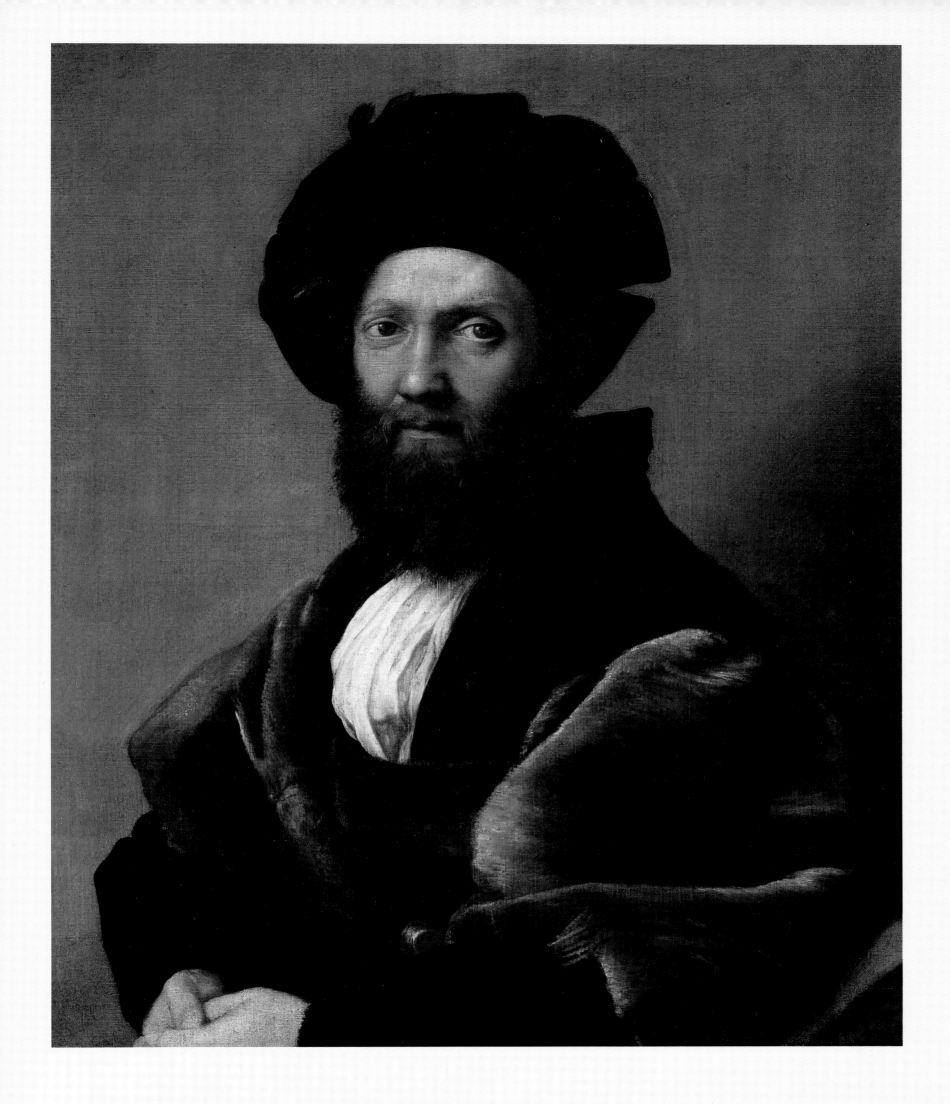

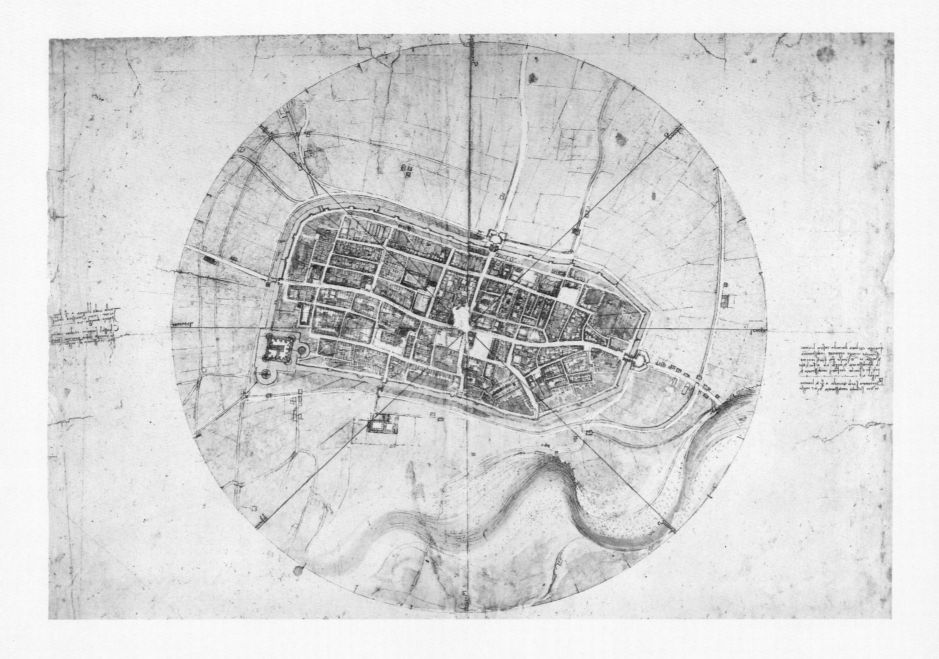

11 *Town plan of Imola*, ca. 1502
Pencil, chalk, pen and wash on paper, 44 x 60.2 cm
(facsimile)
Museo Vinciano, Vinci

It was during Leonardo's time in Florence (1501–1507)
that the magnificent maps – reckoned to be amongst the
first achievements of modern cartography – were created.
There is disagreement with regard to the town plan of
Imola as to whether Leonardo produced the map himself
or simply made slight alterations to an older map dating
from 1473. A survey map (Royal Library, RL 12686,
Windsor) of his survives which suggests that Leonardo's
town plan was developed by him independently. He may,
though, have used the older plan in order to compare his
own measurements with it.

Classical concepts of a man of this world who was
harmonious and universally educated had a decisive
influence on the new image of man in the Renaissance. In
addition to the concept, acquired in the democratic city
states, of man as the creator of himself and of history as the
process of man's self-realization and self-perfection, it was
above all the idea of *humanitas*, as supported by Roman
writers such as Cicero and Gellius, that played a role in
which the educational ideal was based on humane
understanding behavior towards one's fellow man. The
aspiring bourgeoisie of Renaissance humanism considered
itself to be the realization of this classical idea, and
remodelled it in accordance with the demands of its own
age to the type of the *uomo universale*. Universal man could
be a humanist, merchant, artist, patrician, banker, aristocrat
or clergyman, and his most important properties included
self-awareness, intelligence, striving to enhance one's
knowledge, a sense of realism, an all-round education,
knowledge of the ancient world and classical languages, a
musical education, sense of beauty, virtues, tolerance,

creativity, self-discipline, diligence, dexterity and physical
strength.

The image of the universal man who, by combining
theoretical and practical knowledge, differs from the ency-
clopedically educated who only has extensive theoretical
knowledge, was not merely an ideal but repeatedly took
shape in the form of extraordinarily diverse and talented
personalities. Apart from Leonardo, this image of man can
be applied to Leon Battista Alberti, who was a humanist,
architect, painter, sculptor, art theoretician, writer, musician
and natural scientist, to the architect, sculptor and engineer
Filippo Brunelleschi, to the painter, sculptor and architect
Michelangelo and to Lorenzo de' Medici, who was a banker,
politician, poet and governor of Florence.

The *uomo universale* is not, however, an original creation
of the Renaissance, for its origins go back to the classical
era. For example, encyclopedic knowledge was valued in
the classical era, as is shown by Pliny the Elder's 37-volume
work on the history of nature, which enjoyed a revival
during the Renaissance when it was reprinted, read and

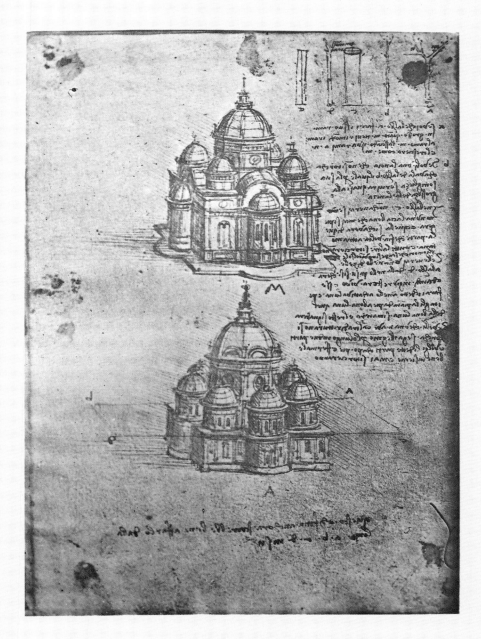

12 (left) Studies of central plan buildings
Pen and ink on paper, 23 x 16 cm
Institut de France, Ms. B, fol. 17v, Paris

It has been proposed that the central plan designs in Manuscript B were originally to be used in a collection of architectural plans. In addition to ground plans and elevations common until then, there are mainly aerial perspectival views, which were a novelty in the field of architectural drawing. However, Vitruvius had already introduced them as a third form of architectural depiction in "De Architectura", his ten books on architecture.

13 (below) Detail of study sheet, 1478
Pen and ink on paper, 20.2 x 26.6 cm
Galleria degli Uffizi, Gabinetto dei Disegni e delle Stampe, Florence

In addition to sketches of two profile heads, there are also mechanical and military drawings on the sheet. Due to a comment which Leonardo notes down in his characteristic mirror writing, to the effect that he is working on two pictures of Mary in 1478, the sheet is important for the artist's early work. The mirror writing was not intended to hide any secrets, as had so frequently been thought, but probably only had the simple practical reason of not wanting to smear the ink when writing with his left hand.

studied. In his theoretical treatise "De Architectura", the Roman architect Vitruvius had already demanded a universal education. He wrote that a master builder had to have an extensive body of knowledge at his disposal which had developed both from his practical trade and intellectual work. In order to be able to plan either a town or a single building, knowledge of social and technical areas as well as of the building trade was needed. Not least, philosophy was also part of the Vitruvian canon of knowledge, for its main effect was to make sure that an architect was not greedy. According to Vitruvius, however, this knowledge in various fields only needed to be of a general nature, so that the architect could coordinate the specialized knowledge of the experts and use it in the proper place.

Brigitte Hintzen-Bohlen

Beginnings in the Florence
of the Medicis 1469–1481

14 *Landscape drawing for Santa Maria della Neve on 5th August 1473*
Pen and ink, 19 x 28.5 cm
Galleria degli Uffizi, Gabinetto dei Disegni e delle Stampe, Inv. 8 P, Florence

The landscape drawing probably shows the view from Montalbano onto the Valdinievole area and the swamps of Fucecchio. It is the first artistic work of Leonardo's that is dated and can definitely be attributed to him, and is at the same time a real rarity: it appears to be the first known depiction of a landscape in Italian art that reproduces an actually existing section of a landscape in an original drawing.

The depiction of the tongue of hills with the fortress, the lines of which partially cover the previously drawn landscape, is a later addition on the part of Leonardo. It was not drawn at the original location. There are also weaknesses in the way the fortress is connected into the scene perspectively, for it is not standing horizontally on the ground. The striking waterfall also appears to be a later addition. It is produced using plain yet powerful strokes, making it unlikely that this was a concrete observation. The water is falling into a pond, the extent of which is peculiarly undefined.

THE WORKSHOP OF ANDREA DEL VERROCCHIO

The first significant note in Leonardo's artistic biography is an entry on the occasion of his admission to the Florentine guild of painters. According to this, Lionardo di Ser Piero da Vinci, his full name, was allowed to accept commissions as an independent Florentine master from June 1472. His apprenticeship, which is generally poorly documented in the case of Renaissance artists, a rule to which Leonardo is no exception, had been completed by this time. In about 1469, he had commenced his apprenticeship with the sculptor, gold and silversmith Andrea del Verrocchio (1435–1488) in Florence. The city, which had been ruled by the Medicis since 1434, had enjoyed an enormous economic and cultural upturn since the Trecento. It had been an artistic capital for two centuries and had risen to become the greatest center of humanism, in which new ideas and artistic developments fell on fertile ground. One of the most renowned artists' workshops in the city was that of Verrocchio. The range of commissions it took on covered almost all artistic techniques: sculpture and jewelry-making as well as painting and architecture.

The range of activities and requirements of the workshop meant that the apprentices received a varied education which always, however, stressed the importance of the drawn design (ill. 17). It was the basis for a work produced in stone, marble, bronze, clay, paint or precious metal. Trained craftsmen who were familiar with the artistic techniques and various materials then appear to have been entrusted to monitor the execution of these designs. Leonardo himself was later to support the view that drawing was the most important prerequisite in the training of an artist, and his first biographer, Paolo Giovio, noted that: "Until they (the students) were 20 years old, he (Leonardo) utterly forbade them to work with brushes and colors and only allowed them to practice with a slate pencil…"

The first project involving Leonardo in Verrocchio's workshop was the production of the dome lantern for the Florentine cathedral of Santa Maria del Fiore. The Florentine architect Brunelleschi (1377–1446) had created a technical sensation in the form of the largest self-supporting dome since antiquity. This was not merely an achievement in terms of the static and structural solution; it also required new equipment to be developed to enable the actual building process to be carried out. After Brunelleschi's death, the commission for the production and erection of the unfinished top of the dome was awarded to the Verrocchio workshop in about 1468. We know that Leonardo was involved in this project from a note that he wrote in about 1515, in which he remembers the special welding technique used for the copper sphere on the Cathedral's lantern. Leonardo was able learn the important fact that the artistic design was only a stage in the realization of a project. Without taking the necessary steps such as developing the right welding process, testing it out on trial pieces, managing transportation up to the roof of the dome, ensuring there was a stormproof anchoring and building a work scaffold, the successful outcome of the project would have been in doubt. This early familiarity with the running of extensive projects was surely the prerequisite for his own later pleasure in experimentation. In addition, it is likely that Leonardo had already been allowed to see technical drawings by Brunelleschi during the course of this project, and these evidently inspired him when making his own first designs for machines. Thus, for example, in order to create the large wall painting of the *Battle of Anghiari,* he designed a moving scaffold which allowed him to work quickly at any point on the entire surface of the painting. In 1478, Verrocchio's workshop was commissioned to produce a bronze equestrian monument (ill. 56). Leonardo was able to work on the project until about 1482, in the process learning the technical requirements for the production of such a monumental work in bronze. The experiences gathered in this way benefited him later when designing the equestrian monument for the duke of Milan, Ludovico Sforza. No independent works by Leonardo are known from his actual period of apprenticeship. This is why, in the search for his earliest work, a landscape drawing kept in the Uffizi (ill. 14) is all the more significant as he dated it, writing left-handed in his extraordinary mirror writing: "Today, on the day of Santa Maria della Neve, 5th August 1473."

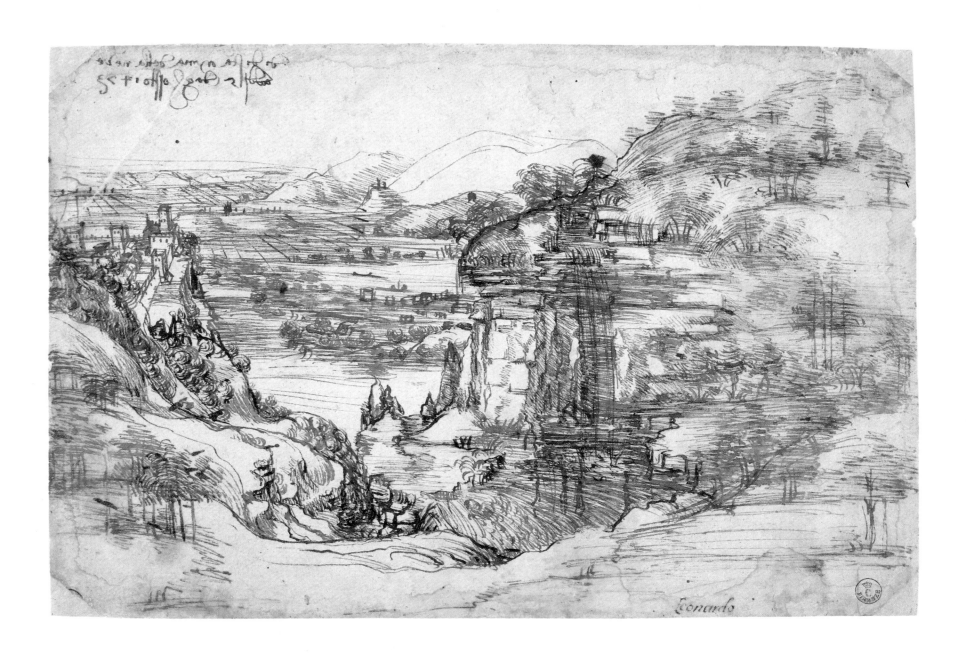

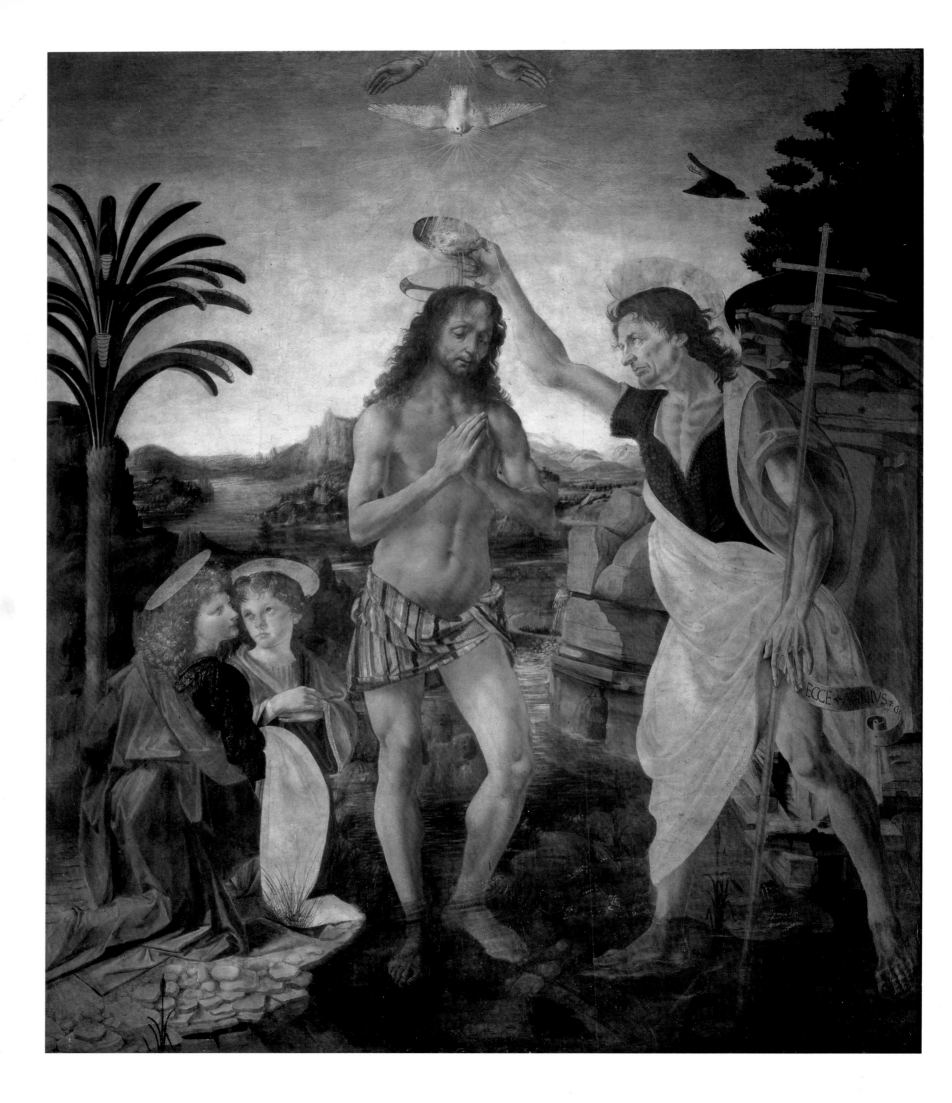

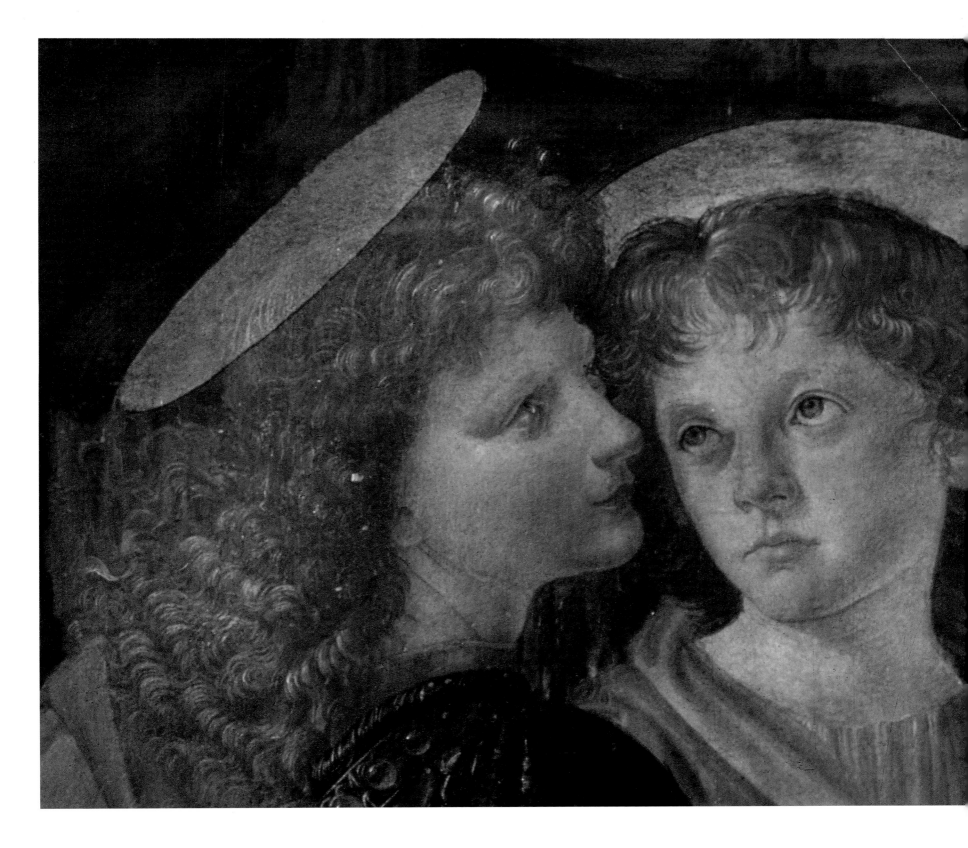

15 (opposite) Andrea del Verrocchio (1435–1488) and
Leonardo da Vinci
Baptism of Christ, ca. 1475–1478
Tempera and oil on panel, 177 x 151 cm
Galleria degli Uffizi, Florence

St. John the Baptist baptizes Jesus by pouring water over his head.
The extended arms of God, the golden rays, the dove with out-
stretched wings and the cruciform nimbus show that Jesus is the
Son of God and part of the Trinity. Two angels on the riverbank
are holding Jesus' garment. The composition is attributed to
Verrocchio, although there can be no definite answer as to which
artist produced it. The angel seen from behind and large sections
of the landscape are now considered to be by Leonardo.

16 (above) Andrea del Verrocchio and Leonardo da Vinci
Baptism of Christ: angel (detail ill. 15), ca. 1475–1478

The gentle modelling of the left angel's head and the fact
that the paint at this point contains oil supports the
general attribution of this section to Leonardo. The
painting was probably produced for the church of San
Salvi in Florence and was mentioned as early as 1510 by
Albertini, who stated that Leonardo painted the angel's
head. A drawing of the angel's head is kept in Turin.

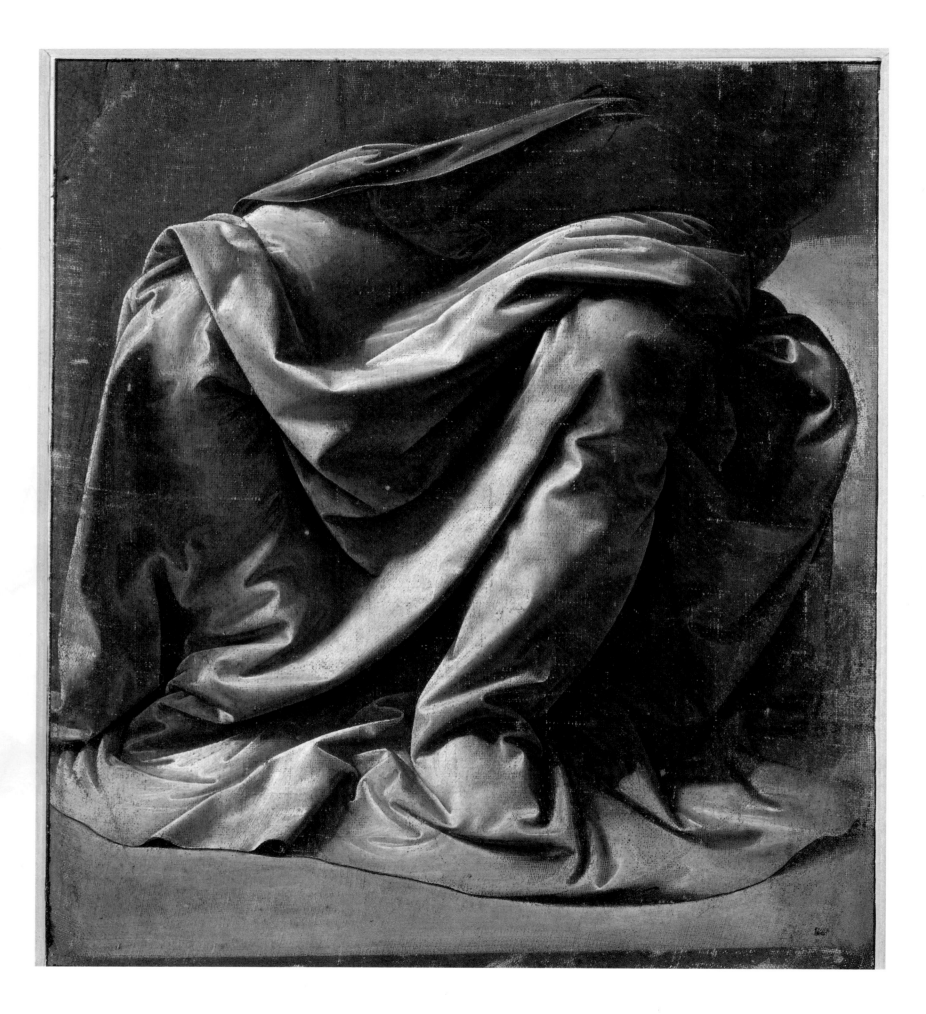

Leonardo's work as an artist starts with a sensation, for pure depictions of landscape, in other words of depicting directly observed nature, were a complete novelty during his time. While imitating nature was the central task of artists at the time, none of them had until then been so rigorous as to go out into the open and draw an actual landscape. Instead, it was customary to create a landscape in the workshop with the aid of sketches or elements copied from models. The landscape was seen as an accessory designed to support the central subject in compositions of the time, the human figure. Simple strokes are used to mark tree trunks and rapidly produced horizontal hatchings mark the crowns. If one compares this with depictions of trees from the Verrocchio workshop, it is noticeable that Leonardo was keeping to his conventions of depiction here. But already he was attempting to depict direct observations and perceptions such as the shimmering of the air in the glistening light. This effect does not, however, appear to have been deliberately aimed for, but rather to have been a chance product of his enthusiastic interpretation of the method of depicting trees. It can be considered certain that Leonardo produced this drawing in front of an actual landscape. Thus, for example, the ensemble of the gorge that has been hollowed out by water and the differentiated treatment of the rocks and layers of stone in front of the broad landscape view are surely the result of a concrete observation which he executed using a range of artistic devices. He used tapering hatchings and the opportunities for variation provided by the pen and ink to give the landscape a convincing sense of depth. He pressed firmly with the pen to create highlights, and used lighter strokes in the background of the picture. Leonardo used hatchings to follow the form and model the landscape; others run parallel and determine the light and dark sections. By including a fortress and placing an accent by means of an invented waterfall, Leonardo was able to raise the drawing to the level of an independent work and wrote on it at a point where the landscape achieves its ideal effect of depth. Precisely at that point, where the landscape is creating its greatest sense of depth, his writing emphasizes the contrast between the flat surface of the paper and the illusion of depth.

THE BEGINNINGS OF FLORENTINE OIL PAINTING

It is difficult for researchers to reconstruct the definite beginnings of Leonardo the painter. As a result of his membership of the Verrocchio workshop, he took part in pictures produced by the master together with his workshop. In the *Baptism of Christ* (ill. 15), for example, the angel seen from behind is thought to be Leonardo's contribution. Vasari writes about this painting to the effect that Verrocchio said he "would never touch colors again" after he had seen the grace of the figure created by Leonardo. But from what point Leonardo started to

appear as an independent artist cannot be stated categorically. No more is known about his first independent commission other than that sources show it dates from 1478 and was for an altar in the Chapel of San Bernardo in the Florentine Palazzo Vecchio. On a drawing which also dates from 1478 (ill. 13), Leonardo noted that he was in the process of working on two pictures of the Madonna. It is not until 1481, however, that we can reasonably confidently connect a commission to a painting which has been preserved: the unfinished panel of the *Adoration of the Magi* (ill. 46), which is now in the Uffizi in Florence.

The early work of Leonardo is a difficult field of research in more ways than just this because none of his paintings is signed and there are also no longer any sources for the earliest pictures now attributed to Leonardo. The only way of identifying them is by making stylistic comparisons between pictures, based on the principle of art history according to which the works of a student are stylistically related to the works of the master. The paintings of the school of Verrocchio can be distinguished mainly by two characteristics: first of all, they demonstrate a closeness to Florentine models such as Filippo Lippi (ca. 1406–1469), and secondly, they are characterized by an interest in the achievements of painting north of the Alps.

One of these was the use of oil as a paint medium for color pigments, which first appeared in northern painting in the first half of the 15th century, and rapidly spread there. Italian art developed this technique later. One of the first Florentine panel paintings known today to have been produced with a paint medium containing oil appears to have been the Washington *Madonna and Child with a Pomegranate* (ill. 18), which is assumed to have been created in about 1470. The panel, at 15.7 x 12.8 cm, is very small by Florentine standards, yet not at all an unusual format in Flemish painting. The Christ Child as well, with his fat tummy, overlong torso and skinny little arms, refutes the widespread generally more rounded Florentine type of depiction. For this reason it is still disputed whether the painting was created by an Italian painter, or by an artist from north of the Alps.

A drawing of the composition still in existence in Dresden is also not able to shed any light on the matter, as it is presumably a copy of the painting. This and a second picture, the *Madonna with the Carnation* (ill. 19) in the Alte Pinakothek, Munich, whose attribution to Leonardo is broadly accepted nowadays, do at least demonstrate that the Verrocchio workshop was familiar with the *Madonna and Child with a Pomegranate*.

The type of head of the Munich Madonna corresponds to the works of the Verrocchio workshop, but the slightly more disorderly and, at the same time, more powerful depiction of the folds and the flowers enables the picture to stand out from those produced by other painters in the workshop and suggests that Leonardo's hand was at work (ills. 29, 31). For the first time, the rocky hills so typical of Leonardo's later landscapes appear in the background, but here they are probably derived from Florentine models such as the painting of

17 *Garment study for a seated figure*, ca. 1470–1484
Oil on canvas, 26.5 x 25.3 cm
Musée du Louvre, Cabinet des Dessins, Inv. 2255, Paris

Garment studies were part of the training of every painter. It is likely that prepared materials were used for this in the workshops in Florence. On them, the students were above all able to study the depiction of light and shade, which is why these works appear to have been carried out primarily in one color. Several such garment studies at different levels of artistic ability survive, though their attribution is disputed. It is above all the fineness of this study that has led to its being attributed to Leonardo.

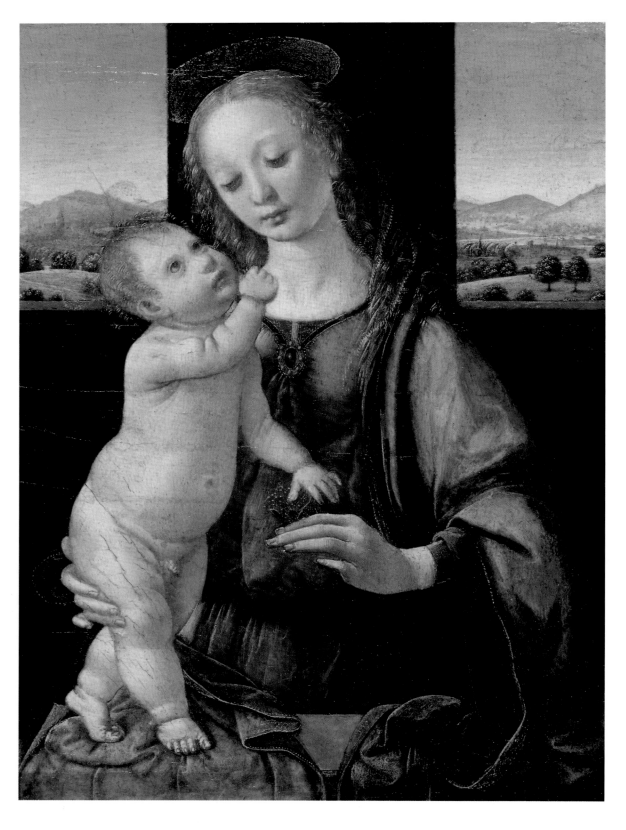

18 (left) Leonardo (?)
Madonna and Child with a Pomegranate, ca. 1470
Oil on panel, 15.7 x 12.8 cm
National Gallery of Art, Washington

The Madonna and Christ Child appear in a window, and
the child is standing on the balustrade below it. She is
holding a pomegranate that has been cut open out to
him, and the boy has taken some of it, for he is showing
Mary red pearls of fruit that he is holding in his clumsy
child's hand. Mary appears melancholy, as if she knows
about the future Passion of her son, symbolized by the
pomegranate.

19 (opposite) *Madonna with the Carnation*,
ca. 1473–1476
Oil on panel, 62 x 47.5 cm
Bayerische Staatsgemäldesammlungen, Alte Pinakothek,
Munich

The authorship of this variation on the Madonna and
Child theme was disputed for a long time. The work was
attributed to both an unknown Flemish artist as well as
to Verrocchio and Leonardo. Mary is holding a red
carnation out to the Christ Child, who is attempting to
grasp it. The vividness of the boy, and his well-observed,
childishly clumsy movement does, however, suggest that
it was Leonardo's work. The convincing plastic quality of
the child suggests that during his early years Leonardo
may have worked in three dimensions, using either clay or
other sculptural techniques.

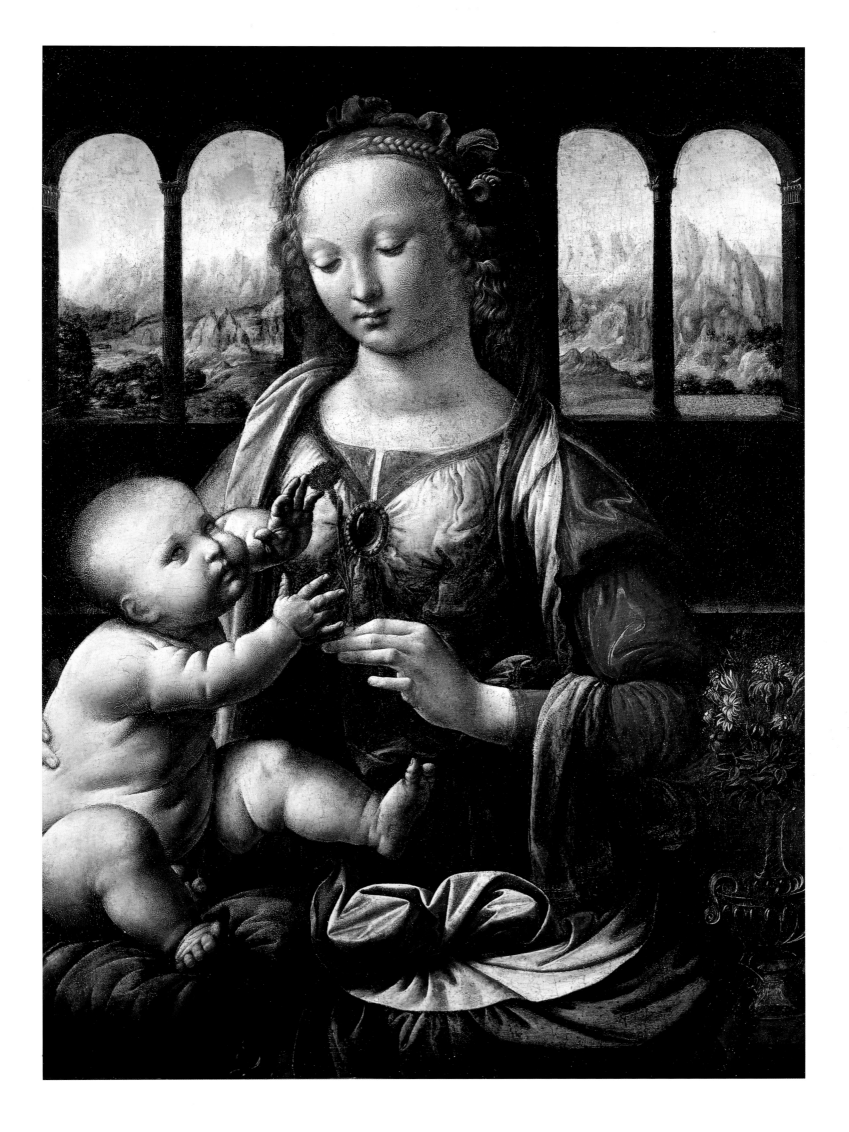

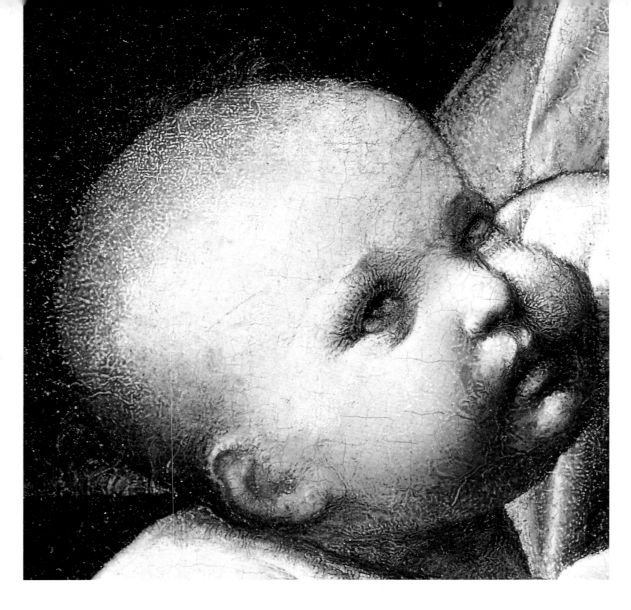

20 (left) *Madonna with the Carnation:* Christ's head (detail ill. 19), ca. 1473–1476

The *Madonna with the Carnation* was produced using a paint medium containing oils and is not in a good state of preservation. The flesh tones, such as these on Jesus' head, clearly show that a layer of paint shrank due to a disparity between the color pigments and the paint medium containing oil.

the *Madonna and Child with Angels* by Filippo Lippi in the Uffizi.

The attribution of the *Annunciation* (ill. 25) in the Uffizi to Leonardo seems to be assured by a study of a sleeve which he made of the angel's garment (ill. 26), at least where that one figure is concerned. The painting is considered by various researchers to be a group work produced by several artists. This theory is, however, less convincing, and the panel rather appears to have been conceived by Leonardo, and executed by him as well. The unusual impression the *Annunciation* panel makes, showing the artist's love of experimentation, demonstrates to us the attempt being made to characterize the figures (ill. 25), the place, the time and the events in such a way that the observer is able to understand them visually. The characterization of the place, for example, conspicuously displays this attempt. According to tradition, Mary was visited at home by the angel. Usually in depictions of the Annunciation, she was placed in a building or shown in her room. The angel was a visitor, so he was placed in a garden, on a path, by a door or window, in order to show that he had just arrived (ill. 27). Leonardo moved the entire scene completely into the open, as a result of which he had to create a visual relationship between Mary and the building (ill. 25). In order to achieve this, he was not

satisfied with merely assigning a building to Mary, but evidently also wanted to show that this was her home because through the door we can make out the outlines of a bed. In order to create a visual link between the Virgin Mary and her bed chamber, the painter also draped Mary's blue cloak in three vertical folds, a rhythm which directs our gaze to the door and her red bed. The solution probably seemed so satisfactory to him that he was prepared to accept that, at first sight, Mary appears to have three legs. The noticeable attempt to determine the figures and the event more closely by means of 'accessories' and assign these to the figures in a visually comprehensible manner is an important individual feature of this early work.

The conspicuous way in which Mary's garment is draped across her stomach suggests that the panel was produced at an early date. The Annunciation scene narrates the moment at which Mary learns of her pregnancy from the archangel Gabriel. According to a long-held tradition, God was depicted as a half-length figure sending golden rays of light and the dove of the Holy Spirit down to Mary from heaven. In Florence, depictions started to appear in which only the dove and golden rays were shown. Filippo Lippi introduced a further innovation in his Florentine *Annunciation* in the Martelli Chapel in San Lorenzo, by depicting a

21 (opposite, above) *Madonna and Child with a Pomegranate:* brooch (detail ill. 18), ca. 1470

The painter of this work knew how to paint the varying reflections of light on the brooch in a striking manner. The material properties are depicted here with a brilliance unusual in Italy.

22 (opposite, below) *Madonna with the Carnation:* brooch (detail ill. 19), ca. 1473–1476

The garment worn by Mary is similar at the neck and chest to the one worn by the Madonna with the pomegranate. The almost identical petticoat and similar brooch also prove the proximity of the two panels and make it more than likely that Leonardo was familiar with the *Madonna and Child with a Pomegranate* (ill. 18) when composing his *Madonna with the Carnation*, irrespective of whether the work was produced by Leonardo himself or Verrocchio's workshop.

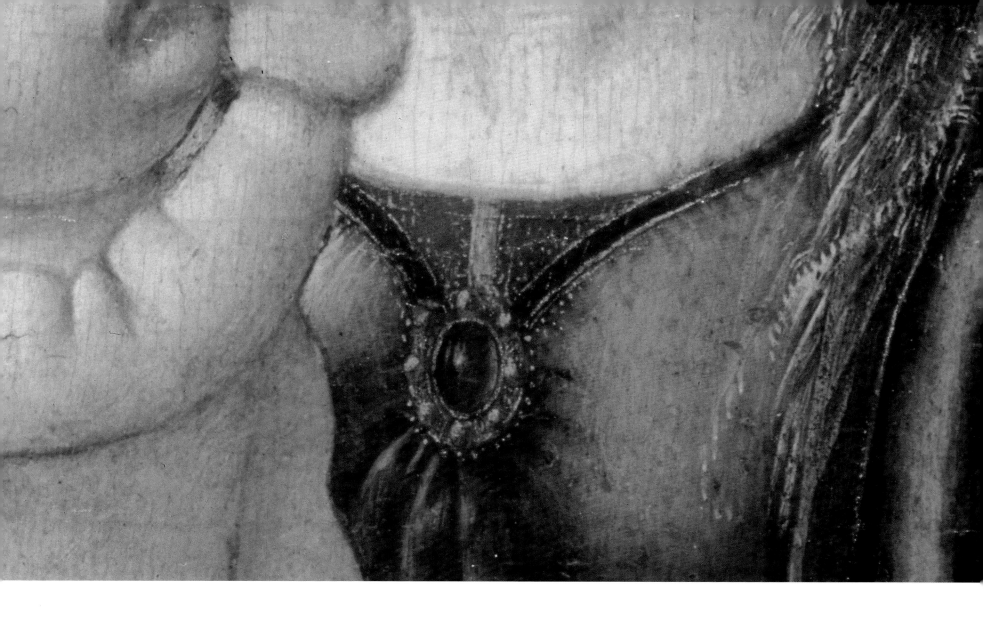
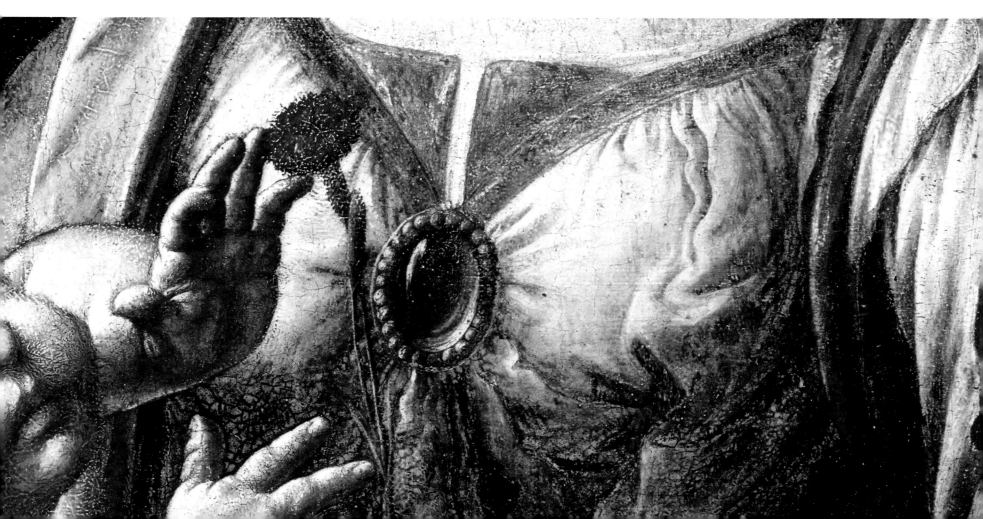

conspicuous draping across Mary's stomach which
was probably designed to make her pregnant state
recognizable. Leonardo adopted this representational
concept, but in addition to God, also for the first time
omitted the dove and represented the golden light
by means of the golden color of the garment draped
across her stomach. Leonardo applied this method of
illustrating of the Immaculate Conception to several of
his Madonna depictions, such as the later *Madonna with
the Carnation* (ill. 19) and the *Madonna of the Rocks*
(ill. 51). For this reason the theory that several hands
were at work on the *Annunciation* (ill. 25) appears rather
improbable. In this painting, rather, Leonardo created
a first original example of the possibilities of pictorial
language in painting.

The attribution of the *Portrait of Ginevra de' Benci*
(ill. 32) to Leonardo has generally been accepted. This
painting also has the special feature that on the one hand
it reflects Flemish models and on the other hand
symbolically characterizes the portrayed woman in an
unusual manner: Leonardo places a juniper tree behind
Ginevra de' Benci, which is a visual representation of her
name (*ginepro* meaning "juniper" in Italian).

The portrait used to be dated to 1474, the year when
Ginevra was married. A few years ago, it was possible to
identify an emblem on the rear side of the panel as that
belonging to the humanist Pietro Bembo (1470–1547),
and this makes a later date more likely. Bembo had
presumably commissioned the portrait between 1475
and 1476, the period during which he lived in Florence,
for there are sources showing that he had an intellectual
friendship with Ginevra.

The portrait of Ginevra de' Benci has been subjected
to a technical examination, which helped to identify
tracing marks and fingerprints. The latter indicate that
Leonardo used the ball of the thumb or fingers to blur
the damp oil colors in order to try to create more gentle
transitions than he could achieve with the brush.
Attempts of that nature have in the meantime also been
found on other paintings by Leonardo.

The painting of the *Benois Madonna* (ill. 33) surprises
us because of the clear tectonics of the compositional
structure and the powerful corporeality of the figures.
The picture depicts Mary and the Christ Child in a
hitherto unfamiliar degree of vividness. Mary is play-
fully, and with obvious pleasure, holding a flower out to

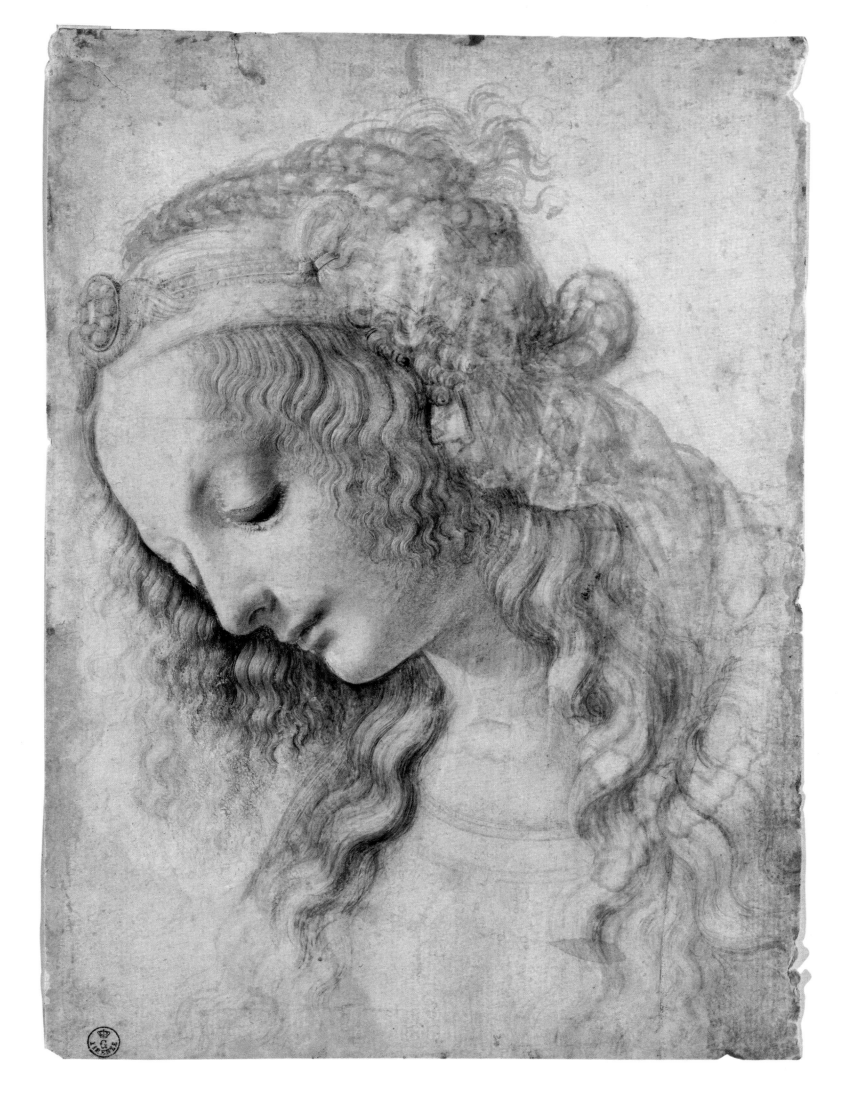

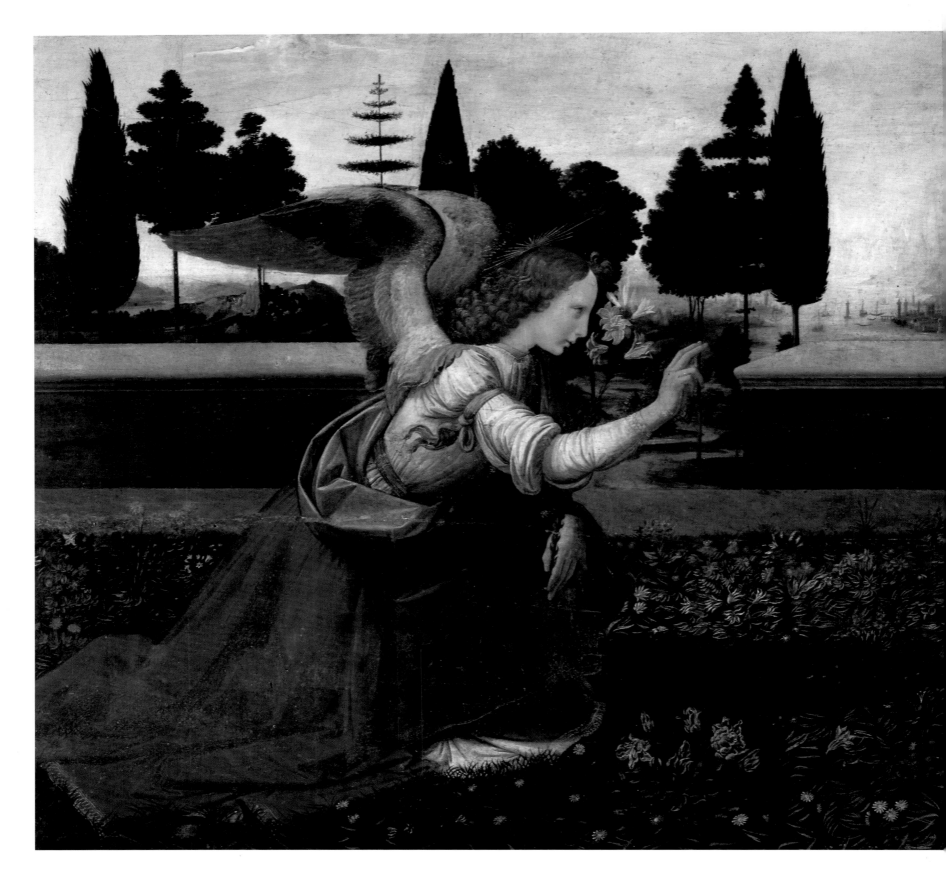

25 *Annunciation*, ca. 1470–1473
Oil and tempera on panel, 98 x 217 cm
Galleria degli Uffizi, Florence

The archangel Gabriel is kneeling as a dignified profile figure and raising his right hand in greeting to Mary, indicating her divine pregnancy. The Virgin has stopped reading and reacts to the Annunciation with an expression of deep respect and by gesturing with her left hand. There is a conspicuous perspectival mistake: her right arm had to be painted too long proportionally, so that, despite her seated position, it would still be able to depict the impressive position of her hand over the prie-dieu. Leonardo depicted Mary in a three-quarter profile in front of the corner of a room. All three spatial coordinates – height, width and depth – converge on this point, thus creating a sense of depth in the picture as well as enhancing the importance of Mary. Her head clearly contrasts with the dark wall and her body is emphatically framed by the cornerstones whose parallel lines are converging on her.

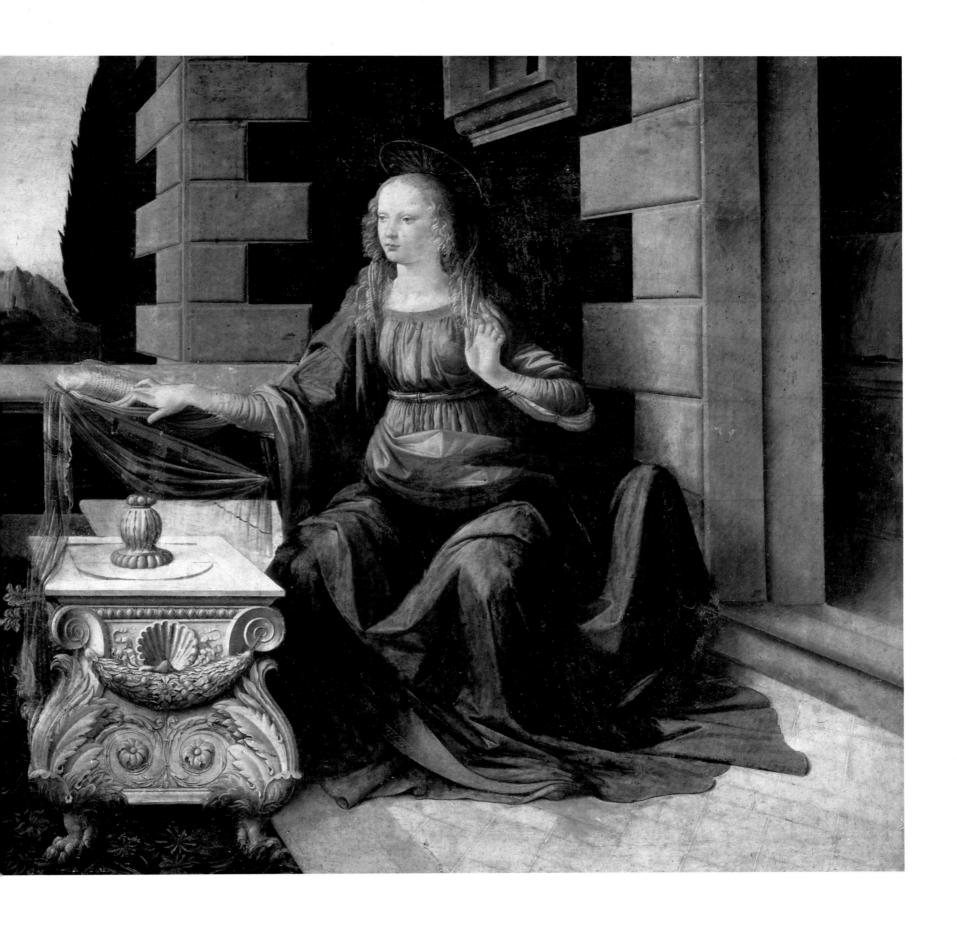

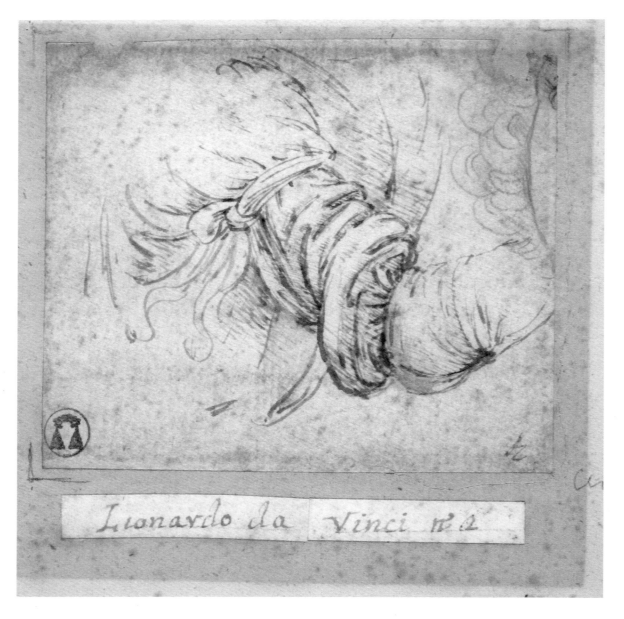

Leonardo da Vinci ...

27 (opposite) *Annunciation*: angel (detail ill. 25), ca. 1470–1473

Gabriel is swathed in generous and magnificently colored garments whose folds gave the artist ample opportunity to display his skill in depicting materials. Behind the angel's raised arm, one's view is guided through the break in the wall at this point into the landscape that lies beyond, thus formally intensifying the significance of the gesture of the Annunciation.

26 (above) Sleeve study for the *Annunciation*,
ca. 1470–1473
Red chalk on paper, 8.5 x 9.5 cm
Christ Church, Oxford

The pen drawing for Gabriel's sleeve in the Uffizi *Annunciation* (ill. 25) displays the same powerful style as Leonardo's first firmly attributed *Landscape drawing* dating from 1473 (ill. 14). The sheet proves the meticulous way in which the artist worked; even details such as the folds on the angel's upper arm (ill. 27) were prepared in sketches in order for him to gain clarity about the *rilievo*.

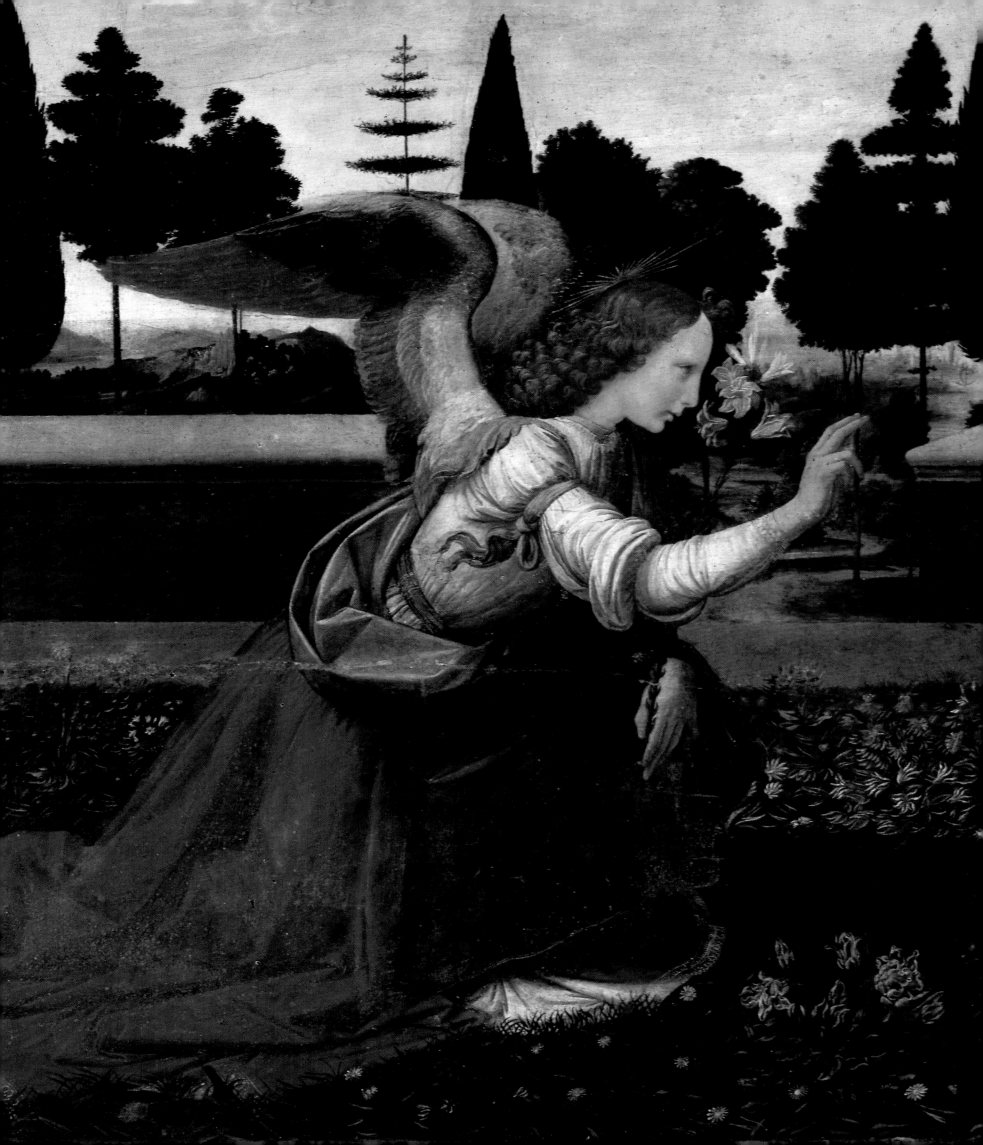

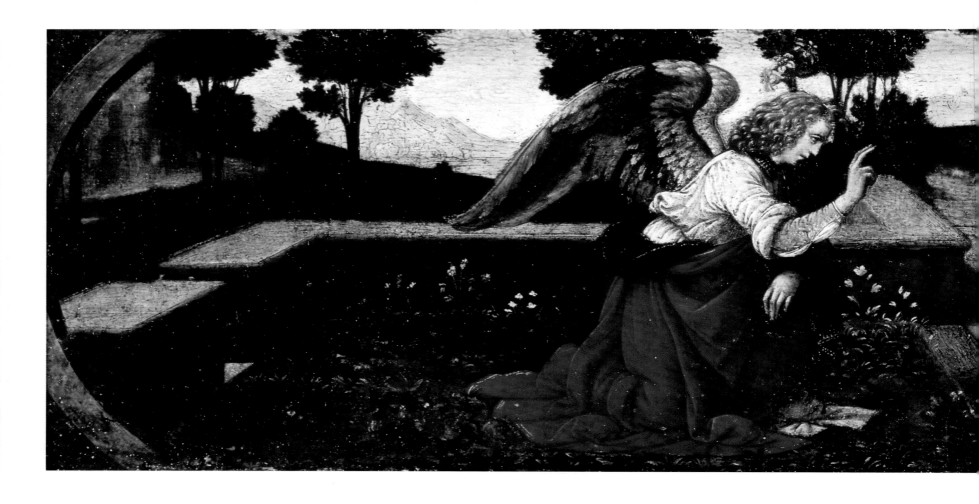

28 Lorenzo di Credi (?) (1456/57–1537)
Annunciation, ca. 1478–1482
Oil on panel, 16 x 60 cm
Musée du Louvre, Paris

This Annunciation predella was originally part of the altar
of the *Madonna di Piazza* in the cathedral of Pistoia,
commissioned from Verrocchio and produced between
1475 and 1485 with the assistance of Lorenzo di Credi in
Verrocchio's workshop. Leonardo's participation in the
work on the altar is the subject of debate. While the
predella panel is reminiscent of Leonardo's great
Annunciation (ill. 25), it does, however, display what by
Leonardo's standards is an atypical weakness in the
control of the surface, for the angel has been moved too
close to Mary.

29 *Annunciation*: flowers (detail ill. 25), ca. 1470–1473

In the Christian calendar, the Annunciation is celebrated on
25 March. This time of year is depicted in the way the earth is covered
with grasses and flowers. The leaves stylistically match the flowers in
the painting of the *Madonna with the Carnation* (ills. 19, 31).

30 *Annunciation*: festoon (detail ill. 25), ca. 1470–1473

The festoon on Mary's stone prie-dieu, with its plants painted in grisaille, is striving for the same vividness as the natural flowers on the panel. The competition between painting and sculpture also becomes obvious if one looks at the little band with which the posy is fastened to the volute; it would be difficult for a sculptor to realize such delicacy.

31 *Madonna with the Carnation*: flower (detail ill. 19), ca. 1473–1476

In this detail, the lively rhythm of the foliage, and the modelling by means of edges of light such as those on the leaf halves, testify to the painter's considerable mastery.

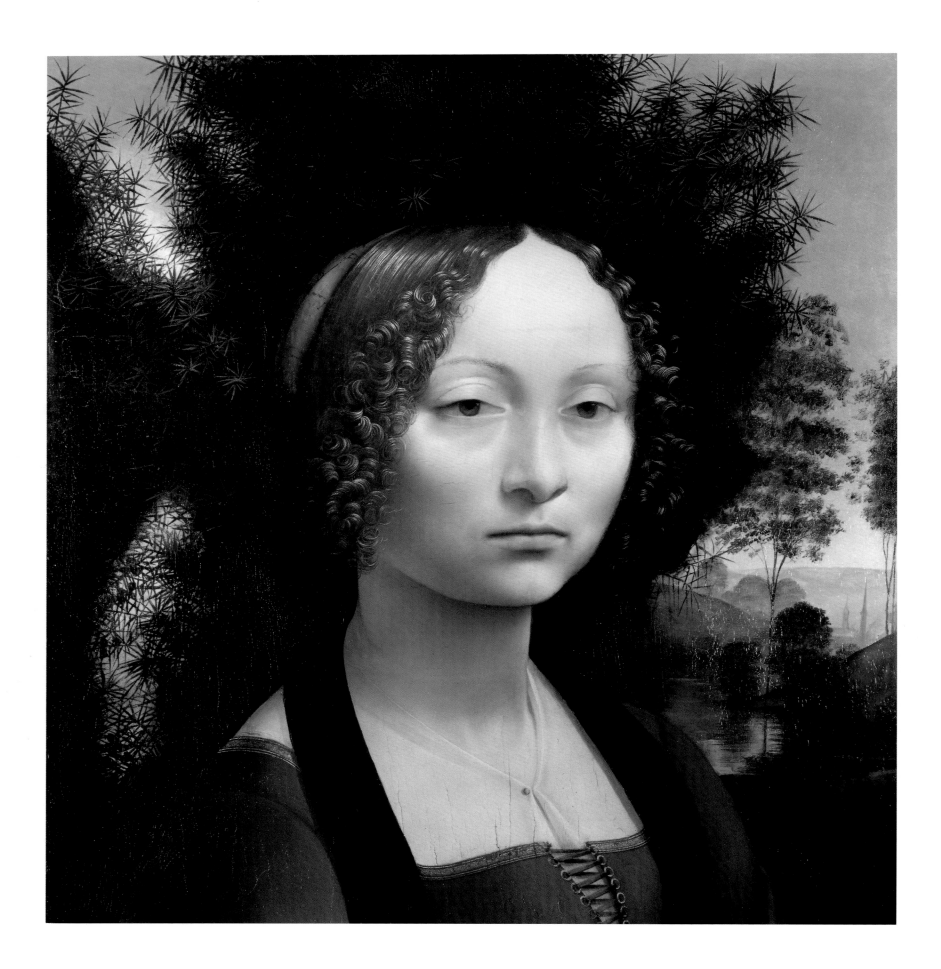

32 (opposite) *Portrait of Ginevra de' Benci*, ca. 1475/1476
Oil on panel, 38.8 x 36.7 cm, trimmed at the bottom
National Gallery of Art, Washington

The portrait of the Florentine Ginevra de' Benci was first
suggested to be a work of Leonardo's by Gustav von
Waagen in 1866, and Wilhelm von Bode was later able to
identify the woman depicted as a Florentine lady called
Ginevra de' Benci, whose portrait Vasari had already
mentioned. About 12–15 centimeters of the panel have
been cut off at the bottom. The majority of researchers
assume that hands were originally painted there, though a
convincing reconstruction has yet to be produced. The
pale color of her face is conspicuous, and it is possibly
meant to reflect the poor state of health that sources tell
us Ginevra de' Benci was in. The strict symmetry of her
hair which frames her face, and above all the strong
contrast with the dark background of the juniper tree,
causes the face to look hard and linear, though also
particularly fascinating.

33 (right) *Benois Madonna*, ca. 1478–1480
Oil on panel, transferred to canvas, 48 x 31 cm
Hermitage, St. Petersburg

Mary and her child are naturally engrossed in their game,
and their gazes make them appear lifelike to a degree that
can be found in no contemporary Italian painting of the
Madonna. Leonardo achieved this quality by means of
nature studies. In 1478, he noted that he was working on
two Madonnas (ill. 13). The *Benois Madonna* can be
dated to that period. The painting has in its present
condition been overpainted in some places and has lost
some of the paint layer.

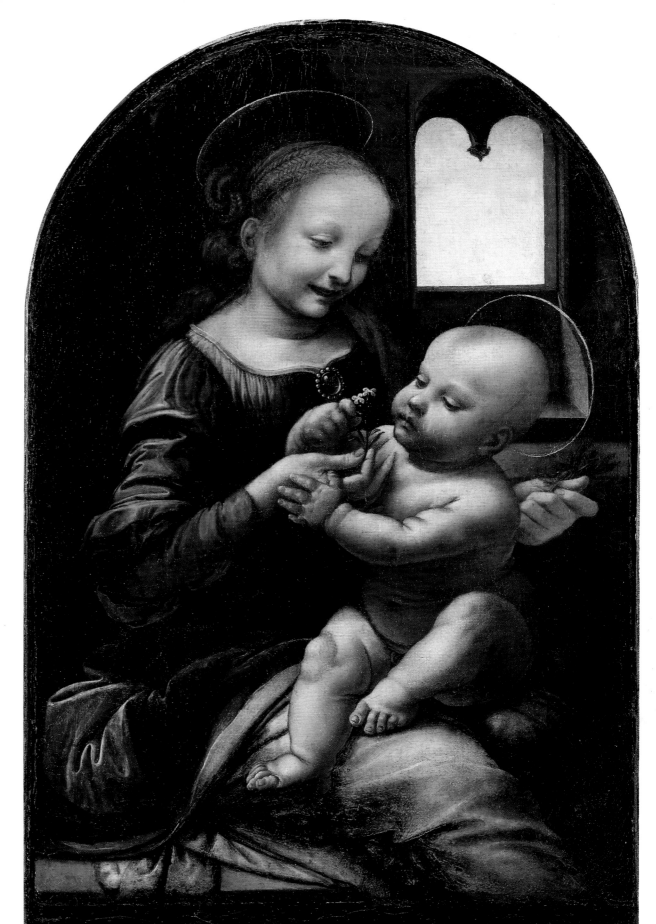

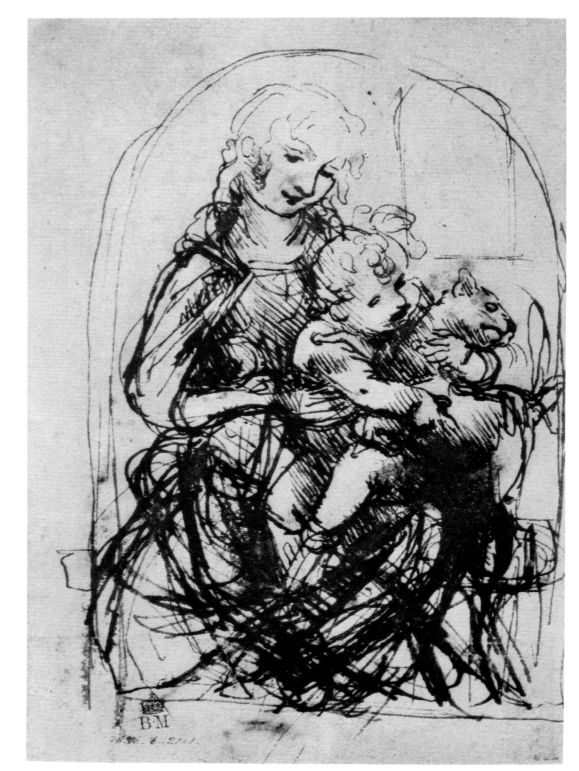

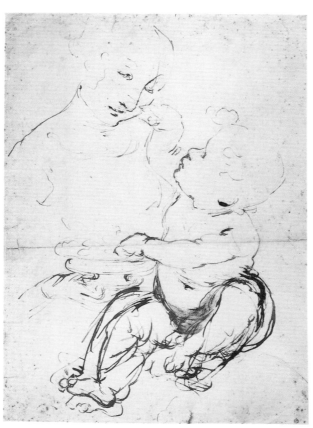

34 Study for the *Madonna with the Fruitbasket*, ca. 1478
Pen and ink over silverpoint on paper, 35.8 x 25.2 cm
(facsimile)
Galleria degli Uffizi, Gabinetto dei Disegni e delle
Stampe, Florence

The drawing of the *Madonna with the Fruitbasket* is
related in terms of its composition and similarly lifelike
figures to the *Benois Madonna* (ill. 33). It may be derived
from a direct study of nature which Leonardo usually
produced in silverpoint. While reworking it with pen and
ink he attempted to create compositional variations such
as that on the boy's leg.

35 Study of the Madonna and Child with a cat, ca. 1478
Pen and ink on paper, 28.1 x 19.9 (facsimile)
Galleria degli Uffizi, Gabinetto dei Disegni e delle
Stampe, Florence

The compositional drawing is connected with the
painting of the *Benois Madonna* (ill. 33), as indicated by
the head of Mary and the sketched window in the
background. Leonardo traced the composition from the
rear side, worked out the mirror image version with
additional variations, and then applied a wash. There is
no record of a painting of this composition by Leonardo.
The motif of the Madonna with a cat was later depicted
in a student's painting that is now in the Brera in Milan
(Brera cat. 286).

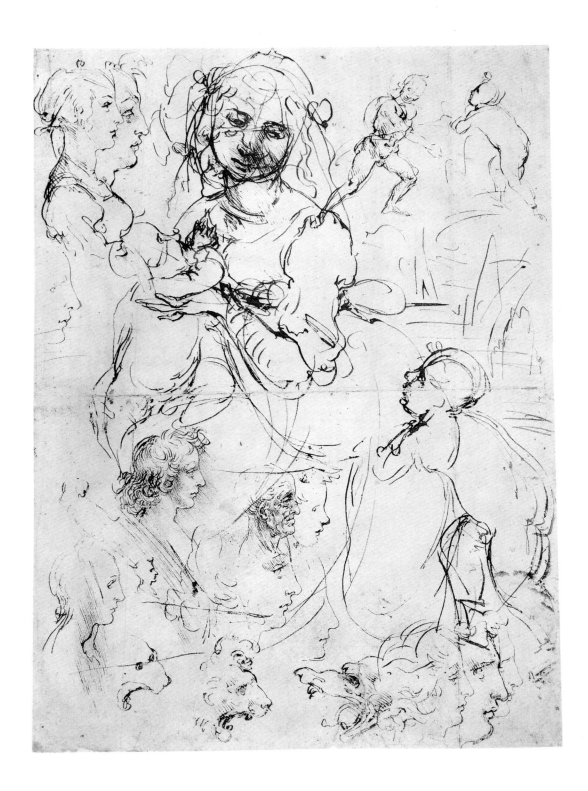

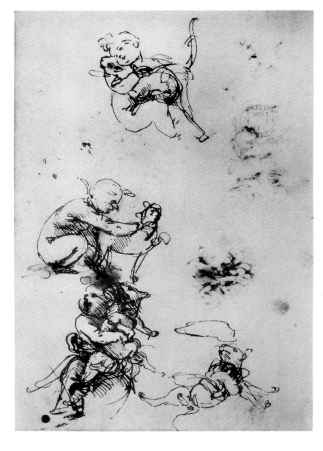

36 Study of nursing Madonna and profile heads,
ca. 1480
Pen and ink on paper, 40.5 x 29 cm (facsimile)
Galleria degli Uffizi, Gabinetto dei Disegni e delle
Stampe, Florence

In addition to a large number of profile heads, the sketch
also shows the composition of a *Maria lactans*. Mary is
kneeling on the ground, holding the Christ Child to her
right breast, while the young St. John appears to be
watching the events. He reappears years later in
Leonardo's *Burlington House Cartoon* (ill. 84).

37 Study of a child with a cat, ca. 1478
Pen and ink on paper, 20.6 x 14.3 cm (facsimile)
Galleria degli Uffizi, Gabinetto dei Disegni e delle
Stampe, Florence

A child and a cat are captured in the characteristic
moments of their play together. As neither a child nor a
cat are usually unmoving models, Leonardo here proved
to have good powers of observation and the ability to
recognize characteristic moments and sketch them swiftly.
The studies demonstrate the manner in which Leonardo
was working towards greater vividness and naturalness in
his paintings and sharpening his observational skills.

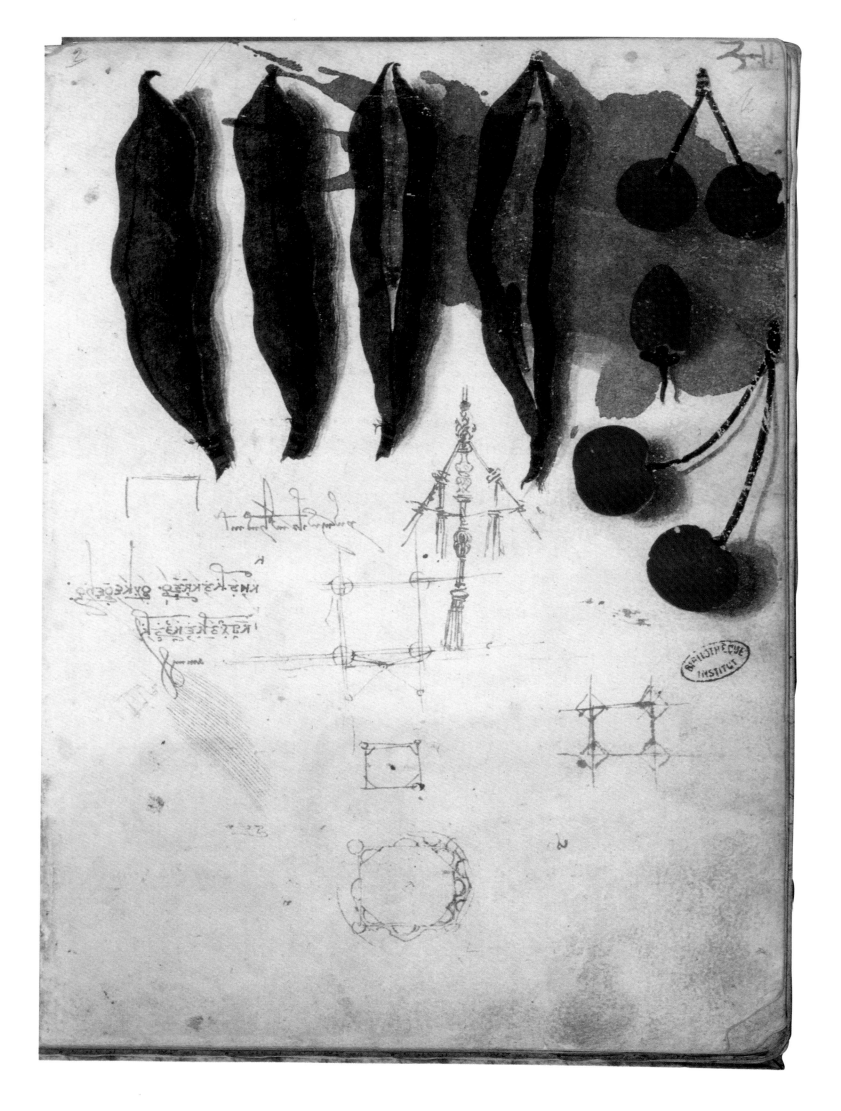

the naked rounded baby. He is gazing at it in concentration and attempts to grasp it with his still awkward baby hands. The effort he is having to make in grabbing for it and the proportions of the child can be traced back to a direct examination which can by no means be taken for granted in this subject matter. That Leonardo made studies using living models on the theme of 'Madonna and Child' is proven by a beautiful series of sketches for a Madonna and Child with a cat (ills. 35, 37), which attempts to capture a variety of moments in the boy's game with the animal. These studies found their expression in the painting of the *Benois Madonna*. The figures are more natural, their actions are more convincing and lifelike. From the point of view of its quality, the picture is already so original that no Florentine painter other than Leonardo could conceivably be its author.

ALBERTI'S INFLUENCE: THE HISTORY PICTURE AND PERSPECTIVE

In 1436, Leon Battista Alberti (1404–1472) completed his Italian edition of the three books "On Painting", the contents of which were soon to find their way into the general knowledge of Florentine artists. As there was no predecessor on which Alberti could base his theoretical undertaking, he made use of a classical work on the principles of rhetoric when formulating his theory of painting: the "Training of an Orator" by the Roman writer Quintilian (ca. AD 35–95). While on the one hand Quintilian explained the high art of rhetorical investigation of a topic, the work on the other hand also contained direct comparisons with painting. According to Alberti, the central task of both rhetoric and painting was to convince the public to perceive something that was not really there. One medium achieved this by means of words, facial expressions and gestures, and the other with figures in pictures.

Another classical text, the "Historia Naturalis" or encyclopedia of nature by Pliny the Elder (ca. AD 24–79), had an effect on Alberti and the Renaissance that cannot be rated too highly. Pliny, who also wrote about painting and sculpture, considered the highest goal of painting to be to produce an illusory imitation of reality. This was to have a determining influence on the Renaissance and, to a particular degree, on Leonardo. In connection with this, Pliny wrote about a competition in which the two painters Parrhasius and Zeuxis agreed to take part. Zeuxis painted grapes that were so deceptively realistic that birds flew down to peck at them; Parrhasius, however, set up a curtain that was painted so realistically that Zeuxis, who was so proud of the judgment of the birds, demanded that the curtain should finally be removed and the picture behind it revealed. When he realized his error, he awarded the prize to Parrhasius in sincere embarrassment, saying that he may have been able to deceive birds, but the other had managed to deceive him, an artist. Later on, Pliny

narrates another event involving Zeuxis, who is supposed to have said about another picture that: "I painted the grapes better than the boy because if he had also been a perfect creation of mine, the birds would have had cause to be afraid."

What Zeuxis had not succeeded in doing in Pliny's second example was to form the main object of painting during the Renaissance: the human figure. It was depicted either in altar paintings or in history paintings whose themes included historical events, episodes from the Bible or stories from mythology, or in the form of portraits.

Alberti considered the history painting to be the most venerable genre in painting. Portraits should be similar to those depicted and the person portrayed should appear lifelike. He rejected the conception of the picture as held by the Byzantine or Greek traditions, the painting of icons, which was remote from nature. Leonardo made the following comment: "That painting which comes closest to the object it is imitating deserves the most praise. I state this to the bewilderment of those painters who want to correct the works of nature, such as those who paint a one-year-old child whose head is in actual fact a fifth the size of the entire body, while they paint it as if it were an eighth the size of it … and they have made this mistake so frequently and seen others make it, that it has become something of a custom with them, which has forced its way into their odd judgment and taken root there to such a degree that they are now themselves convinced that nature, and those who imitate nature, are making a great mistake by not doing as they do." Leonardo's criticism shows that Alberti's conception of painting as an imitation of nature was not immediately accepted without opposition. Above all, this new formulation was slow in entering the main field of painting, the area of religious art, as these were works that did not merely have to obey aesthetic points of view but primarily had to correspond to the requirements of religious teachings and liturgy.

Alberti incorporated a variety of classical ideas into his treatise. But he personally held the distinction of presenting for the first time a newly developed method of depiction which created a new quality in the imitation of nature, and which was not even known in the classical age that he so greatly admired: central perspective (ills. 39–43).

While central perspective played an important role for Leonardo, it would increasingly make way for his own developments. The early religious paintings, above all the *Adoration of the Magi* (ill. 46) in the Uffizi in Florence, are based on perspectival constructions, but what connects *St. Jerome* (ill. 44) to the *Adoration of the Magi* is less a matter of perspective than of their comparable condition: neither painting was finished, except for an underpainting in shades of brown.

Leonardo's panel of St. Jerome is impressive because of the two-dimensional ornamental arrangement of the figures as well as the enormous perspectival depth of the landscape. The underpainting establishes the levels of

38 Fruit, vegetables and other studies, ca. 1487–1489
Pen and ink, coloring on paper, 23.5 x 17.6 cm
Institut de France, Ms. B, fol. 2r, Paris

The pods and fruit are painted in color over an ink blot. This "watercolor" is unique amongst Leonardo's surviving works on paper and can, together with the lunettes of the *Last Supper* (ill. 72), be considered a precursor of the still life genre. The sheet is part of the oldest remaining manuscript by Leonardo. In addition to architectural studies, the codex also contains designs for military equipment and flying machines.

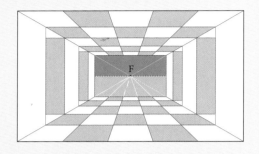

39 Diagram of the vanishing point

Perspective using a vanishing point reflects the idea in illustration 40 on the picture surface, in which the lines of sight become geometric compositional lines. Vanishing point *F* (cf. ill. 41) corresponds to the eye, a point at which all lines meet and it is at the greatest distance from the picture surface in the composed pictorial space. The greatest possible size of an object is at the front surface of the picture and the object becomes increasingly small the closer to the vanishing point the compositional pyramid intersects.

The geometrical principles of central perspective, which had been developed by the Florentine architect Filippo Brunelleschi (1377–1446), were introduced to the public for the first time in the Latin edition of the treatise on painting written by his close friend, the humanist Leon Battista Alberti (1404–1472). This law of perception was known before Brunelleschi's time; it is able to create an illusion of a three-dimensional space on the two-dimensional painted surface, appearing as the view into a peep-show or into a room through a window. The further away an object is in the space, the smaller it becomes. But it was the precise system for measuring and constructing it that turned the principle of foreshortening to create a sense of depth into a powerful instrument for imitating nature in two dimensions. It meant that the science of mathematics could be seen as an indispensable prerequisite for the art of painting, and that the profession of painter, which was seen as a craft, in the process became a practical activity which had to be taken seriously and was founded on theoretical principles.

Perspective began its triumphal march mainly in the background of depictions of figures, for in practice it proved to be of limited use when painting figures. Those figures important to the picture became too small and ended up being peripheral to the picture if they were too far in the background. They therefore continued to be depicted in the foreground, and the perspectival space started behind them. They also continued to be placed largely next to each other, rather than being structured to create a sense of depth. The result of this was that the staging of the figures on the surface continued to have a decisive effect.

A different method of depiction was used in order to give the figures and objects a sense of depth. The desired plasticity of the objects was achieved by modelling them with light and shadow in such a way that they appeared to curve towards the observer away from the picture surface. This technique had already been used by artists in antiquity and enabled the above-mentioned Zeuxis to deceive the birds with the painted grapes. The effect was related to that created by a relief, in which the figures project into real space. That appears to be why Leonardo called this technique *rilievo*.

In his notes, Leonardo writes about tonal reliefs that can help the painter imitate the play of light and shade. This method of depiction and perspective had an effect on the direction of the light in the picture, as each object depicted in relief presupposed the existence of its own imaginary source of light, and the perspectival space itself had an independent source of illumination. If the artist wanted to imitate nature convincingly, he had to bring all the sources of light into line or make it clear why they differed in the picture.

40 Diagram of lines of sight

Perspective is based on the idea that straight lines of sight convey the entire visible surface of an object to the eye, where they meet at one point. A rectangle *a* will be turned into a pyramid of lines of sight *b* and transferred to the eye *c*. If this pyramid (see *S*) is divided down into increasingly small distances from the eye, one gains an increasingly small picture of the object. It was not known how the image was created in the eye. Leonardo investigated this question during the last years of his life.

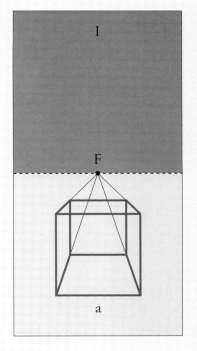
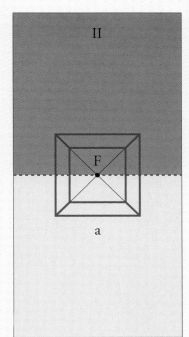
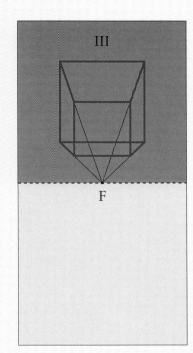

I

F

a

II

F

a

III

F

41 Diagram of the line of horizon

Vanishing point *F* is the point furthest away and therefore lies on horizon line *H*. The position of the horizon line determines the angle of view onto object *a*. If one looks at object *a* from above, the horizon is higher (I), if one looks at object *b* from the front, the horizon line runs through the middle of it (II), and if one looks at object *c* from below, the horizon is lower than the object (III).

43 (below) Diagram of *rilievo*

Only by means of light and shade can circle *a* be modelled into hemisphere *b*, which appears to curve out of the picture plane. To do this a source of light has to be assumed according to which one can shade in the dark sections. If one also depicts the shadows that a sphere casts onto a lower surface, one can achieve the impression of a complete sphere *c*.

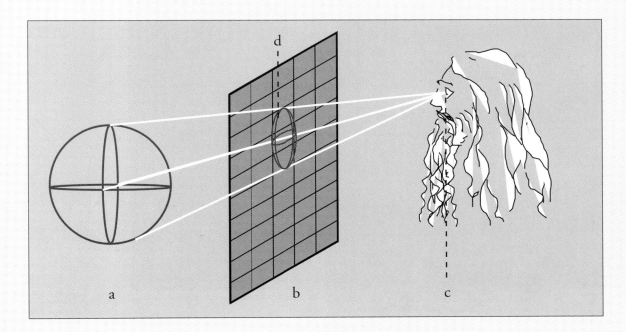

d

a b c

a b c

42 (above) Diagram of foreshortening

The same arrangement as in illustration 40, but this time a glass plate *b* is mounted between object *a* and the fixed eye *c*. The outlines of object *d*, which is seen in foreshortening, are simply drawn on glass plate *S* and can, with the aid of a graticulation grid, be altered to any desired size. Leonardo himself sketched such a drawing device in about 1480 (Codex Atlanticus, fol. 5r).

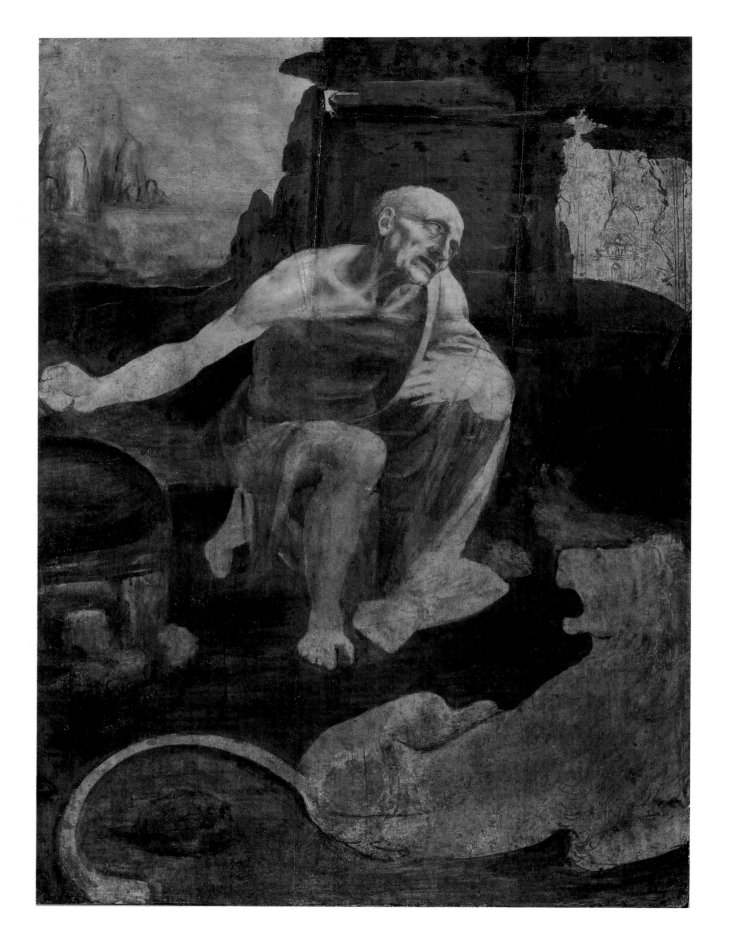

44 *St. Jerome*, ca. 1480
Oil on panel, 103 x 75 cm
Vaticano, Pinacoteca Apostolica Vaticana, Rome

In about 370, St. Jerome, later a Father of the Church, is said to have
withdrawn to live as a hermit in the desert of Chalcis near Antioch, in order
to produce a translation of the Bible and live as an ascetic. Leonardo depicts

the Father of the Church as a penitent, not a scholar. St. Jerome is kneeling
in a humble posture that arouses our sympathy, in front of the sketched
cross of Christ on the right, and before him lies the lion, his attribute. In his
right hand he is holding a stone with which he is striking his breast. The
head section of the unfinished panel was sawn out in the 18th century and
not replaced and restored until the 19th century.

brightness of the composition. The dark surface of the rock formations and landscape in the foreground cuts St. Jerome and the lion out like silhouettes. The light surfaces next to them contrast greatly, and afford views onto the landscape lying beyond. The artist relieved the figure of the saint of the manner of representation that had been conventional until then and which depicted him as a small penitent figure on both knees at the edge of the picture. Leonardo equally decided not to give Jerome his usual attributes of cardinal's hat and book. The lion, necessary in order for the saint to be identified, has lost its exclusively symbolic function in order to become a more natural animal. Leonardo thereby distanced himself from the traditional iconography, nonetheless managing to execute the required theme with a hitherto unknown intensity by depicting Jerome not as a Holy Father of the Church but as a beardless emaciated penitent.

It is not known who commissioned the panel, nor why it remained unfinished. Equally, the picture of St. Jerome has not been definitely dated, as is the case with so many of Leonardo's paintings. On the one hand, due

to the similar painting technique, it is reminiscent of the *Adoration of the Magi* (ill. 46), also an unfinished underpainting, but on the other hand, the convincing anatomical depiction of the figures suggests that it might be a work dating from the 1490s.

The unfinished panel of the *Adoration of the Magi*, commissioned in 1481, combines the plasticity of the figures with a perspectival construction in the background. Mary and the Child, and the middle and youngest kings in the foreground, form a triangle whose peak corresponds to Mary's head; for the first time, figures in Leonardo's work come together in the form of a *figura piramidale*. Mary and the two kings are not underpainted, but only indicated in gentle sections of shade. It is possible that they were left out so that they could be executed using particularly pure, magnificent colors. This procedure is unthinkable in Leonardo's late work. In his writings he later criticized this technique: "That which is beautiful is not always best; and I say this about painters who are so very concerned with the beauty of colors that they apply them, not without care, creating very weak and almost imperceptible shadows,

45 *Chariot*, ca. 1485
Silverpoint, pen and ink on paper, 21 x 29.2 cm
Biblioteca Reale, n. 15583, Turin

The careful composition of the page suggests that Leonardo intended to present it to someone. It is possible that it was included in the letter of introduction to Ludovico il Moro, to whom Leonardo described himself as being mainly a military engineer and military architect (ill. 3). The page is convincing not so much as a result of the technical solutions of the chariot as by the envisualization of their effect. It is uncertain whether the actual technology sketched here was Leonardo's own invention. He would undoubtedly have been familiar with such classical chariots, fitted with scythes, from treatises.

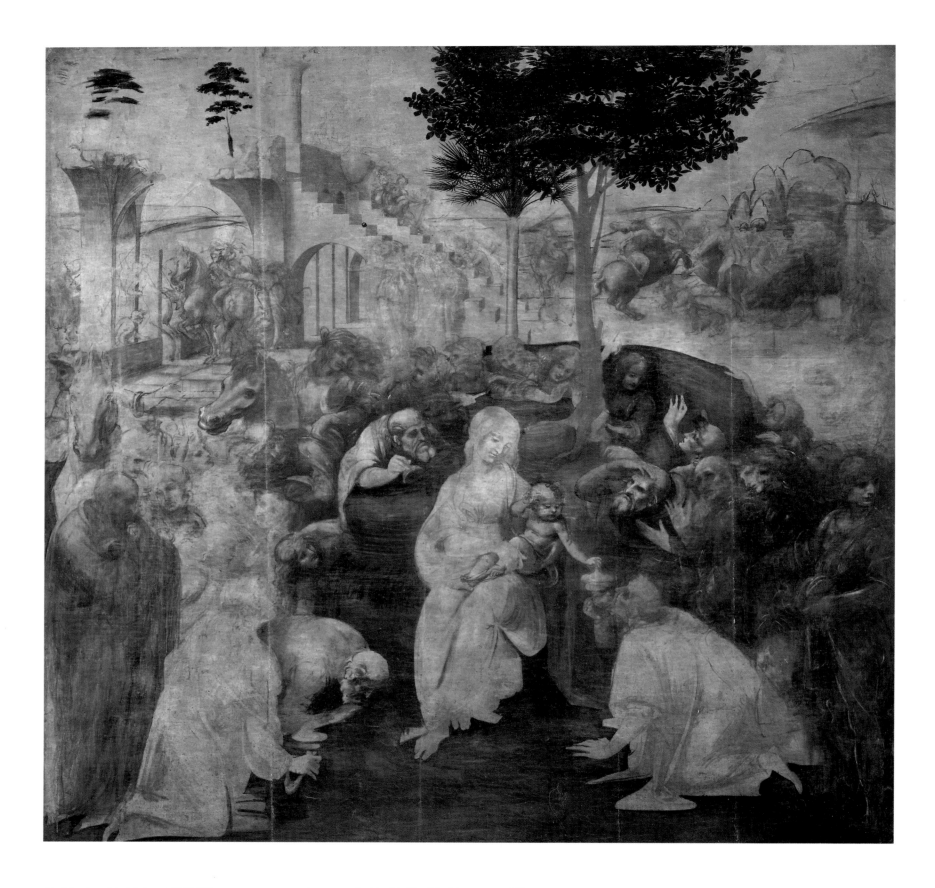

46 *Adoration of the Magi*, ca. 1481/1482
Oil on panel, 243 x 246 cm
Galleria degli Uffizi, Florence

Since the Early Christian era, the 6 January has been
celebrated as the feast of Epiphany, the appearance of
God amongst men in the form of Jesus Christ. Mankind
is represented by the Three Kings, who are paying

homage to the Messiah. The fall of the pagan world began
at the same time as his appearance. Leonardo appears to
have depicted this moment, so dramatic in human
history, in his panel. It remained unfinished because
Leonardo left Florence and moved to Milan, though we
do not know why he did so. Chemical reactions and
soiling mean it is now difficult to read this fascinating
panel in detail.

not appearing to care about the three-dimensional appearance. And this mistake makes them smooth-talkers without any substance."

Even though the panel remained unfinished, the *Adoration of the Magi*, with its symmetrically composed main group which differs from the traditional linear composition, is now considered one of the most progressive works in Florentine painting. It puts into practice the demands Alberti made of history paintings in a way no other work in its era does. All the figures are involved in the events in the picture. The distinguished kings display their emotions in a more dignified manner than the accompanying figures around them (ill. 47), and the overall number of participants is kept within moderation. The figures are grouped in a circle around Mary and are expressing, with more or less vigorous gestures, their emotion at the first demonstration of divinity of the Christ Child.

Several drawings are considered to be potential preparatory studies for the *Adoration of the Magi*. In addition to a central perspective study of the ruined building in the background, which was given a roof carried by supports in order to clarify the proportions (ill. 49), a variety of studies of the postures of individual figures exist. This large number of differing types of drawings leads us to conclude that the composition of the panel was worked out very thoroughly.

The painting also differs from the traditional way of depicting the Adoration in Florence by means of the puzzling scenes in the background, the equestrian battles and an unfinished staircase. This led to the assumption that the Augustinian convent of San Donato in Scopeto, which had commissioned the picture, wanted to use this picture composition in order to convey its own theological interpretation of the Adoration theme. But irrespective of such a theologically

47 *Adoration of the Magi* (detail ill. 46), ca. 1481/1482

The accompanying figures are taking part in the holy event in various stages of emotion. The bearded man on the left is leaning curiously down to Mary and the Child in sudden astonishment. The man next to him already appears to be filled with the inner realization that this is the incarnation of God, and the young man standing behind him has turned away from the events and is raising his right hand meaningfully up to heaven.

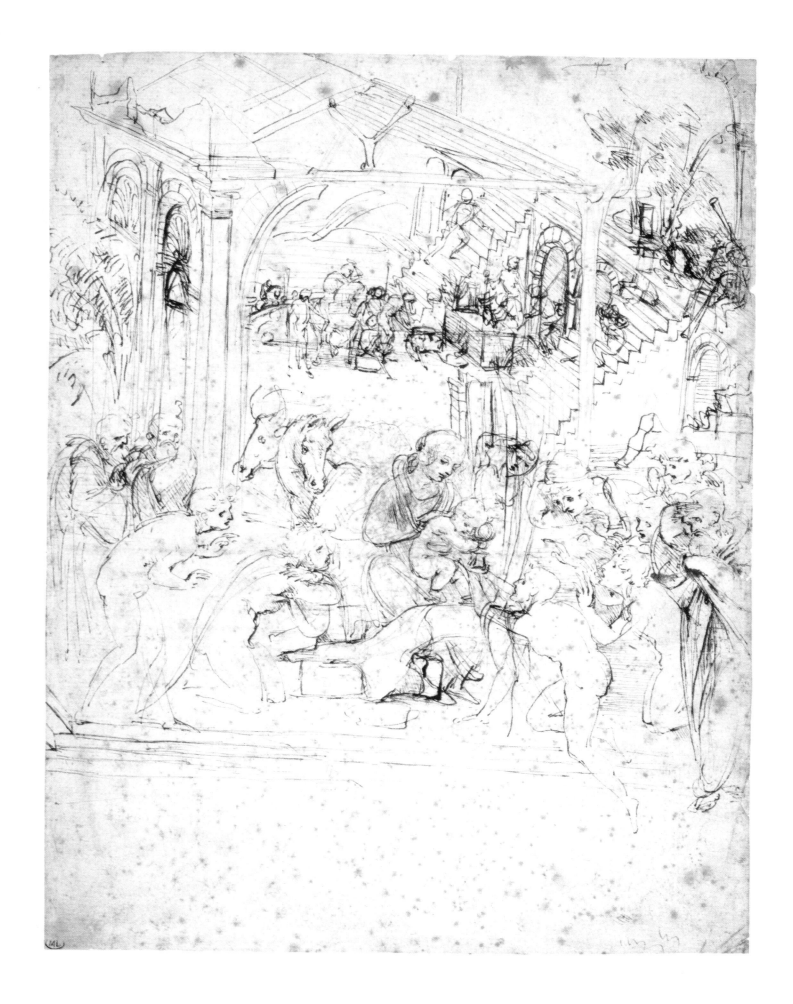

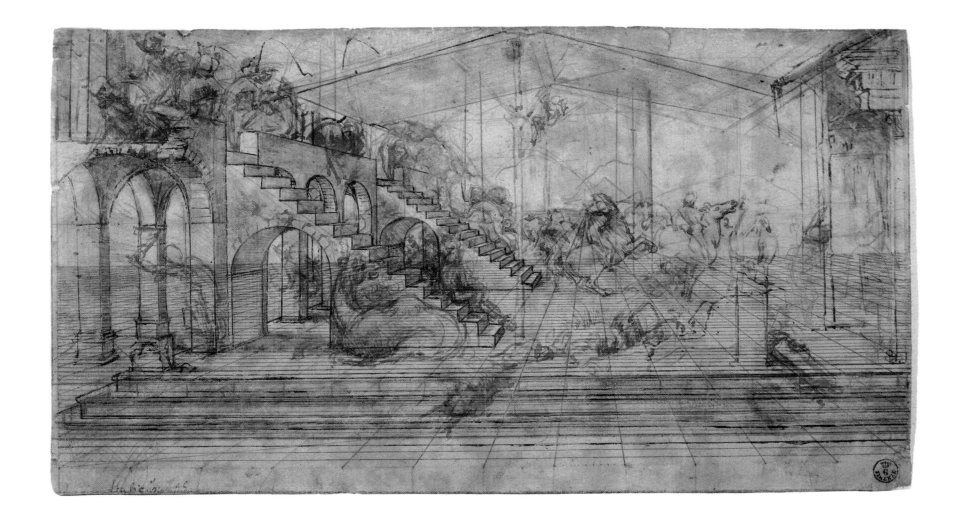

learned interpretation, the picture develops its peculiar fascination in its narration of the most varied frames of mind and the compositional connection of the individual groups. This power of attraction is, of course, further intensified by its unfinished state – just as is the case with the picture of St. Jerome. It is certain that there would have been unfinished paintings produced by other Renaissance painters that did not survive the intervening years. The mastery of Leonardo's works, however, was recognized at an early stage, and they were preserved even though, judged purely by criteria of craftsmanship, they were pieces of abandoned work.

The first undisputed work by Leonardo da Vinci,

which according to the contract had to be delivered within thirty months, was probably unfinished because Leonardo left Florence in 1481/1482 and went to Milan. It is not known what caused him to leave. Vasari's account that he personally conveyed a musical instrument which he had himself designed as a gift from Lorenzo de' Medici (1449–1492) to Ludovico Sforza also fails to explain his move. Amongst Leonardo's papers there exists a draft letter of application to the duke of Milan (ill. 3), in which he extols his universal abilities as an engineer, architect, sculptor and painter. It is, however, disputed whether this letter might not have been written later in Milan, once he had already settled there.

49 (above) Perspectival study of the background of the *Adoration of the Magi*, ca. 1481
Pen and ink, traces of silverpoint and white on paper, 16.3 x 29 cm
Galleria degli Uffizi, Gabinetto dei Disegni e delle Stampe, Florence

In this study in central perspective, Leonardo worked out a background for the *Adoration of the Magi*. In the center at the front there is already an indication of how Leonardo intended to achieve a connection between the perspectival space and the figural space, for he has sketched in rocks and grasses. In the panel he took this solution further, but decided to omit the planned roof construction, which would have been a reminder of the stable in Bethlehem.

48 (opposite) Design for *Adoration of the Magi*, between 1478 and 1481
Pen and ink over silverpoint on paper, 28.5 x 21.5 cm
Musée du Louvre, Cabinet des Dessins, Paris

This compositional plan is clearly related to the panel of the *Adoration of the Magi* (ill. 46), though the composition underwent several alterations before Leonardo decided on the final appearance of the picture.

Breakthrough in the Milan of the Sforzas 1482–1499

50 *Head of a girl*, ca. 1483
Silverpoint and white highlights on prepared paper,
18.1 x 15.9 cm
Biblioteca Reale, Inv. 15572r, Turin

The eminent art expert Bernhard Berenson called this
sheet "the most beautiful drawing in the world." It is
thought to be a study for the angel in the *Madonna of
the Rocks*.

The Milan years brought about an important change
in Leonardo's character. There he started to read books
selectively in his endeavor to raise his experiments,
investigations and observations to a scientific level, and
systematized his methods of research. His intensive
studies of nature, and the corresponding concentration
on the theory of painting, soon made him a recognized
member of the circle of scholars at the Milan court.
Until this time, his paintings had been influenced by
his investigation of traditional methods of depiction.
In the process he had already been attempting to
produce a more lifelike expression by producing new
inner links between the figures in pictures and their
surroundings.

The *Madonna of the Rocks* (ill. 51) in the Louvre was
the first picture that Leonardo produced in Milan. The
painting is the central panel of a larger altar which the
convent of San Francesco Grande had commissioned
from Leonardo and two of his pupils, the brothers
Ambrogio and Evangelista De Predis (ca. 1455–ca. 1508)
and the sculptor Giacomo del Maino (provably
active 1469–1502) for its Chapel of the Immaculate
Conception. There is no documentation relating to
the structure of the altar and its figural program, as
the chapel was torn down in the 18th century and
the structure of the altar can only be reconstructed in
a sketchy manner from the confraternity's documents.

The contract for the *Madonna of the Rocks*, which
dates from 25 April 1483, also lists the figural program.
According to it, Leonardo was required to paint two
prophets and angels on the main panel showing Mary
and the Christ Child, but the painting in the Louvre
only has one angel, the young St. John and Mary and
the Child (ill. 51). It is therefore assumed that the length
of the negotiations between the Franciscans and
Leonardo about the altar, which lasted until 1508,
were caused by a breach of contract on the side of the
artist.

Apart from the panel in the Louvre, two further
versions of the painting exist; one is in the National
Gallery in London (ill. 52) and is attributed to Leonardo
with the collaboration of his assistants and dated to
around 1508. The second is in a private collection. The
fact that both versions only differ minimally from the

painting in the Louvre, and that the reasons behind
these repetitions are not known, is a further unsolved
aspect connected to this project.

In this commission, Leonardo was not able to make
use of any traditional means of depiction, even though
something in the manner of a *Sacra Conversazione*
would have been conceivable. As in the structure of his
Annunciation (ill. 25), he developed pictorial relation-
ships regarding the interaction of the figures which
continue to be very difficult to interpret. While the work
is generally connected with the theme of the Immaculate
Conception, so far it has not been possible to devise any
convincing way of reading the picture.

The figures are woven together in a pyramidal
composition by means of gestures and gazes, and the
angel gazing out of the picture enables the observer to
participate in the events in the painting. The figures are
given a plastic modelling by the light and shade, and, in
a manner comparable to his early Madonnas, placed in
front of a dark background from which, on either side,
one can gaze into the distance. Thus, in this painting,
Leonardo achieved a backlit effect which by far exceeds
his sensitivity before this date in the depiction of surface,
space and light, and this alone makes the Paris *Madonna
of the Rocks* one of his great masterpieces.

The patron of the arts Ludovico Sforza (1452–1508),
known as "Il Moro", had after the murder of his elder
brother Galeazzo Maria Sforza (1444–1476), the right-
ful heir of the founder of the ruling dynasty, become the
guardian of the latter's son and in that way seized power
over Milan in 1480. Like his brother before him,
Ludovico wanted to justify his rulership by donating an
equestrian monument in honor of his father Francesco
Sforza.

Leonardo was probably not commissioned to produce
the monument before 1485 and worked on it until
1499, when the French invasion of Milan spelled the
permanent end of the project. His first design for the
monument dating from the mid-1480s shows a rearing
horse with a dynamic rider, under whose front hooves a
conquered soldier lies. This motif was not merely a
reference to the taking over of power in Milan, but was
principally an envisualization of the name of Sforza,
which roughly translates as "force".

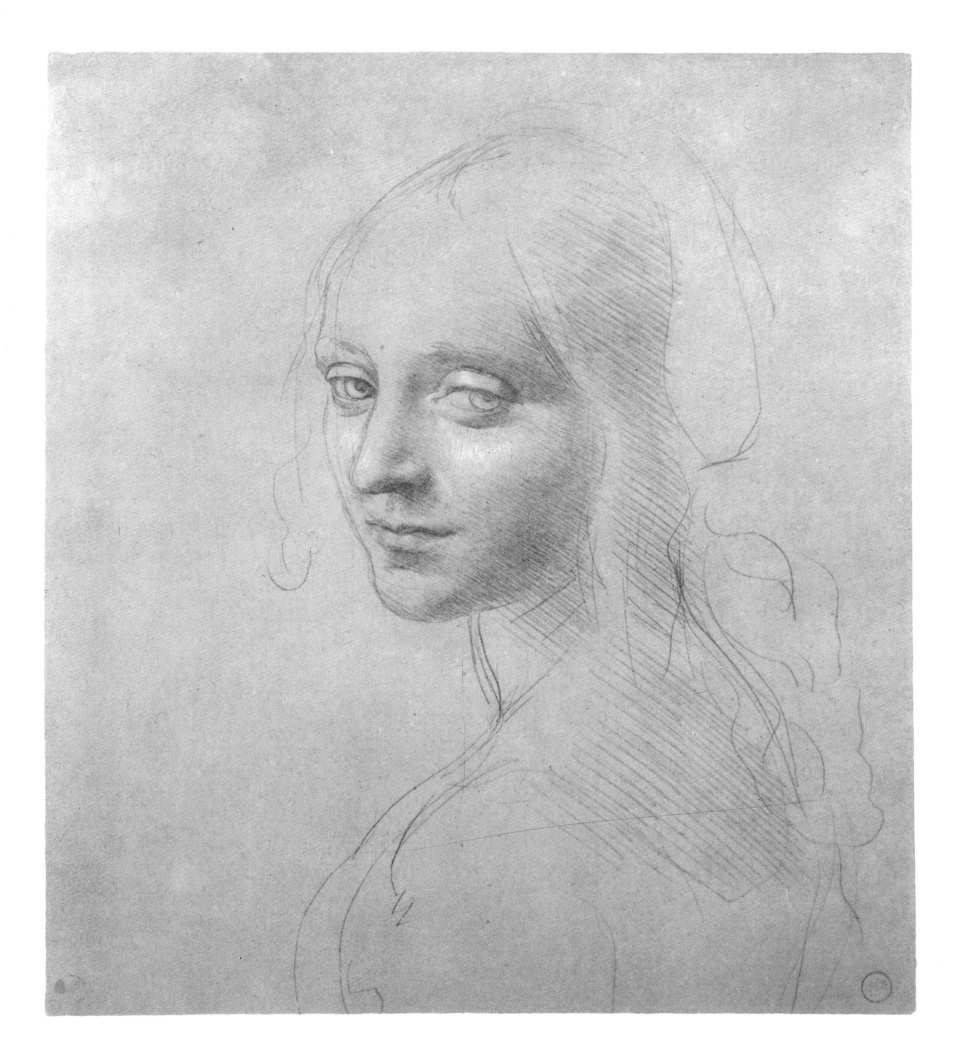

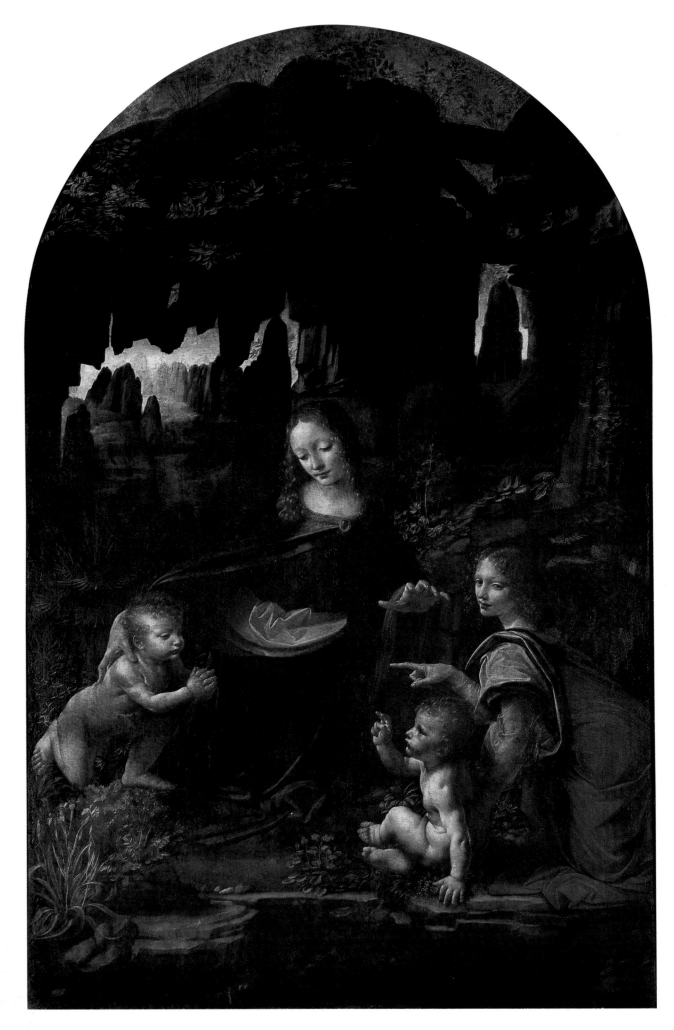

51 *Madonna of the Rocks*, ca. 1483–1486
Oil on panel, transferred to canvas,
199 x 122 cm
Musée du Louvre, Paris

The painting is an early example of the later
more frequent depiction of the dogma relating
to the Immaculate Conception of Mary. The
name of the picture reflects an iconographical
peculiarity: the religious figures are depicted in
a rocky grotto, in which they are sitting on a
stone floor. The figures are subjected to a strict
spatial arrangement called a pyramidal
composition. The painting had a considerable
influence on Leonardo's artistic colleagues in
Lombardy.

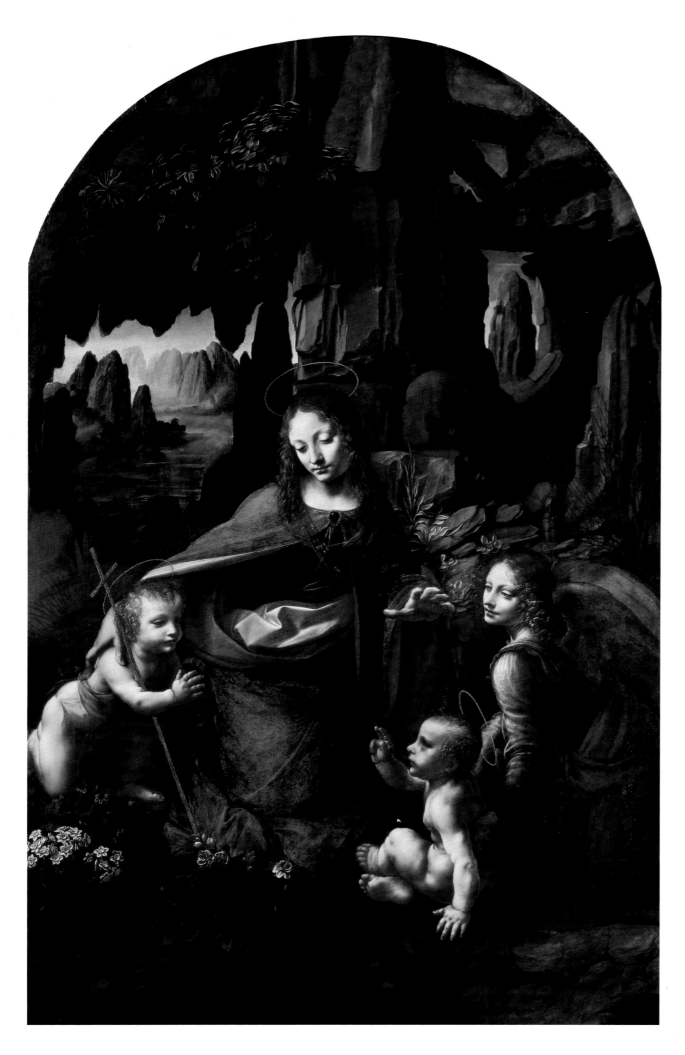

52 Leonardo and his workshop
Madonna of the Rocks, ca. 1495–1508
Oil on panel, 189.5 x 120 cm
The National Gallery, London

The second version of the *Madonna of the Rocks* was produced with the assistance of Leonardo's workshop. It was in the Milan church of San Francesco Grande until bought by an Englishman in 1785. It must therefore have replaced the Louvre version (ill. 51) in the church at some unspecified point in time. The function of this version is disputed and uncertain to this day.

53 (above) *Madonna of the Rocks* (detail ill. 51),
ca. 1483–1486

In the background, the dark rocky grotto extends into a
monumental rocky landscape which merges into the diffuse
light, its numerous vistas giving the painting an enormous
sense of perspectival depth.

54 (opposite) *Madonna of the Rocks*: Christ Child and
angel (detail ill. 51), ca. 1483–1486

In contrast with traditional iconography, Leonardo has
not conceived Mary and the Christ Child as a closely
united group, but has placed Jesus beneath his mother's
hand next to an angel on the right side of the picture. In
accordance with the composition of the group of figures
which are connected to each other by means of glances
and gestures, the angel has embraced him and is looking
at him; his finger, however, is pointing at the small St.
John in the Mother of God's arms who is adoring the
Christ Child, whose hand is raised in blessing, entirely in
the traditional manner.

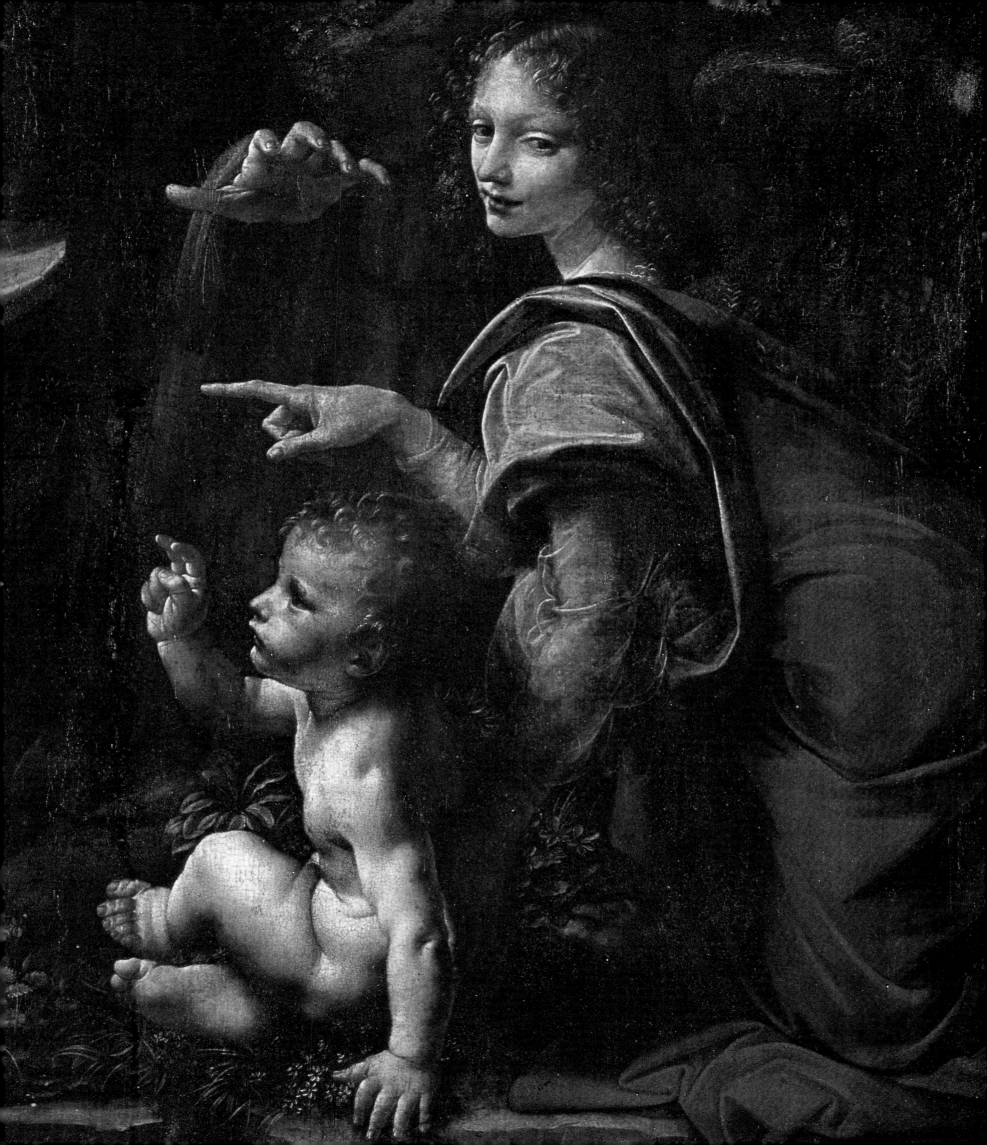

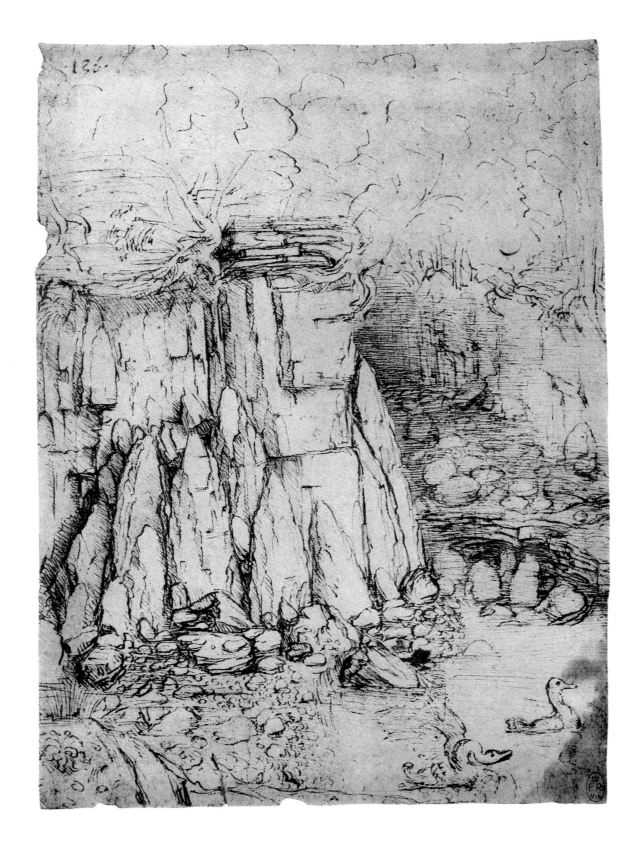

55 (above) *Cavern with ducks*, ca. 1482–1485
Pen and ink on paper, 22 x 15.8 cm (facsimile)
Galleria degli Uffizi, Gabinetto dei Disegni e delle
Stampe, Florence

This drawing of rocks and water birds is considered to be
a study connected with the *Madonna of the Rocks*. It also,
however, has motifs similar to the remaining fragments of
the wall decorations in the Sala delle Asse in the Castello
Sforzesco in Milan.

56 (opposite) Andrea del Verrocchio (1435–1488)
Colleoni Equestrian Monument, 1478–1488
Bronze, 3.96 m (without base)
Campo di Santi Giovanni e Paolo, Venice

Verrocchio's monument of Colleoni scarcely differs from
older equestrian monuments which cities commissioned
during the 15th century to honor the outstanding services
rendered by their *condottiere*, such as Donatello's
Gattamelata in Padua. Both depictions have a more or less
similar position of rider and horse, derived from the most
famous equestrian monument of the age, the classical
Roman equestrian monument of Marcus Aurelius.

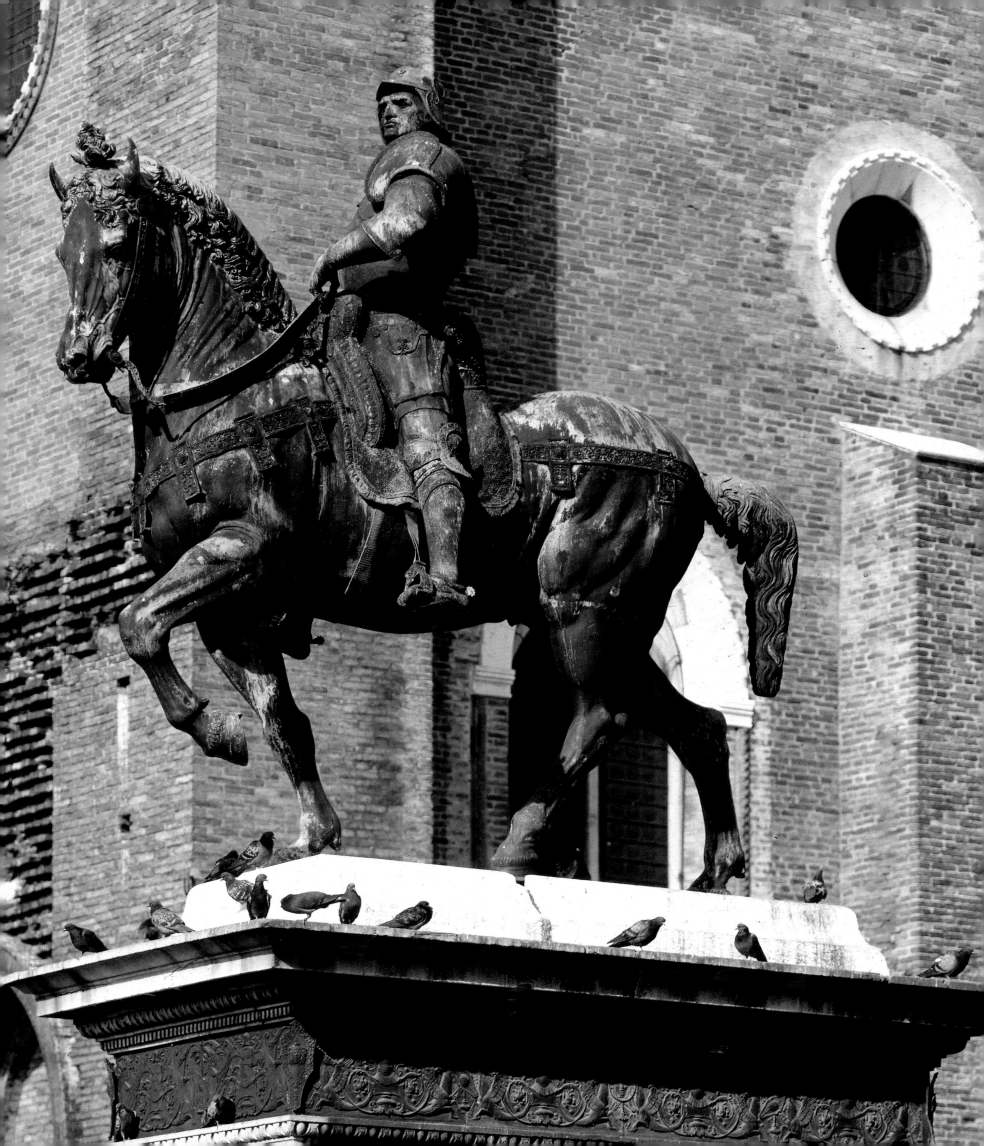

57 (left) Study of horses, ca. 1490
Silverpoint on prepared paper, 25 x 18.7 cm (facsimile)
Galleria degli Uffizi, Gabinetto dei Disegni e delle
Stampe, Florence

Leonardo displays considerable delicacy in the modelling
of the outer surface of the horse, and this combines with a
confidence in its figural design. Since the *Adoration of the
Magi* Leonardo had become particularly interested in
horses, and this is documented by a large number of
studies of their proportions and movements.

58 Study for the *Trivulzio Equestrian Monument*,
ca. 1508–1510
Pen and ink on paper, 28 x 19.8 cm (facsimile)
Galleria degli Uffizi, Gabinetto dei Disegni e delle
Stampe, Florence

This drawing is probably quite rightly identified with the
tomb of Marshal Giovanni Giacomo Trivulzio, though
there is no record that Leonardo was commissioned to
produce such a work. It shows the same design for the
horse and rider as the first version of the *Sforza Equestrian
Monument*, but in this instance the dynamic solution has
been abandoned in favor of a walking pace.

As expressive as Leonardo's design of the rearing horse
was, as great were the demands which he made of the
structural engineering of the monument and the process
of bronze casting. This enormous technical effort and
the resulting technical problems delayed the completion
of the project. In 1489, Ludovico Sforza turned to the
Florentine ambassador of Lorenzo de' Medici in Milan
and in vain asked for experts on bronze casting to be
found who would be able to carry out Leonardo's
demanding project.

On 23 April 1490, Leonardo noted that he had

"recommended the horse," and in June, he and the
architect and engineer Francesco di Giorgio Martini
(1439–1502) made a journey to Pavia in order to
take part in a consultation of experts on the planned
construction work on the cathedral. On this occasion
Leonardo saw the classical equestrian monument of the
Regisole, which no longer exists. It made a deep
impression on him. He was particularly impressed by
the natural movement of the horse, saying that "the trot
has almost the quality of a free horse."

Here for the first time Leonardo encountered a

classical equestrian statue whose naturalness probably convinced him that "the imitation of antique works is better than that of modern." For example, Verrocchio's *Colleoni Equestrian Monument* (ill. 56) was, when compared to the most famous surviving classical equestrian monument of Marcus Aurelius on the Roman Capitol, excessively tense and constrained in its movements. It is likely that Leonardo recognized similar aesthetic shortcomings in his own design, for after his return to Milan he abandoned his first design, started studying the anatomy and proportions (ill. 57) of living horses, and then designed one of the most ambitious bronze equestrian monuments in Western history.

The full-scale model of the horse in an "earthen material," a type of modelling plaster or clay, was unveiled in November 1493 in the courtyard of the Milan fortress as a highlight in the celebrations of the engagement of Bianca Maria Sforza, the niece of Ludovico, to the German emperor Maximilian (1463–1519). At a height of over seven meters, it surpassed anything known until then. However, the figure who was to be glorified in the monument, Francesco Sforza, is mentioned neither in contemporary accounts nor in Leonardo's writings (ill. 61, 62). This is possibly because his casting was to be carried out separately and it was therefore necessary to produce a separate casting model. In the position and stance, the design is similar to that of the familiar *condottieri* monuments, but its size clearly raises it to a different level. The artist was following new paths both in terms of the transfiguration of power, and the artistic execution of a monumental and at the same time vivid creation.

Yet shortly after the model was unveiled, the chances of the project being realized had become much slighter, for the enormous amount of bronze, about 158,000 pounds, which was necessary for the casting and had already been collected, had to be returned in 1494. It was smelted in order to produce weapons urgently required by Ludovico's brother-in-law, the duke of Ferrara, Ercole I d'Este. Finally, in 1499, the French occupying forces destroyed the model. From letters we know that casting models still existed in 1504, which the duke of Ferrara asked the French king to return, but without result.

During his second period in Milan, in about 1510, Leonardo produced designs for a second equestrian monument that was also not constructed: it was the funeral monument for Marshal Gian Giacomo Trivulzio (ill. 58), who was in the service of the French. Not until recently has research dated a group of horse drawings (ill. 59) to the last three years of Leonardo's life, for they are all drawn on paper bearing a French watermark. They suggest that Francis I also asked Leonardo to design an equestrian monument, though no trace of such a commission has remained in other documents.

59 *Equestrian monument*, ca. 1517/1518
Black chalk on paper, 27.8 x 18.4 cm
Galleria degli Uffizi, Gabinetto dei Disegni e delle
Stampe, Florence

This sensitive chalk drawing probably dates to the later years Leonardo spent in France. Giovanni Paolo Lomazzo of Milan wrote towards the end of the 16th century that Leonardo had also created anamorphotic depictions of horses for Francis I. No trace of them has survived.

60 *Cannon foundry*, ca. 1487
Pen and ink on paper (facsimile)
Galleria degli Uffizi, Gabinetto dei Disegni e delle
Stampe, Florence

The project for casting a gigantic cannon leads us to assume that Leonardo was familiar with the customary process for casting cannon. The heavy cannon was to be moved by means of levers and block and tackle, then to be mounted on a moving undercarriage. Even though this is merely a drawing on a technical subject, one can clearly see what an enormous effort the figures are having to make to shift the weight.

During the classical era, the process of casting in bronze was a widespread sculptural technique which was also discussed by the Roman writer Pliny the Elder in his "Historia Naturalis". During the Middle Ages, few bronze works were produced, but during the Renaissance the process was increasingly used.

Bronze casting is based on a simple principle: first a negative of the object to be cast in bronze is created by making a mold of it in a fireproof material such as plaster. This plaster negative mold is then filled with liquid bronze.

After the bronze has set, the plaster mold is smashed and the bronze work is revealed.

In practice the process turned out to be more difficult, for a solid work that had a diameter larger than five centimeters started to shrink while it cooled. Air pockets would form creating flaws in the casting. A second considerable disadvantage was the fact that a solid casting required a large amount of bronze and the object became very heavy.

Therefore, the most popular process was to produce a wax model of the object molded over a fireproof core. The thickness of the wax layer would determine the thickness of the layer of bronze later. The wax model was covered with a coating of plaster which was then heated so that the layer of wax melted and ran out through drainage channels. What remained was the core and the negative mold, and bronze was poured into this to occupy the space originally filled by the wax. When pouring in the bronze, it was important to make sure that all the air was able to escape, otherwise the casting would have been damaged by trapped air, forming bubbles. For that reason, wax sticks were added to the wax model that stuck out of the negative mold, so that after melting the wax channels were created through which air could escape from the hollow mold. The channels through which bronze was poured into the mold were also created using such wax sticks. Once the casting was ready and the coating of plaster had been removed, it was necessary to saw off the bronze sticks that had been created by bronze filling the channels for pouring in the metal and allowing air to escape. The rough cast was then engraved, polished and sometimes a patina was added. The disadvantage of this technique was that the original was lost when the wax was melted, meaning that only one casting could be produced.

While planning the Sforza equestrian monument, Leonardo developed a process (ill. 61) that enabled him to produce several casts and calculate the precise amount of bronze needed before casting. This also enabled him to precisely calculate the number of smelting furnaces (ill. 62) that would be needed and give an exact estimate of the cost.

He created the model using an earthenware material such as modelling clay, and used it to create a negative mold with plaster. He carefully detached this negative mold from the original and divided it into two halves. He covered the insides with a layer of wax whose thickness he was able to control precisely. The quantity of wax he used corresponded precisely to the required amount of bronze. He then filled the inside of the mold with a fireproof material before joining the two halves together again, melting the wax and pouring in the bronze. In this way, the original model was preserved and could be used to produce as many negative molds as one wanted (ill. 61). While Leonardo's Sforza monument was never cast, we do know from sources that the negative molds had been produced.

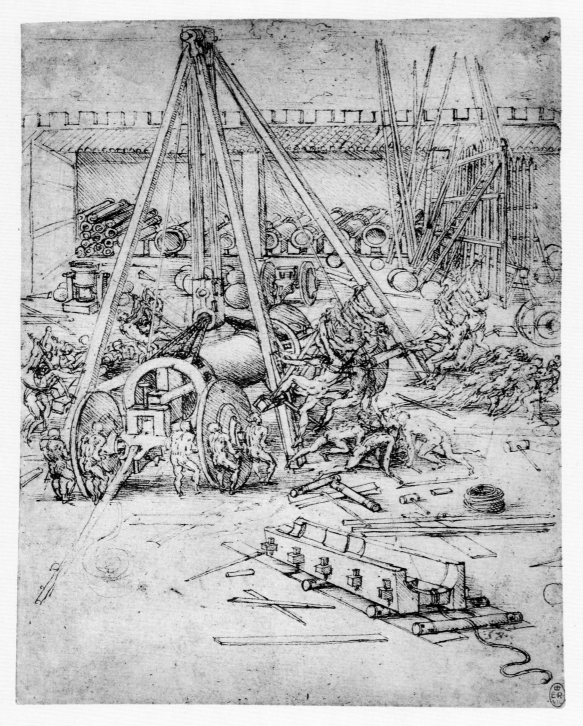

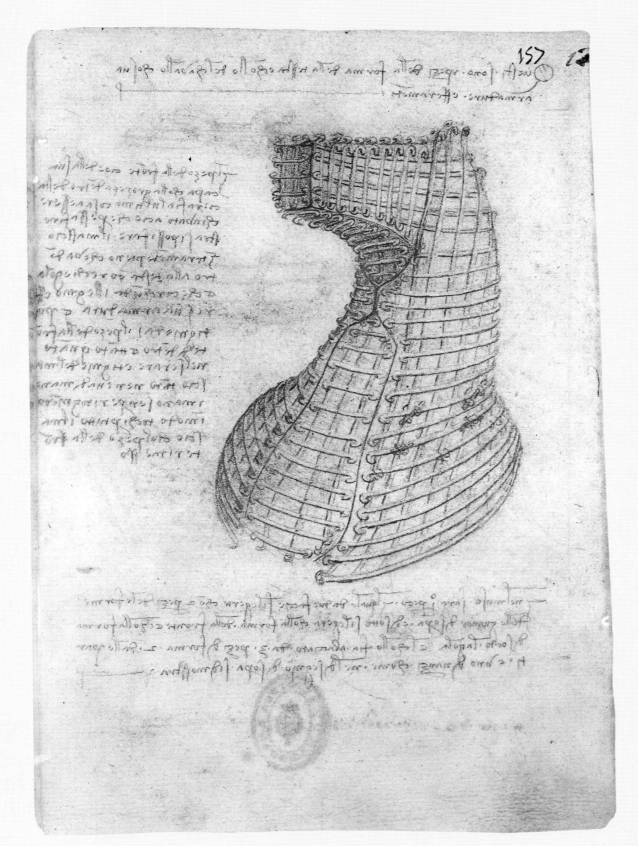

62 (above) Manuscript page on the Sforza monument,
ca. 1493
Pen and ink on paper, 21 x 15 cm
Biblioteca Nacional, Codex Madrid I, fol. 149r, Madrid

In the center, the sheet shows, from above, the hollow for
casting the Sforza monument with the horse head down.
We can see the outer negative mold and channels to the
furnaces through which the bronze is to be poured in.
Two rectangular and two round furnaces surround the
smelting hollow. The sketch of the horse seen from the
side shows that it was to be cast head down.

61 (left) Manuscript page on the Sforza monument,
ca. 1493
Red chalk on paper, 21 x 15 cm
Biblioteca Nacional, Codex Madrid I, fol. 157r, Madrid

This impressive red chalk drawing shows the head and
neck sections of the negative mold for the bronze casting,
which was reinforced by fittings. On the neck and lower
side of the head one can see how Leonardo subdivided
this negative mold in order to simplify taking it off after
the casting was complete.

THE FLORENTINE *APELLES* AND THE DEPICTION OF MAN

The so-called portrait of the musician in the Milan Pinacoteca Ambrosiana is the only remaining male portrait by Leonardo (ill. 63). Its attribution is now generally accepted. The picture shows a young man with a cap in a three-quarter view facing towards the right. Only his raised right hand is depicted, holding an unfolded sheet of music. The results of an examination of the painting have proven that the hand and the sheet of music were produced using a different technique from the rest of the figure, which suggests that it was reworked at a later date. Whether Leonardo or another artist was responsible for this, and when it occurred, is something we can only speculate about.

The dating of the painting to Leonardo's first years in Milan is suggested by a particular type of Flemish portrait which is derived from the work of Jan van Eyck (ca. 1390–1441) and would probably have been known at the Milan court because of the painter Zanetto Bugatto, who was trained in Flanders. A dark background, a strong three-dimensional composition of the head as well as a vivid gaze and depiction of both hands were characteristic features of this type of portrait. Antonello da Messina (1430–1479), another Italian painter who was committed to the Flemish style, could also have been a possible model for the client and via him for Leonardo himself. Antonello probably spent a short period in Milan during 1475. His portraits are placed against a dark background, do not normally show the hands, and are captivating due to a particular vitality about the eyes.

Leonardo's client appears to have wanted his portrait to be carried out in this or a similar style, for the *Musician* certainly has a concentrated and alert expression, though where he is looking remains concealed from the observer. His tightly curled hair is brightened up by delicate highlights. But there is an important difference between this and portraits by Flemish masters and Antonello: the head is modelled more powerfully by light and shade. Leonardo was endeavoring to achieve a pronounced *rilievo* and as a result, on the finely glazed flesh tones, he achieved a play of light more sophisticated than any other painter in Milan at the time could have been expected to achieve.

The later addition of the hand with the sheet of music, which is the device that makes it possible to identify the subject matter of the portrait, could have been inspired by the works of another Flemish artist. Hans Memling (1433–1494), who lived in Bruges, painted several portraits which only show one of the portrayed person's hands. Occasionally the person is holding an object such as a letter in the male portrait in the Uffizi. It is possible that Leonardo did not find out about this type of Flemish portrait until after he finished his painting, and was as a result inspired to rework his picture. The concentrated gaze and the position of the hand focus the portrait onto one moment, as if the musician is waiting for his entry.

In the early 1490s, Leonardo formulated his con-ception of painting for the first time. It was probably one of the customs at the Milan court for the scholars to represent their own disciplines in discussion groups. According to Alberti's beliefs, painting was also one of the sciences, as it was based on mathematical principles. Due to his familiarity with architectural treatises, Leonardo had already received an initial theoretical foundation, but it appears that he did not study Alberti's writings on painting in more detail until he had had the idea of writing his own treatise on the subject.

In Alberti's writings, the point is the simplest principle in the science of painting, and can be used to construct a line, which in turn produces the surface which is the actual medium of painting. The visible part of bodies is made up of surfaces. If painting wants to imitate nature, the corporeal or three-dimensional world, it has to use surfaces to produce the illusion of bodies. Surfaces are colors and their appearance depends on the quantity and type of light (ill. 43). "He [Leonardo] felt nothing to be more important than the rules of optics, and on it he founded the principles of the distribution of light and shade," Paolo Giovio wrote in about 1527.

It was principally on the distinction between it and other imitative arts such as poetry, music and sculpture that Leonardo based his conception that painting was superior to all other arts, above all poetry, which was highly regarded. First of all, painting was dependent upon the most important of the senses: sight. Further, it could narrate a story just as well as a poem, but surpassed the latter in three respects: first of all, painting is not tied to any language and is therefore universally understandable, and secondly, it is able to present an entire story in an instant, whereas poetry can only string pieces of information together. Thirdly, it shows everything as if it were real. The result is that the observer is directly affected by it.

Painting surpasses music because music dies away, but painting is beauty preserved for eternity. It surpasses sculpture as the sculptor cannot control all the elements himself, for his works exist in real space and depend on real lighting conditions. The fact that the painter can and must depict all dimensions of nature that can be perceived by the eye makes him an almost divine creator. In his paintings, he can create a nature that is so realistic that nature itself is deceived, such as the birds fooled by the painted grapes in the episode narrated by Pliny. But he can also create things that do not exist in nature, such as a fabulous creature, by creating a hybrid of known parts of animals which then looks like a possible creature.

Even caricatures of people in the sense of an exaggerated characterization of a person's outward appearance can be depicted. They are, in the end, based on studies of nature in which individual sections of expressive heads are exaggerated (ill. 67). In addition to this, Leonardo stylized individual shapes of noses, eyes and mouths and studied their expression with regard to the appearance of a figure. He used the individual forms of a face, which reveal a certain type of character, to investigate people. The puzzling grouping of five heads

63 *Portrait of a Musician*, ca. 1485
Oil on panel, 43 x 31 cm
Biblioteca Ambrosiana, Milan

It was not until 1904 that the hand and sheet of music were discovered underneath overpaintings, and it is these that have given the painting its present title. Since this discovery, efforts have also been made to identify the person depicted. The names of two important court musicians in Milan during that period are known: Franchino Gaffurio (1451–1522) and Josquin des Prés (ca. 1450–1521). But there is no clear indication enabling us to identify either of these two in this portrait.

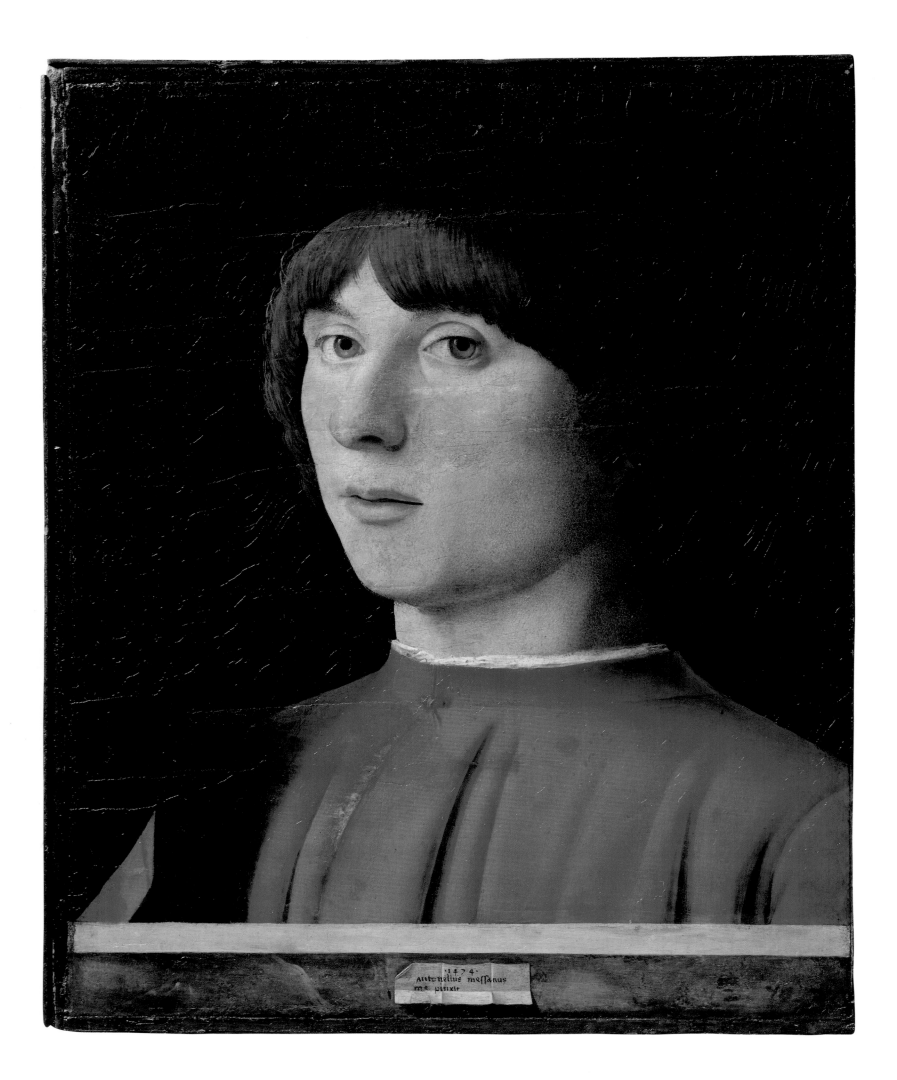

65 (above) Study of the effect of light on a profile head, 1487–1490
Black chalk, pen and ink on paper, 20.3 x 14.3 cm (facsimile)
Galleria degli Uffizi, Gabinetto dei Disegni e delle Stampe, Florence

Rilievo is the soul and the highest goal of painting, it says in the book on painting. Leonardo made a very precise study of the distribution of light and shade. In the drawing he shows clearly the gradation of light on the face when it comes from a single source above. This page is considered to be an early indication of the preparation of a theoretical treatise on painting.

66 (right) *Male head in profile with proportions*, ca. 1490
Pen and ink on paper, 28 x 22.2 cm
Gallerie dell'Accademia, Inv. 236v, Venice

The profile head contains notes on proportion such as "the size of the figure is eight heads." Above the notes on the left is a circle with a line through it, meaning that the text was included by Melzi in the treatise on painting. Leonardo not only produced studies of the proportions of the human head, but also a table in which he recorded all possible types of noses. In addition, he combined various forms of foreheads and chins as well as different types of noses and mouths.

64 (opposite) Antonello da Messina (ca. 1430–1479)
Portrait of a Young Man, 1474
Oil on panel, 32 x 26 cm
Staatliche Museen zu Berlin – Preußischer Kulturbesitz, Gemäldegalerie, Berlin

One influence on Leonardo's sole male portrait, the so-called portrait of the musician, may have been the portraits of Antonello da Messina, which were famed for their realism. Due to his knowledge of Flemish pictures, the painter had made a decisive contribution to the spreading and perfection in Italy of what was at the time the new medium of oil painting, and normally depicted figures in three quarter life-size as statue-like half-length portraits in front of a barrier. As in the *Portrait of a Young Man*, the face is particularly emphasized by the dark background and simple headgear, with the eyes directed straight at the observer.

on a sheet (ill. 68) shows how strongly the movable section of the face around the mouth and chin determine the expression. Apart from the dignified profile figure in the foreground, it is the view of the wide open mouth in the background that is particularly impressive.

Leonardo formulated the superiority of the painter compared to the other artistic genres in the following words which also describe the divine act of creation: "In fact whatever exists in the universe, in essence, in appearance, in the imagination, the painter has first in his mind and then in his hand; and these are of such excellence that they can present a proportioned and harmonious view of the whole, that can be seen

simultaneously, at one glance, just as things in nature." This phrasing places particular emphasis on an artist's hands, to which both painters and sculptors had attached considerable importance since the High Renaissance.

Leonardo's main definition of painting concerned man: "A good painter has two chief objects to paint, man and the intention of his soul; the former is easy, the latter hard, because he has to represent it by the attitudes and movements of the limbs. The knowledge of these should be acquired by observing the dumb because their movements are more natural than those of any other class of persons."

It is possible that Leonardo was familiar with the

definition of all the imitative arts which the Greek philosopher Aristotle (ca. 387–322 BC) had written down in his treatise on poetry. For the first printed book in the Greek language had appeared in Milan, and evidence exists that there was a circle of scholars who were familiar with classical Greek texts. Aristotle's view was that the object of imitation in art was men in action whose destiny lay between the opposites of worthy and lowly. It was possible for the classical philosopher to portray the human character within this scale.

The portrait of *Cecilia Gallerani* (ill. 70), known as the *Lady with the Ermine*, is an important turning point in Leonardo's painting, first suggested in the re-worked version of the *Musician* (ill. 63). Leonardo did not interpret man as an outer shape to be imitated, instead viewing him as a speaking individual with a specific emotional constitution. Here, too, something that is not identified has attracted the attention of the portrayed woman; she has turned and is looking over her shoulder, and the ermine across her arm appears to be following the same urge. The observer is attracted by the woman's behavior, wants to know what she is curious about and in so doing imitates her mental state. In this, Leonardo made use of a phenomenon of painting which Aristotle had already mentioned in his "Poetics": the inborn tendency to imitate.

In both genres of painting, the portrait and the history painting, it was Leonardo's opinion that giving a figure a soul was a vital factor in the credibility of what was depicted. In this respect Leonardo exceeds the requirements of Alberti, who had only imagined men of action in connection with history paintings. "If they [painted figures] are not endowed by their creator with lively actions according to the intention that you imagine to be in such a figure, [it] will be judged twice dead; dead because it is not alive, and dead in its action," Leonardo noted.

In the portrait of *Cecilia Gallerani*, the artist is incorporating the observer into a production, building up tension in him without easing it. In his curiosity, the observer is repeatedly referred back to the depicted woman. In Leonardo's words, a painting presented in such perfection would cause "lovers to speak to the portrait of the thing loved as if it were alive."

The painting of *Cecilia Gallerani* (ill. 70), together with that of *Ginevra de' Benci* (ill. 32) has been technologically investigated. The proof of smears caused by the same hand on both works supports their attribution to Leonardo. During the course of this examination, it was also determined that the plain background behind Cecilia Gallerani never included a window, as was thought for so long.

Leonardo used the unusual portrait of Cecilia Gallerani as a proof of his skillfulness when Isabella d'Este of Mantua became interested in having a portrait done. She was an important patron of the arts in Italy and the sister-in-law of Ludovico il Moro, and in 1498, requested the picture in order to be able to see for herself just how high the quality of Leonardo's portraits was. In an accompanying letter, Cecilia Gallerani remarked that there was little similarity with her present appearance,

67 (above) Leonardo's circle
Five caricature heads, after 1490
Pen and ink on paper, 18 x 12 cm
Gallerie dell'Accademia, Inv. 227, Venice

Several such drawings still exist in which Leonardo either portrays or invents pronounced facial features, exaggerating them like a caricature. The five caricature heads are thought to be a copy made by an artist who had access to Leonardo's drawings. The strokes lack the vividness that characterized Leonardo's drawings.

68 (opposite) *Group with five heads*, ca. 1494
Pen and ink on paper, 26 x 20.5 cm (facsimile)
Galleria degli Uffizi, Gabinetto dei Disegni e delle Stampe, Florence

It has not so far been possible to come up with a convincing interpretation of these five types. The figure wearing the laurel wreath is thought to be a portrait. At any rate, it is the main figure in the group, because with its profile view it is occupying the most dignified position, and the others are arranged about this figure. Leonardo recognized that the moving parts of the face, such as the eyebrows, eyes and mouth, were a prerequisite for the expression of various emotions such as laughing, crying, anger and fear.

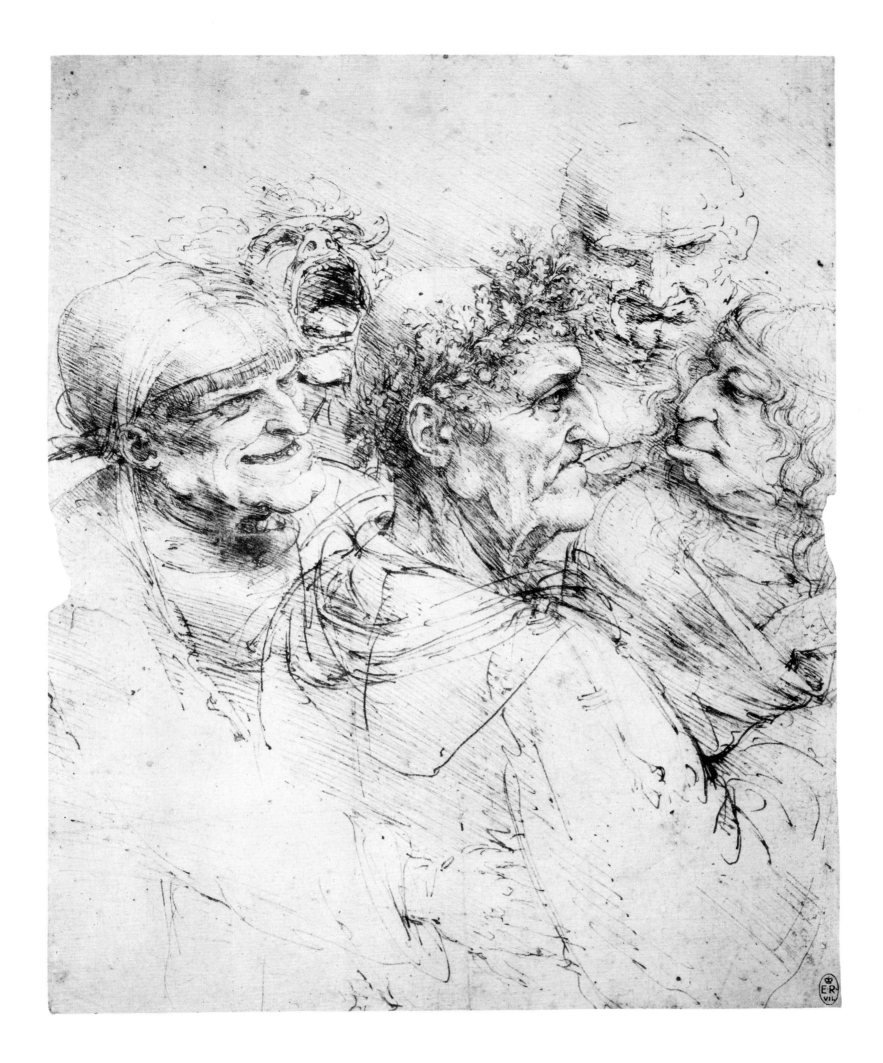

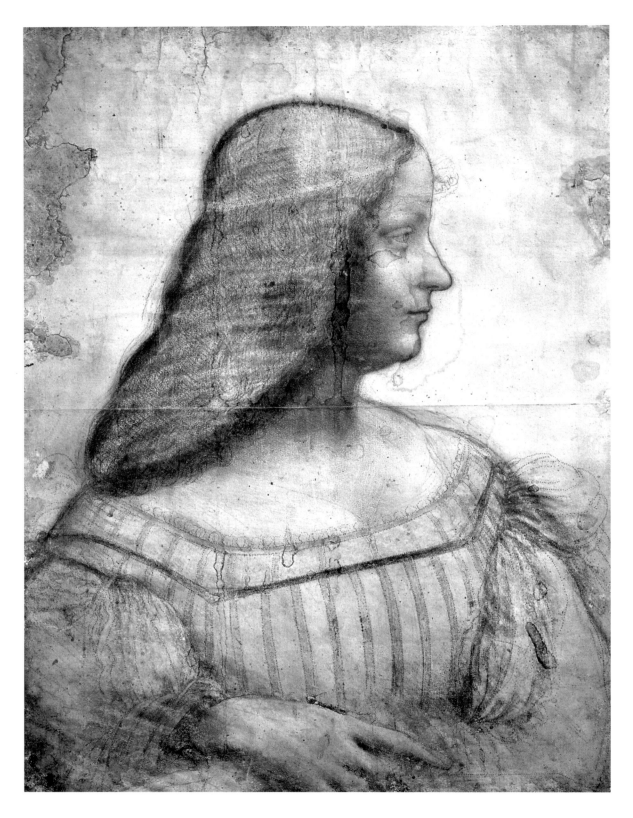

69 (left) *Isabella d'Este*, 1500
Black chalk, red chalk and yellow pastel chalk on paper,
63 x 46 cm
Musée du Louvre, Cabinet des Dessins, Inv. M. I. 753,
Paris

The cartoon shows the portrait of Isabella d'Este. Holes
were made in it so that it could be transferred, but these
perforations do not match all the details of the drawing
precisely, in some places correcting them with great
sensitivity. Leonardo probably produced these perfo-
rations himself. The cartoon has clearly been trimmed
and is in a poor state of preservation, so that it is no
longer possibly to state with any certainty whether the
unusual coloring with colored chalks was produced by
Leonardo himself.

70 (opposite) *Cecilia Gallerani (Lady with the Ermine)*,
ca. 1490
Oil on panel, 54.8 x 40.3 cm
Czartoryski Museum, Cracow

Cecilia Gallerani is holding the heraldic animal of
Ludovico il Moro in her arms. She was his favorite and
gave birth to his child in the same year as he married
Beatrice d'Este. The charming and vivid impression
Cecilia makes gained Leonardo the reputation of being a
talented portrait painter.

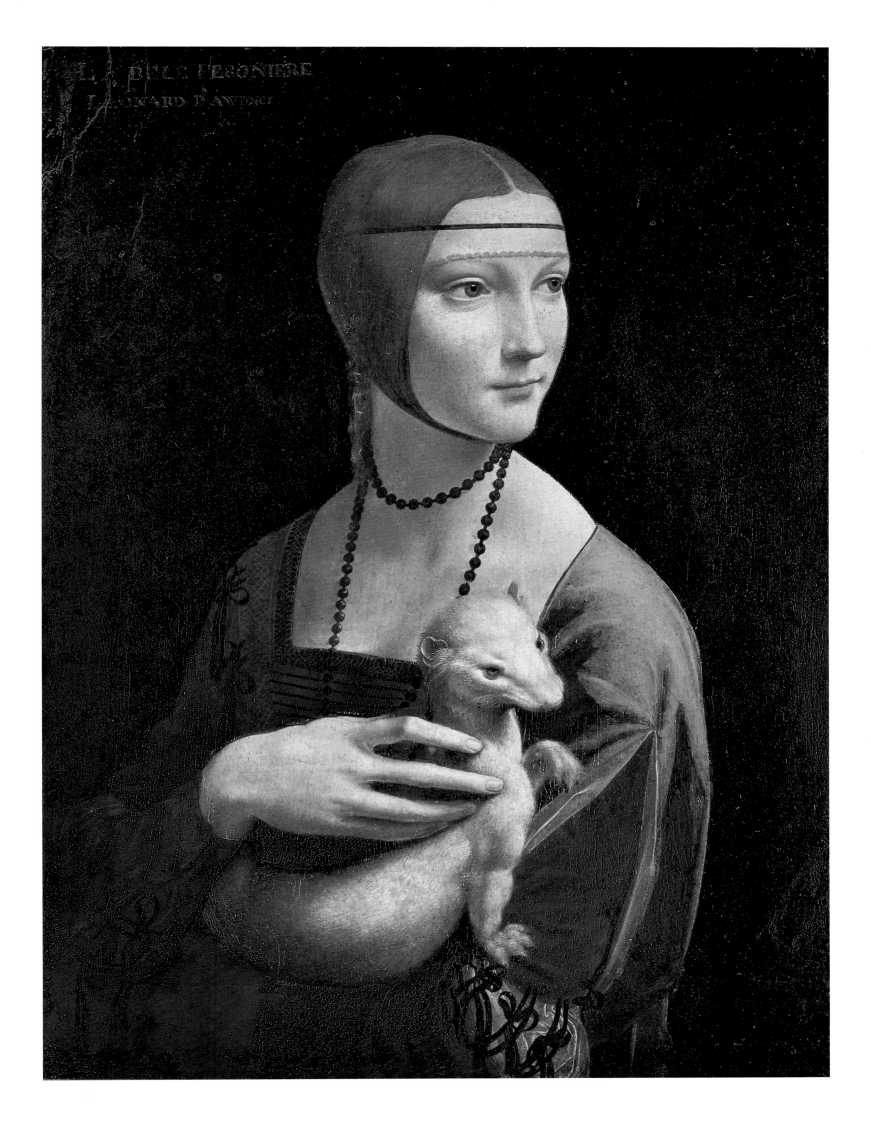

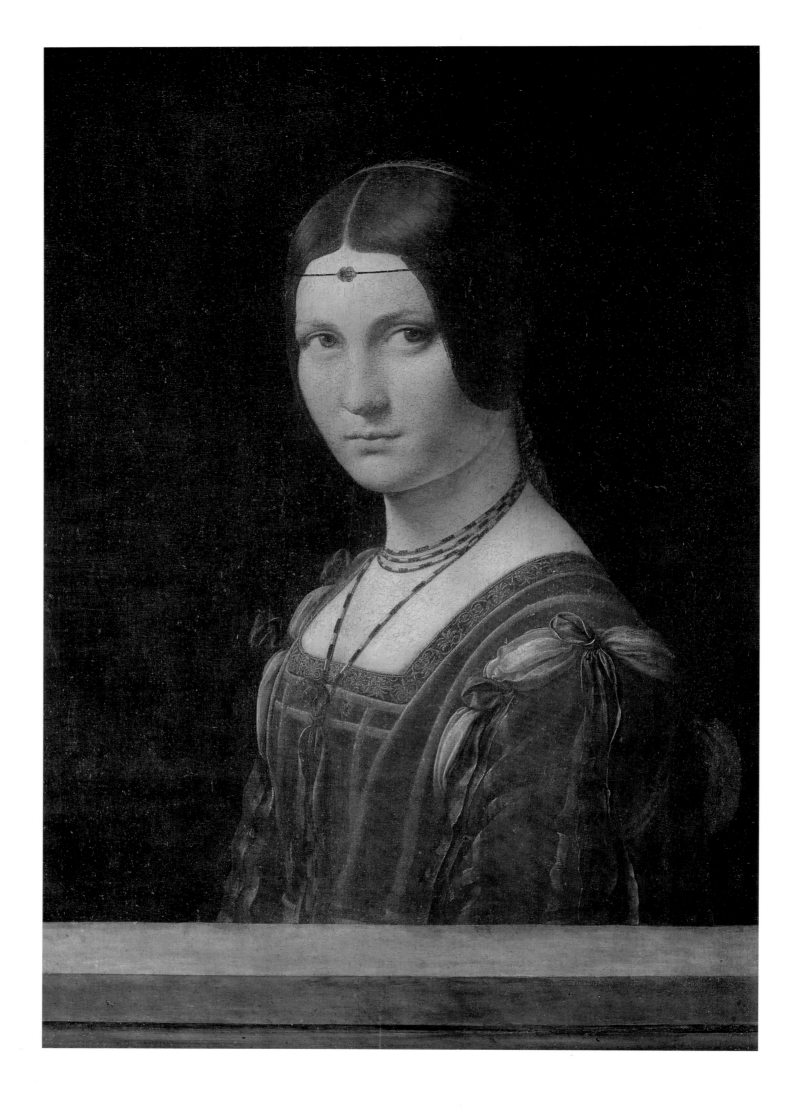

as she was still young at the time the portrait was produced. This comment is an important clue as to the dating of the painting.

The fashion of the clothes of the portrayed woman was introduced to Milan by Isabella d'Aragon, who married a Sforza in 1489. For that reason, the portrait can scarcely have been produced before 1490. Because old sources show that Cecilia Gallerani was already 25 years old at that time, her identification with the portrayed young woman was long treated with reservation, despite the fact that the Greek word galè means "ermine", and the valuable furred animal on the woman's arm was hence a visual pictorial embodiment of her name (ill. 70). Only recently have archives been discovered which prove that the dates of Gallerani's life were copied incorrectly, and that Cecilia Gallerani was just 17 years old in 1490.

Leonardo left Milan towards the end of 1499 and stopped off in Mantua before travelling on to Venice, where he was probably commissioned by the city state to produce a defensive structure in Friuli to counter an imminent Turkish invasion. In Mantua before this, he made one or several drawings portraying Isabella d'Este, and it was probably there that he produced a cartoon. In March 1500, the portrait of Isabella was with Leonardo in Venice, as reported by an eye-witness. In 1501, Isabella d'Este asked for another copy of her portrait.

In the Louvre in Paris there exists a cartoon of a female portrait which has been linked to this commission (ill. 69). Comparisons of the woman depicted there with a medal have confirmed her identity as Isabella d'Este. The cartoon is, however, in an exceptionally poor state of preservation, but is artistically superior to two other surviving paintings in Florence and Windsor Castle, making the attribution of the Paris portrait to Leonardo appear likely. The portrait suggests that Isabella d'Este made two requests of Leonardo: first of all to be depicted in the profile view, which was considered to be particularly dignified, and at the same time to appear as vivid as the young Cecilia Gallerani in her portrait.

Leonardo succeeded in combining these two elements by once again having the figure react to some stimulus that is not visible to the observer. Despite her almost frontal posture, Isabella has turned her head so far to one side that it appears as if by chance in a precise profile. This vigorous quality can be clearly perceived despite the poor condition of the cartoon in the Louvre (ill. 69). But one of the copies is useful for reconstructing the incomplete lower section in the Paris portrait. At the lower edge one can see the woman's right hand, and one can only guess at the position of the left arm. The right hand is already reminiscent of the *Mona Lisa* (ill. 119), but the index finger is, as if by chance, pointing to a book lying on the balustrade on the right. This is how Leonardo characterized Isabella d'Este as an educated woman, which is how she is also described in contemporary sources.

PICTURES THAT SEEM TO HAVE THE POWER OF SPEECH: THE *LAST SUPPER* IN MILAN

After Ludovico il Moro was made duke of Milan in 1494, he decided to make the monastery of Santa Maria delle Grazie his family's burial place. This is the context within which Leonardo was probably commissioned to decorate the monks' dining room, the refectory, with a depiction of the Last Supper.

Leonardo's *Last Supper* (ill. 72) is not the only wall painting in the refectory. On the opposite wall is a large Crucifixion scene by the local painter Donato Montorfano, which was completed in 1495 according to an inscription. Both themes were frequently depicted in monastic dining halls in Tuscany (ill. 74). The commission from the Dominican monks for the *Crucifixion* appears to have gone out before that for the *Last Supper*, for Ludovico il Moro would surely have made use of a more important painter once he had decided that the monastery of Santa Maria delle Grazie was to be his family mausoleum.

Leonardo's *Last Supper* (ill. 72) is indisputably one of the most famous and important works in the history of painting. The quality of the wall painting was recognized within a very short space of time after its completion; copies were produced of it and its praises were sung in contemporary sources. After conquering Milan in 1499, the French king is even said to have expressed the desire to bring it to France, but his advisors were apparently able to dissuade him on the grounds that, given the technological conditions of the time, transporting the painting would have been tantamount to destroying it.

Scarcely 20 years after the completion of the work, the traveler Antonio de Beatis reported that, while the wall painting was *excellentissima*, it was already starting to come to pieces, possibly because the wall had absorbed water. Ever since, every generation has worried and made efforts to a greater or lesser degree to preserve this work. In 1943, during an air raid, a bomb exploded in the refectory of the monastery of Santa Maria delle Grazie and destroyed the roof and the wall to the right of the *Last Supper* right down to the foundations; the work of art, protected by sand bags, fortunately survived this catastrophe largely unscathed. Since about 1980, extremely extensive and technologically lavish restoration work has been taking place to preserve it, made particularly necessary by increasingly destructive air pollution. The work was still unfinished in 1998, 500 years after the completion of the *Last Supper*.

This restoration followed the disputed decision to remove all overpaintings and completions of missing sections, preserving only those parts originally painted by Leonardo. The sole exception to this are the wall hangings, where large parts of the overpaintings have been left intact. This measure has uncovered an extremely large number of missing sections, though on the other hand, for the first time in centuries it is possible to make out the quality of the work. Colorful reflections of the apostles' garments on the metal containers have

71 *La belle Ferronière*, ca. 1490–1495
Oil on panel, 63 x 45 cm
Musée du Louvre, Paris

This portrait has long been a subject of controversy over its attribution to Leonardo. The refinement with which the woman is gently turning her head and in which the eyes pick up and continue this movement clearly show it to be a work by Leonardo. Coarse overpainting of the hair has had an adverse effect on the painting without, however, being able to conceal its high quality. It has not so far been possible to establish beyond doubt the identity of the person depicted.

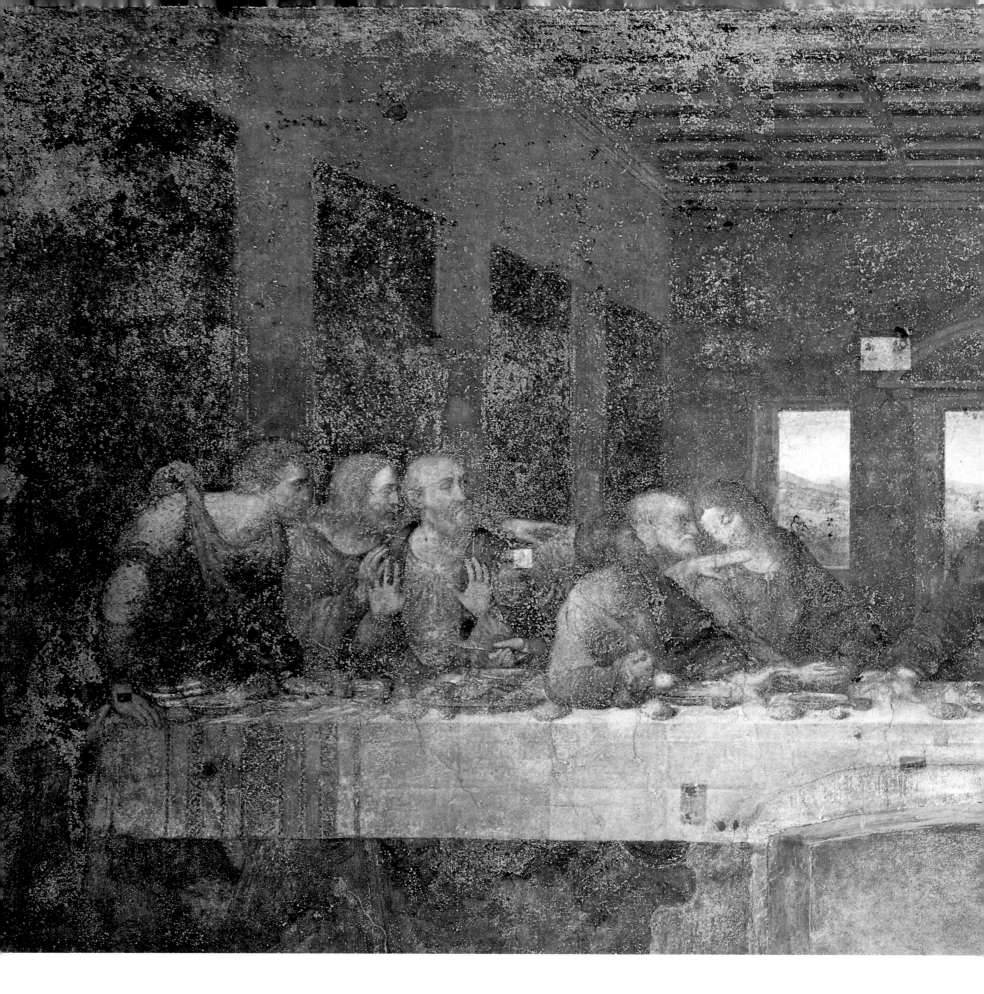

72 *Last Supper*, ca. 1494–1498
Mixed media, 460 x 880 cm
Refectory of Santa Maria delle Grazie, Milan

With this wall painting, Leonardo introduced a new era in painting. At first sight, it appears to be a snapshot of a lively dinner party. When examined more closely, however, this snapshot turns out to be a superbly staged depiction of the entire story of the Last Supper. Jesus is pointing to the bread and wine, and only a few of the apostles appear to recognize that he is about to conduct the first Eucharist. Most of the others are still busy discussing the announcement that one of them is a traitor.

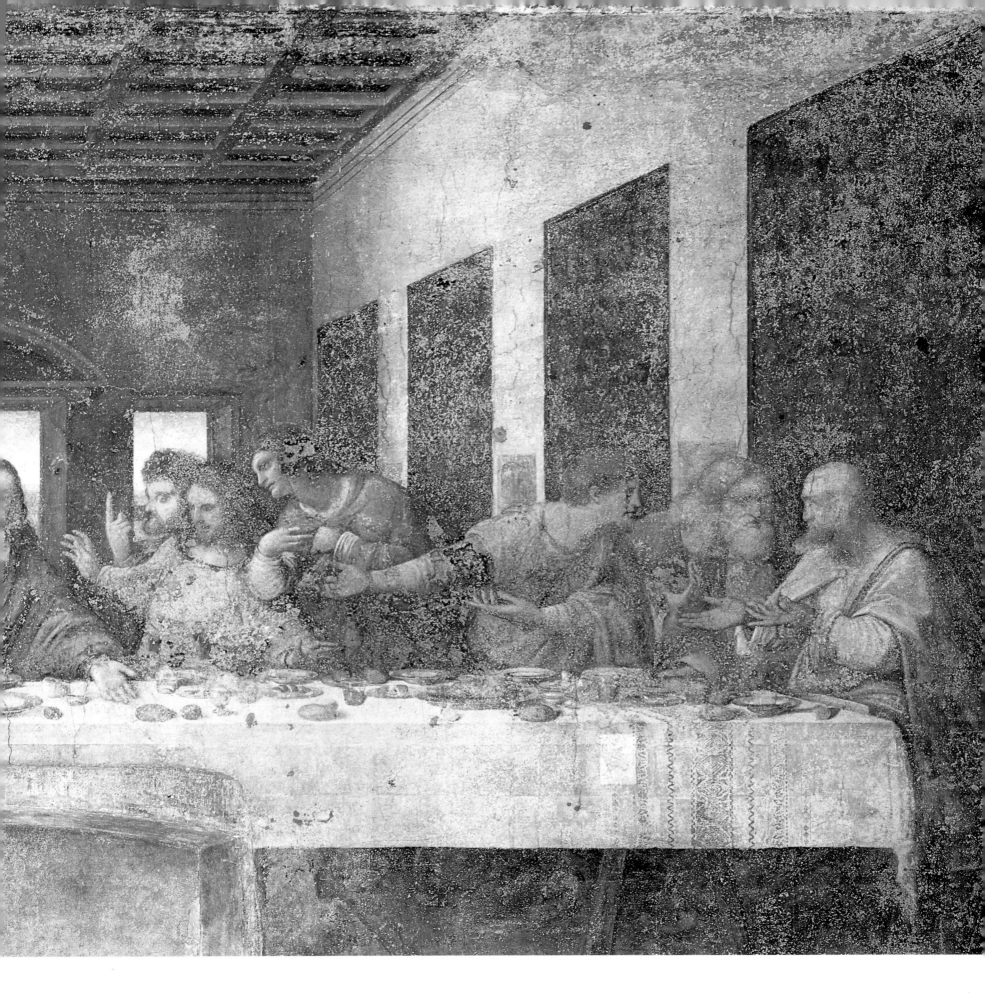

73 (following page) *Last Supper*: Jesus Christ (detail ill. 72), ca. 1494–1498

The central scene shows Jesus – easily recognized by the gesture of his hand – preparing the Eucharist. Goethe did not make a correct interpretation of this scene as he wrote his description based on an engraving that omitted an important detail: the wine glass to which Jesus is pointing with his right hand.

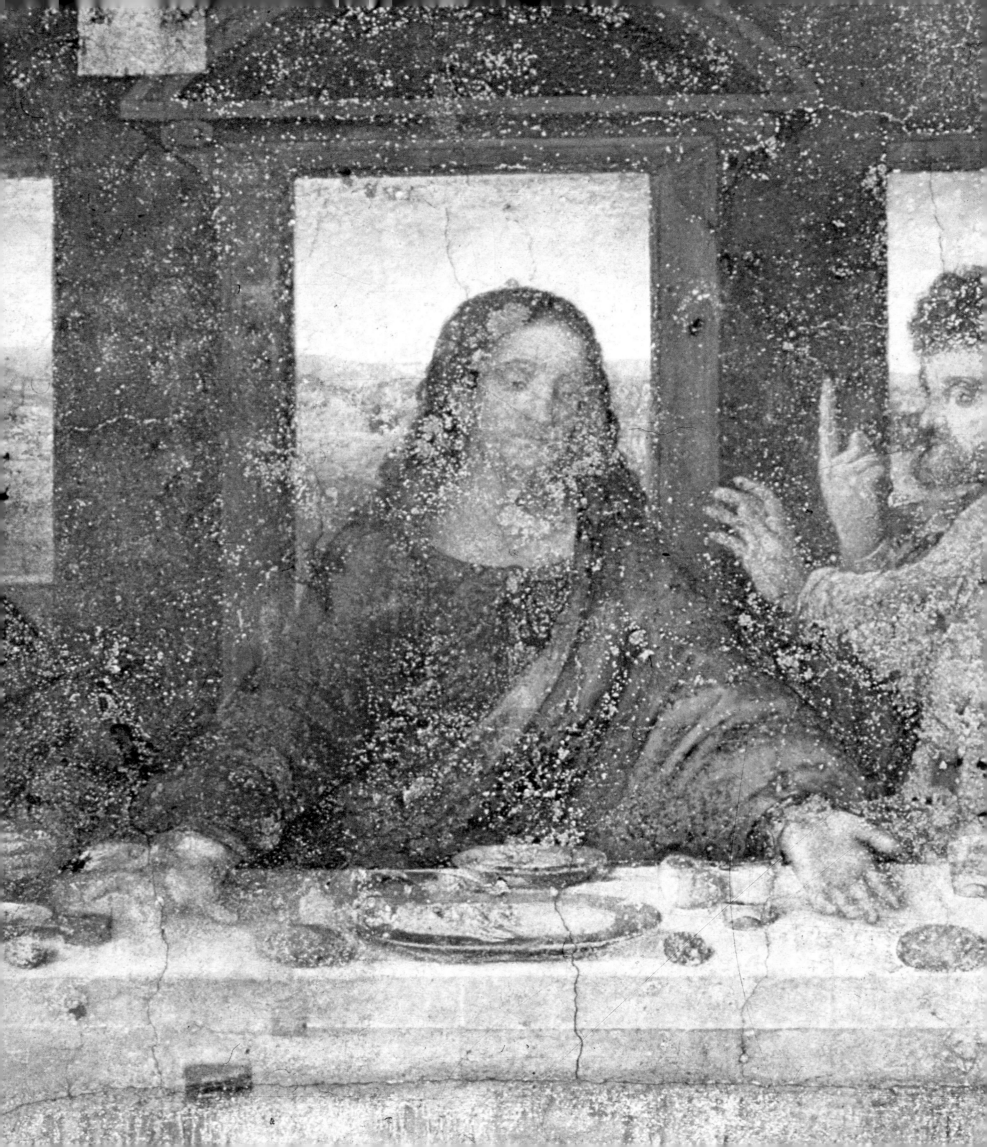

been revealed, as has an extremely subtle depiction of light and shade. The work did not merely bring the original colors to light, it also made it possible to examine the construction of the paint layers and the methods of painting used. They confirm a contemporary account according to which Leonardo worked very slowly at the painting and occasionally only painted a few strokes during the course of a day. So slow a method of working would not have been possible if the usual fresco technique had been used for the wall painting, as the paint pigments had to be applied to a moist layer of plaster allowing them to bond with it as it dried.

As in all his major undertakings, Leonardo had thought through the conditions of production and sought a new technical solution for the process of painting. He decided in favor of mixed media and

painted over two ground layers using oil and tempera paints, as was done in panel painting. The Milan curator responsible for the *Last Supper* feels this particular technique is partially responsible for the fact that the disintegration of the work set in so early, given the unfavorable climatic conditions.

It cannot be determined exactly when the commission went to Leonardo. The completion of the painting in 1498, in contrast, is documented by a reference to it by the monk and mathematician Luca Pacioli in his book "De divina proportione".

There are differing opinions amongst art researchers as to which episode from the Gospels is depicted in the *Last Supper*. Some consider it to portray the moment at which Jesus has announced the presence of a traitor and the apostles are all reacting with astonishment, others feel that it also represents the introduction of the

74 Domenico Ghirlandaio (1449–1494)
The Last Supper, 1480
Fresco, 400 x 800 cm
Refectory of San Marco, Florence

Ghirlandaio's wall painting is a famous example of the Tuscan tradition of depicting the Last Supper in monastic refectories. In accordance with the customary iconography, Judas is instantly recognizable as the only one sitting in front of the table. Ghirlandaio endeavored to depict the apostles in as lifelike a manner as possible. His figures are nonetheless sitting isolated next to each other in a row, and are not connected in any inner way. The epochal step taken by Leonardo with the communicating figures in his version becomes evident when comparing the two paintings.

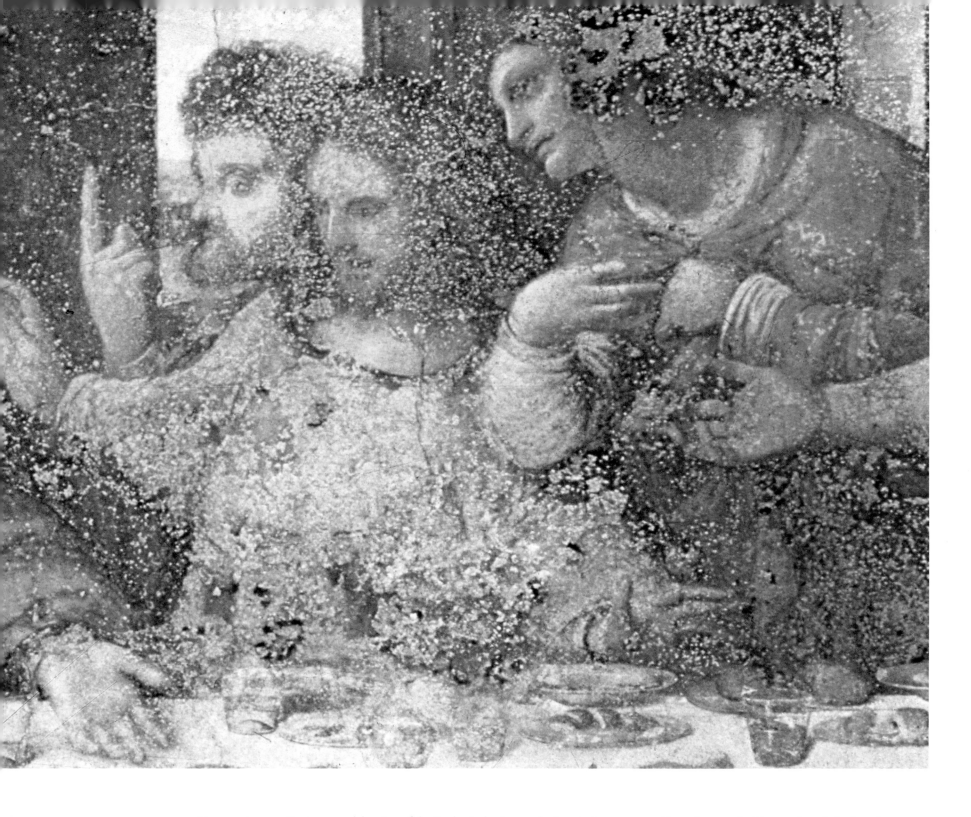

75 *Last Supper*: group around St. James the Great (detail ill. 72), 1494–1498

The group around St. James the Great is depicted right next to the central scene with Jesus Christ. This picture shows its condition before the wall painting was restored, today the details of St. James the Great's face are no longer visible.

celebration of the Eucharist by Jesus, who is pointing to the bread and wine with his hands. And yet others feel it depicts the moment when Judas, by reaching for the bread at the same moment as Jesus as related in the Gospel of St. Luke (22:21), reveals himself to be the traitor. In the end, none of the interpretations is convincing, as none of them takes into account Leonardo's conception of painting.

From the time of the Gallerani portrait, Leonardo developed his paintings by basing his designs on men of action. As he wrote in his treatise on painting: "A picture, or rather the figures therein, should be represented in such a way that the spectator may easily recognize the purpose in their minds by their attitudes" – as if they had the power of speech.

Once the event had been selected, the least important part of the work of a painter according to Leonardo's own account, he first sketched a rough overall composition in which the figures already made a recognizable contribution to the overall events in terms of posture and gestures (ills. 77, 78). If the figures were depicted engaged in a conversation, the emotional state of the speaker and what was being conveyed had to be clear from the posture, gesture and facial expression. So he had to start by developing this pictorial plan before he could start working out the individual figures in more detail (ill. 76), tightening the composition and turning it into a vivid, yet harmonic overall arrangement.

The existing structure of the picture shows that Leonardo's painting of the *Last Supper* was constructed

76 Study of an apostle's head and architectural study, ca. 1494–1498
Red chalk, pen and ink on paper (facsimile)
Galleria degli Uffizi, Gabinetto dei Disegni e delle Stampe, Florence

The head is a study for St. James the Great in which Leonardo was concerned mainly with investigating the expression of the figure. The open mouth and widened gaze create the impression of astonishment. In addition, the sheet includes an architectural study in ink, a design for an aesthetic solution to the corner of a fortress wall, probably representing Leonardo the architect rather than Leonardo the builder of fortresses.

symmetrically according to the laws of central perspective, with a main figure in the center. According to this pictorial logic, as well as the theme upon which the painting is based, Jesus is the main figure in the picture. He is physically and psychologically isolated from the other figures and with his hands is pointing to the bread and wine, making the introduction of the Eucharist the central event (ill. 73). In Leonardo's conception, the other figures are reacting directly to Jesus, and at the same time, some of them are coming into contact with each other.

James the Great, whose mouth is opened in astonishment, is sitting on the right next to Jesus, and spreading out his arms as if trying to say to the two disciples behind him, who are attempting to command the attention of Jesus with their eloquent gestures and the way they are pushing forward, that they should be quiet and listen (ill. 75).

James the Less, the second from the left, places his hand on Peter's back, while Andrew next to him is still holding his hands before him and speaking, but his eyes are already seeking out Jesus. Peter and John are facing each other deep in conversation (ill. 72), just like the group of three on the far right who still seem to be animatedly discussing the previous announcement of the existence of a traitor.

That this announcement has indeed already taken place is proven by the behavior of John and Peter. In contrast with the usual manner of depiction, in which John is lying against Christ's chest, here Leonardo refers to the Gospel of St. John (13:24): "Simon Peter therefore beckoned to him, that he should ask who it should be of whom he spake."

By combining these two apostles into a group with Judas in this manner, Leonardo was distancing himself from the traditional scheme of depiction used for Last Suppers, according to which Peter and John sat to the right and left of Jesus. In contrast to the other apostles, however, he characterized them so clearly that they are identifiable to the observer. He identified Peter by means of the threatening dagger that he would, at dawn, use to cut off the ear of Malchus, one of the soldiers arresting Jesus.

John, the favorite disciple, is wearing red and blue garments as is Jesus, and is seated at his right hand, the most honorable place. But Judas above all was clearly characterized by Leonardo, for he was not, as was

77 Study for the *Last Supper*, ca. 1494/1495
Pen and ink on paper, 26.6 x 21.4 cm
Royal Library, RL 12542r, Windsor

The sketched design of a Last Supper shows that Leonardo at first planned to simply show the moment at which the presence of a traitor is announced. He enlarged this scene somewhat to the right, depicting it in more detail. Next to Jesus, John is sitting leaning on the table. Judas is, in keeping with tradition, depicted in front of the table and is rising in order to take the bread, thereby identifying himself as the traitor.

customary, placed in the center of the picture in front of the table, but placed amongst the row of disciples. He is identified by means of several motifs such as his reaching for the bread, the purse containing the reward for his treachery and the knocking over of a saltcellar, a sign of misfortune. Leonardo even formally expressed his isolation from the group by depicting him as the only one whose upper body is leaning against the table, shrinking back from Jesus.

Hence, Leonardo's *Last Supper* is not a depiction of a simple or sequential action, but interweaves the individual events narrated in the Gospels, from the announcement of the presence of a traitor to the introduction of the Eucharist, to such an extent that the

moment depicted is a meeting of the two events. As a result, the disciples' reactions relate both to the past and subsequent events. At the same time, however, the introduction of the Eucharist clearly remains the central event.

Everyone who has personally stood in the refectory in Milan before the *Last Supper* can confirm that the painting is experienced as an illusory continuation of the real space. That Leonardo created this effect entirely deliberately is shown by the fact that the lighting in the picture corresponds to the light entering through the real windows in the lunettes on the left refectory wall. Researchers have, however, discovered that at no point where the observer stands is the pretended continuation

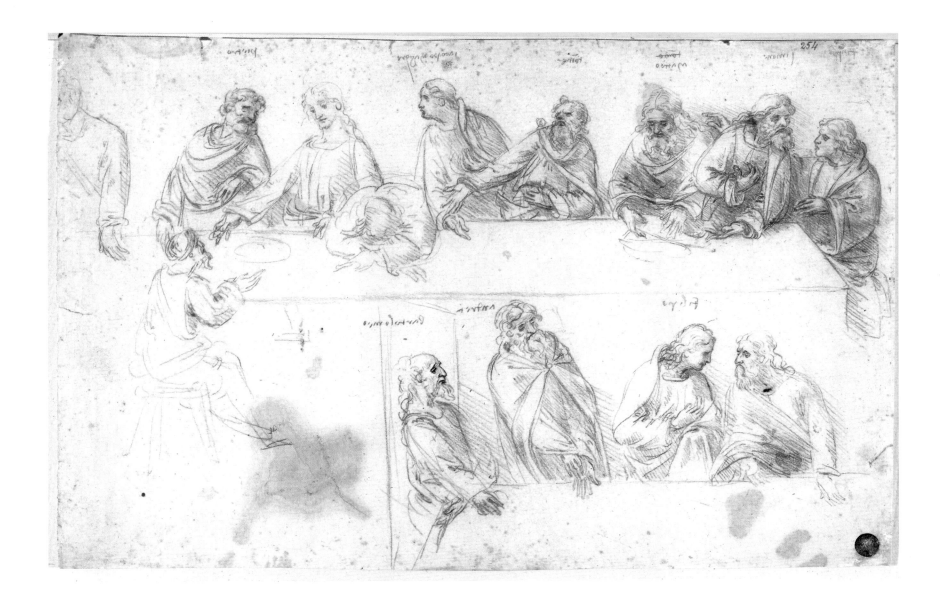

of the hall into the pictorial space entirely successful, which would have had to be the case if Leonardo had attempted to achieve this effect using a central perspective construction.

A small observation can, perhaps, qualify this objection. If one stands on the right and looks at the *Last Supper*, the painted space continues almost without a break on the left wall of the refectory, and if one stands on the left the illusion on the right works. If one, however, stands directly in front of the picture, it is the ceiling that determines the main impression and creates the illusion that the refectory continues into the pictorial space. The ideal position for an observer appears to have been avoided out of knowledge of the real use of the refectory, for the monks sat on benches along the long walls. The table of the prior, which might have been considered the worthy position for the ideal viewpoint, does not at first appear to have stood opposite the *Last Supper*, but directly beneath it, for Leonardo's wall painting starts at the precise height of the furniture at the time – a wooden pew. The Crucifixion scene on the opposite wall, in contrast, extends almost to the floor. Not until later was the seat

removed from beneath the *Last Supper*, a doorway made in the middle of the wall and the prior's table placed opposite the painting, just as Goethe was to find the tables arranged years later when he visited Milan.

Avoiding the ideal viewpoint can possibly only be explained in that, if the laws of perspective had been properly applied, the observer would have to be looking at the underside of the Last Supper table, for he stands significantly lower than the lower edge of the wall painting. Leonardo himself made the following comment on this problem: "A painted figure, if one is looking down at it from above, will always appear as if one is looking down at it from above, even when the eye of the observer is lower than the picture."

So Leonardo's pictorial composition was not determined by geometry; his goal was the visual coherence of the scene. For the first time, the *Last Supper* clearly showed the paradox that characterized Leonardo's painting: "Those who want to produce a deceptively real imitation of nature must not copy nature but deceive the observer. The latter can only, however, be achieved by someone who is familiar with nature and the laws of perception."

78 Leonardo's workshop
Study for the *Last Supper*, ca. 1494/1495
Red chalk on paper, 26 x 39.2 cm
Gallerie dell'Accademia, Inv. 254, Venice

This sheet is one of the most remarkable drawings to have been connected with Leonardo. The composition is strongly reminiscent of the *Last Supper*. One thing there is total agreement about, however, is that the stiff figures were not drawn by Leonardo. But it is possible that he produced preliminary sketches of some of them and that they were drawn by a student. Whatever the case, the mirror writing is a sign that Leonardo used this piece of paper.

COMMISSIONS IN THE REPUBLIC OF FLORENCE 1500–1506

79 Leonardo's workshop
Design for *St. Anne*, ca. 1501
Slate pencil on prepared paper, 21.8 x 16.4 cm
Private collection, Geneva

Mary is trying to prevent Jesus playing with the lamb, but Anne tells her to let the boy be. Jesus must accept his fate, his death for the salvation of mankind, which is symbolized by the lamb. The drawing was first published by Carlo Pedretti and filled the gap between a contemporary description of a design for St. Anne and Leonardo's surviving composition on this theme. Even though the attribution of the drawing to Leonardo is disputed, there is nothing to suggest that it could not have been produced in Leonardo's workshop.

During the years Leonardo was working on the *Last Supper*, he was also commissioned by Ludovico Sforza to decorate some halls in the Castello Sforzesco (ills. 131, 132). After completing them, he noted with resignation that under the circumstances there could be no more talk of the "horse". For when Milan fell to the French in battle, Leonardo moved to Florence again. Before the move to Florence, it is possible that after staying in Venice he spent a short time in Rome, which can be deduced from a note in which the villa of Hadrian in Tivoli is mentioned. That would have been the first occasion on which Leonardo encountered a large quantity of classical works of art. In contrast to many of his colleagues, however, Leonardo cannot be proven to have adopted ideas directly from classical models, although he studied them and was very well acquainted with their qualities such as grace, movement and vividness. This, together with an over-interpretation of a note that he wrote, until very recently led to the incorrect conception that Leonardo had rejected the classical era, which is considered the most important source of knowledge for the Renaissance artist. However, one can reach a different conclusion by remembering the entry concerning the equestrian monument of the *Regisole* in Pavia.

A further note written by Leonardo can possibly shed some light on his attitude to models: "It is a sorry student who cannot outdo his teacher [in this case classical art]." Here Leonardo was formulating an artistic standard which derives from orientation to a model. Appropriating knowledge by copying or repeating is the basis for recognizing stylistic qualities in the works of art that have been handed down. Proficiency is expressed not in the supreme mastery of formal and craftsmanlike methods, but in the interpretation in which one's own visual language is expressed. The quotation, in addition to this, reveals a scientifically working Renaissance artist who believed that extending one's level of knowledge would produce a continual improvement of art.

In Florence, Leonardo was given accommodation by the Servite monks, who according to Vasari, commissioned him to produce a high altar painting showing a Madonna of the Annunciation. The theme of the picture is not completely clear. According to Vasari, he presented a cartoon of *St. Anne, Mary, the Christ Child, the young St. John and the Lamb* which is said to have created quite a sensation. Whether the composition is identical to the commissioned altarpiece is, however, not clear from Vasari's writing.

In addition, no drawn plan by Leonardo survives which contains both the young St. John and the lamb. Therefore one must assume that Vasari made up a cartoon based on oral traditions, which he admitted never having seen as the cartoon was allegedly in France at the time. It is likely that Vasari is referring to a group of Leonardo's works which he created showing the Madonna and St. Anne.

WAYS OF NARRATING RELIGION: THE COMPOSITIONS OF THE MADONNA AND ST. ANNE

The worship of St. Anne, which did not begin until the late Middle Ages, does not derive from any biblical sources regarding Mary's mother. During the course of the increasingly important worship of the Madonna, however, the parents of the Mother of God, Anne and Joachim, continued to grow in importance, though Joachim, like Christ's foster-father Joseph, played a subordinate role. This is the background against which the development of the theme of depictions of St. Anne needs to be viewed. In Italy, it was mainly the Byzantine tradition that was formally followed, by depicting the Christ Child on Mary's lap, who in turn is seated on the lap of her mother Anne. At the beginning of the 15th century, the icon-like stylization of the Byzantine pictorial form was broken up in Florentine art by Masaccio (1401–1428), who used a method of depiction that was based more strongly on observation. The problem of characterizing two equally large women as mother and daughter, and at the same time representing the allusion to the sequence of generations in an obvious manner, was solved by Masaccio by placing Mary at Anne's feet.

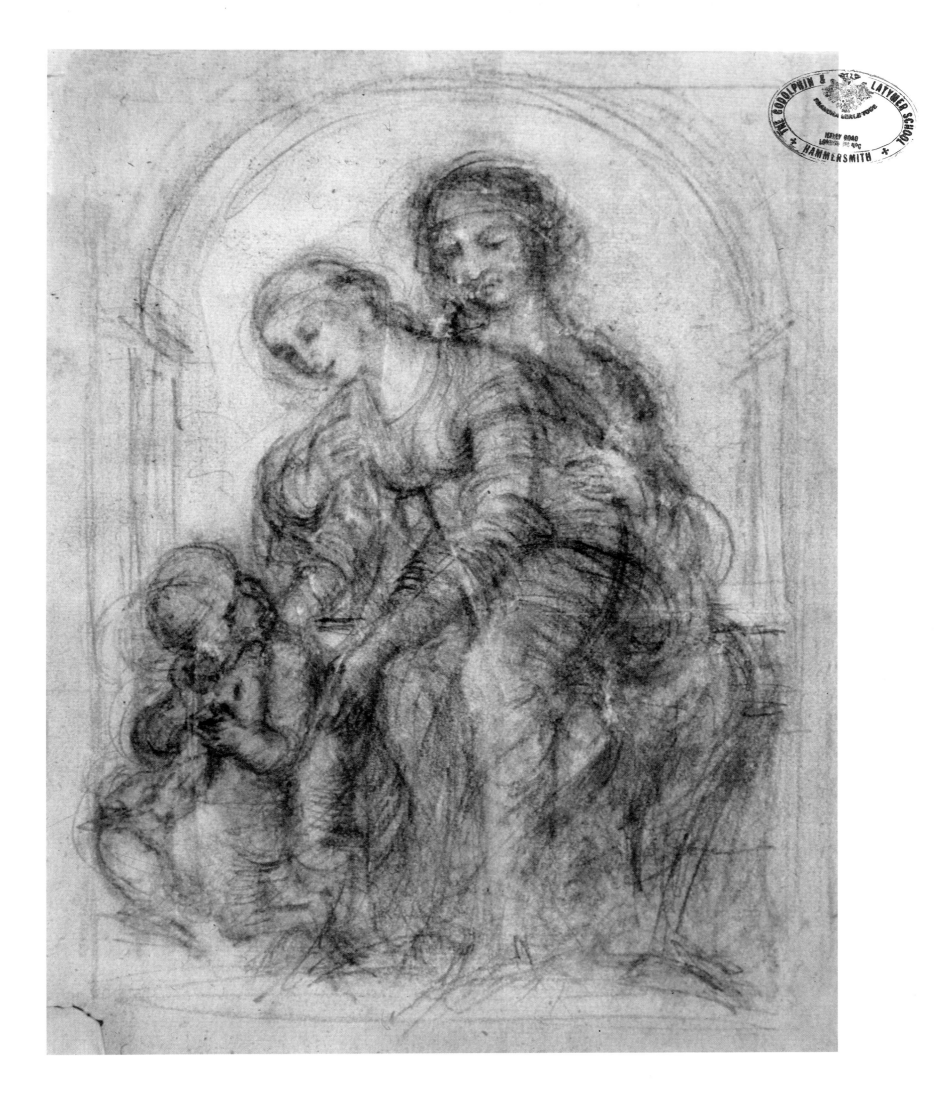

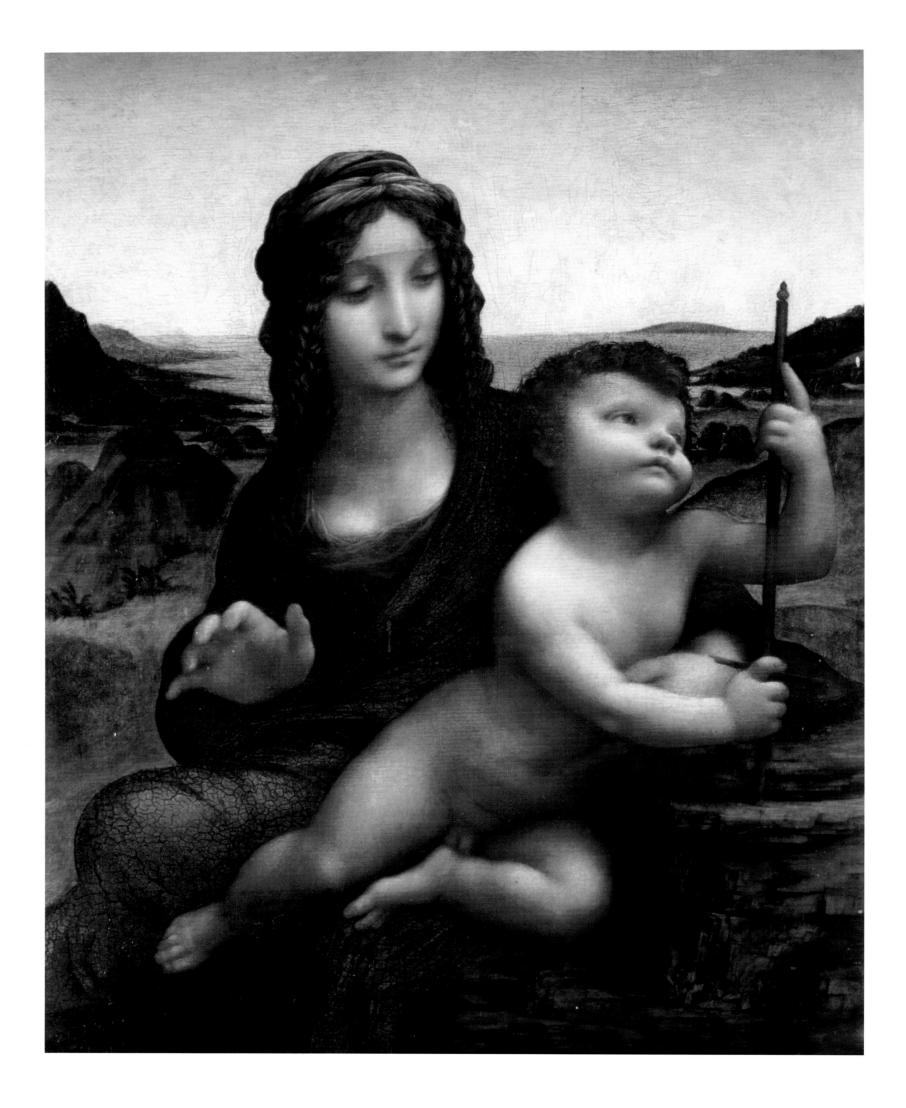

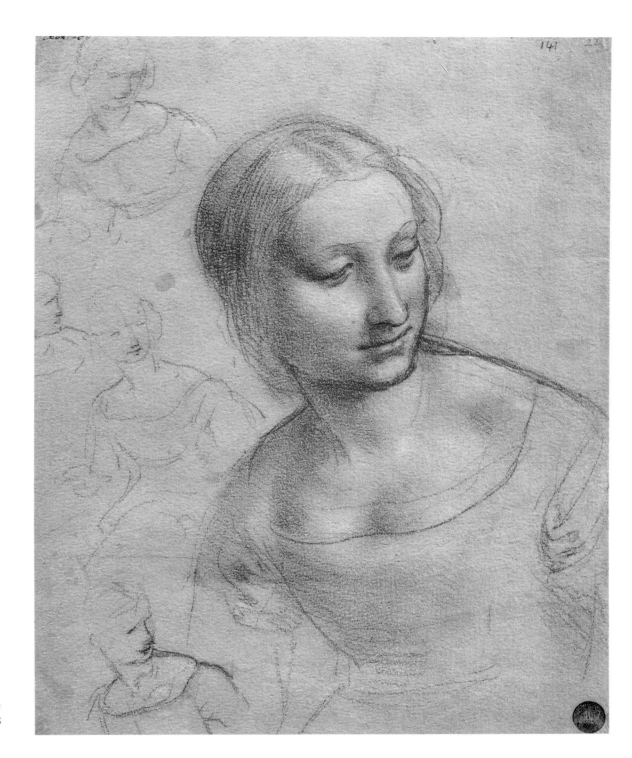

81 (right) Leonardo's workshop
Study for *Madonna with the Yarnwinder (?)*, ca. 1501
Red chalk and silverpoint on rose-colored prepared paper,
25.7 x 20.3 cm
Gallerie dell'Accademia, Inv. 141, Venice

The red chalk drawing is generally connected with the
Madonna with the Yarnwinder, as the female figure has a
posture similar to that of the Mary depicted in that
painting. There is, however, a clear difference between the
turning of the bodies of the two figures, so that the dating
of the page remains a matter for debate.

80 (opposite) Leonardo's workshop
Madonna with the Yarnwinder, 1501 (?)
Oil on panel, 48.3 x 36.9 cm
Collection of Duke of Buccleuch, Drumlanrig Castle

Leonardo is thought to have taken part in producing this
version of the *Madonna with the Yarnwinder*, a fact
suggested primarily by the rock in the foreground and the
boy's face. Martin Kemp even considers this panel to be a
version produced immediately after the commission of
1501.

In the last quarter of the 15th century, the worship of St. Anne was given an additional boost by the Church when Sixtus IV (1414–1484, pope from 1471) would – which was unusual – only grant an indulgence if the simple prayer had been spoken in front of a picture of *Anna metterza* (St. Anne with the Virgin and Child). Alexander VI (1430–1503, pope from 1492), even combined a prayer to St. Anne with 10,000 years of indulgences for mortal sins and 20,000 years for venial sins.

This is the context within which Leonardo's interest in the theme of depictions of St. Anne needs to be seen. In 1501, the vicar-general of the Carmelites, Fra Pietro da Novellara, noted in a letter to Isabella d'Este, whose Florentine art agent he was, that Leonardo was working on a cartoon including St. Anne (ill. 79). He also described the iconography and included an interpretation of the picture: "On it, a Christ Child is depicted, about one year old, who seems to be wriggling free of his mother's arms and climbing on top of a lamb, apparently in order to throw his arms around its neck. The mother, however, seems to want to move from the lap of St. Anne, where she is sitting, in order to grasp hold of the child and pull it away from the lamb, the sacrificial animal which is a sign of his Passion. St. Anne for her part is rising a little from her seat in order, as it seems, to prevent her daughter from pulling the child away from the lamb; this is possibly meant to represent the Church, which would not wish the sufferings of Christ to be prevented. These figures, although they are depicted at life size, fit into a small cartoon as they are all either sitting or leaning forward and each of them is

more or less standing in front of the other, in a row to the left; this design is not yet finished, though."

A drawing discovered some years ago in a private collection in Geneva, made by someone in Leonardo's circle, shows a composition which matches Novellara's description. At the beginning of our century, a painting in Berlin (destroyed by fire during the Second World War), which was considered to be the work of an artist working in Florence at the beginning of the 16th century, was linked with Novellara's description. The picture evidently had the same composition. Two other versions of this painting do, however, still exist in Paris and Madrid. There is also a panel by Raphael, the *Holy Family* in the Prado dating from 1507, which reflects this composition. As all these versions of the painting appear to derive from the same cartoon, there can be little doubt that the drawing in Geneva is the one described by Novellara. It provides a reliable starting point for judging other designs on this theme.

Novellara mentioned a second painting being produced in Leonardo's workshop, a *Madonna with the Yarnwinder* for Florimond Robertet, and also gave a detailed description of this painting. Two highly regarded paintings broadly agree with this account, though in one respect they show a clear difference: the boy's foot is supposed to have been in the basket with the yarnwinders. None of almost a dozen known versions of this composition includes this motif, and just one contains a basket.

Novellara mentioned that Leonardo's students painted, but that the master himself was usually occupied with other matters and rarely took up the brush with his own hand. Researchers are, therefore, increasingly considering the possibility that the painting of the *Madonna with the Yarnwinder* was not painted by Leonardo in person, but only existed as workshop versions produced under his more or less close supervision. Salai, the student of Leonardo whose artistic abilities have been ignored by art history, is the only one whom Novellara mentions by name in connection with this painting. Salai is the only student of Leonardo mentioned by Vasari in the first edition of his "Lives of the Artists", with the additional comment that Leonardo always went over his paintings. The versions of the *Madonna with the Yarnwinder* in the Buccleuch Collection (ill. 80) and in a private collection in New York (ill. 83) can, therefore, be regarded as such "workshop originals".

Both 1501 compositions, that of St. Anne, Mary, Jesus and the Lamb and that of the *Madonna with the Yarnwinder*, show that he was endeavoring to combine the individually conceived figures to form an exciting composition. Their coherence appears more likely to have been constructed in accordance with formal criteria than to have developed as if independently from a communicative network of relationships. If one compares them with the composition of St. Anne, Mary, Jesus and the young St. John in the *Burlington House Cartoon* (ill. 84), one can perceive a clear change in the interpretation of the pictorial figures. Due to sensitively

82 (above) Study for the *Burlington House Cartoon*, ca. 1503–1510
Charcoal, pen and water and color on paper
The British Museum, 1875-6-12-17, London

The main sketch reproduces the compositional layout of the *Burlington House Cartoon* (ill. 84) with a precision not found on any other design sketch by Leonardo. The smaller secondary sketches show how Leonardo developed his composition. Leonardo traced over the unclear main sketch in its final form with a slate pencil, so that he obtained an easily readable drawing of the composition on the reverse side, though the wrong way round.

83 (opposite) Leonardo's workshop
Madonna with the Yarnwinder, after 1510
Oil on panel, transferred to canvas, 50.2 x 36.4 cm
Private collection, New York

The painting shows a later version of the 1501 *Madonna with the Yarnwinder*. Because of its background it is dated to 1516, for the landscape suggests that the *Mona Lisa* (ill. 119) was painted beforehand. The high quality suggests that it was produced in Leonardo's workshop. The history of the panel can be traced back to 1756, when it was sold in France.

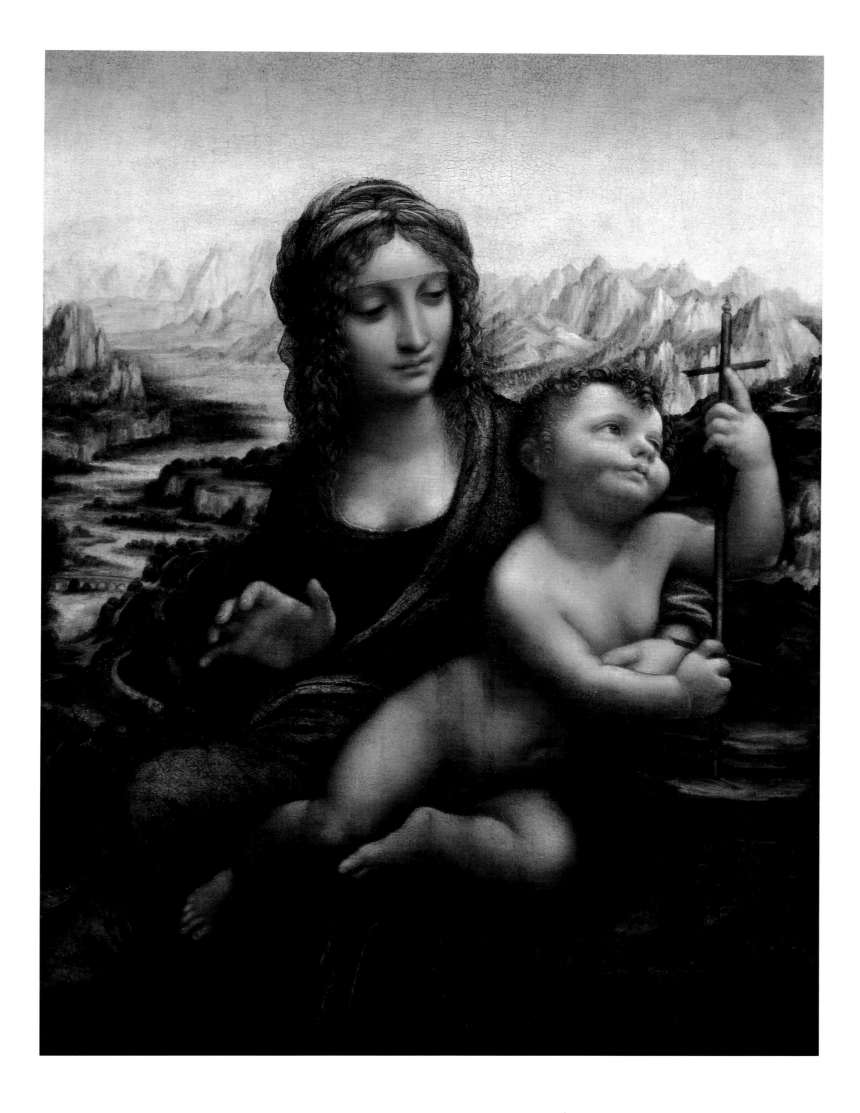

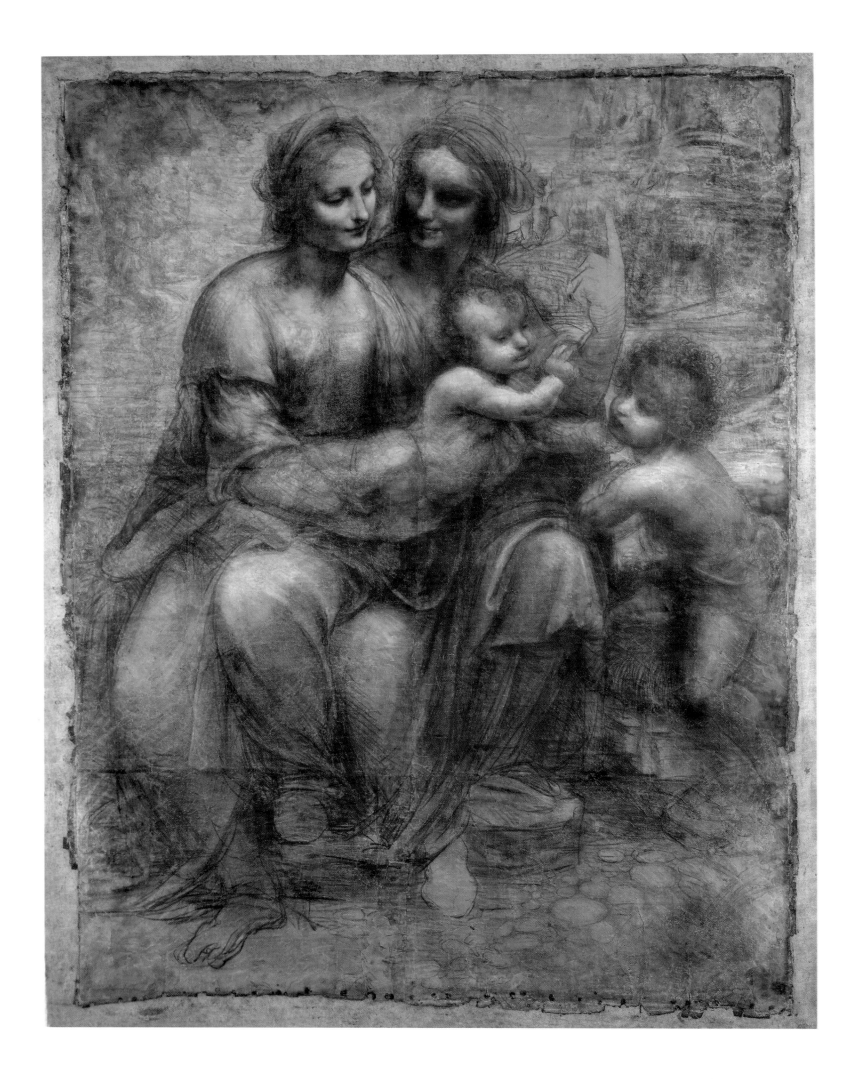

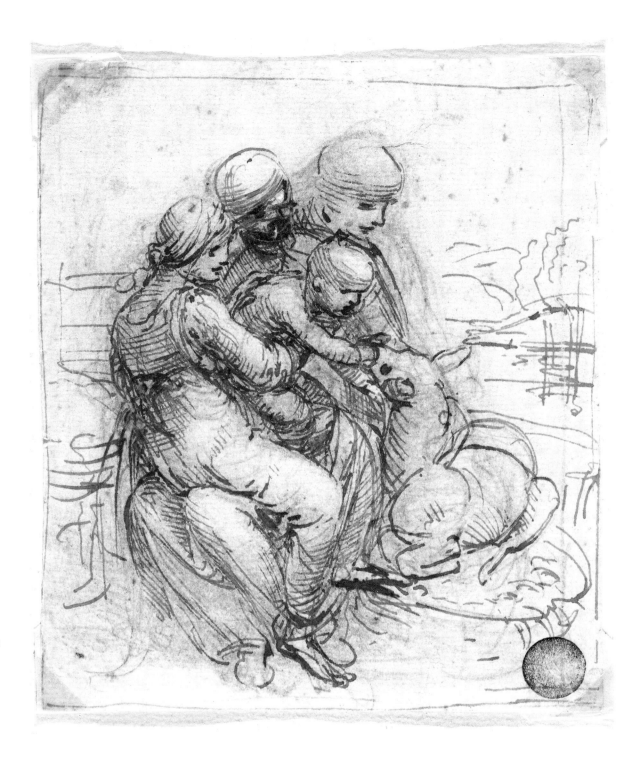

85 (right) Study of *St. Anne, Mary, the Christ Child and the young St. John,* ca. 1501–1506
Lead pencil, pen and ink on paper
Gallerie dell'Accademia, Venice

The first idea of this composition featuring St. Anne was that the Christ Child and St. Anne would both be bending down to the lamb. Leonardo also conceived Anne in a second position, with her head leaning towards Mary, though her hand is still resting on the neck of the lamb. Behind the group he placed a landscape that does not yet have the form of that in the Louvre painting. The compositional sketch precedes the sheet with the compositional sketches for the *Burlington House Cartoon* (ill. 84).

84 (opposite) *Burlington House Cartoon,* ca. 1503–1510
Black chalk, white lead on paper, 141.5 x 104 cm
The National Gallery, Inv. 6337, London

The cartoon of the Madonna and Child with St. Anne and the young St. John is one of the principal works in the National Gallery in London. In 1986, a vandal shot at the cartoon and severely damaged it around the area of Mary's chest. Restorers had an opportunity to examine the cartoon while repairing it. They could discover no sign on it that it was used either by Leonardo or any other artist at a later date for transferring the design to another medium. In the Pinacoteca Ambrosiana is a *Holy Family* attributed to Bernardino Luini. It corresponds precisely to the figural composition of the London cartoon, with the exception that Joseph is added in the background on the right.

indicated movements which result from natural body postures and due to a succinct expression of the states of mind of the individual figures, the fundamentally abstract theme becomes a vivid narrative. Anne occupies the center of the composition, Mary is sitting on her right leg and holding the Christ Child out towards the young St. John, who is leaning against Anne's left leg. Mary appears to have overcome her motherly feelings of protectiveness towards the boy and to have recognized that her son, who is turning towards the somewhat older St. John in a twisting motion, cannot escape his fate of the Passion. The boy's self-will, his consciousness and gesture of blessing appear to confirm what St. Anne is attempting to explain by means of her arm pointing

upwards and the expression of agreement on her face: he is Jesus Christ, the Son of God, who for the good of mankind must accept his fate. This fate is symbolized by St. John the Baptist, the sacrificial function emphasized by his famous words "Ecce agnus dei" (Here is the Lamb of God).

St. Anne's hand with the index finger pointing upwards is only outlined briefly and also appears somewhat large proportionally. It is entirely feasible that Leonardo wanted to abandon this metaphorical pointing finger in favor of a psychologically coherent interpretation of the figures. In addition, the non-hierarchical pyramidal arrangement of the figures is noteworthy. Mary and St. Anne both form the peak

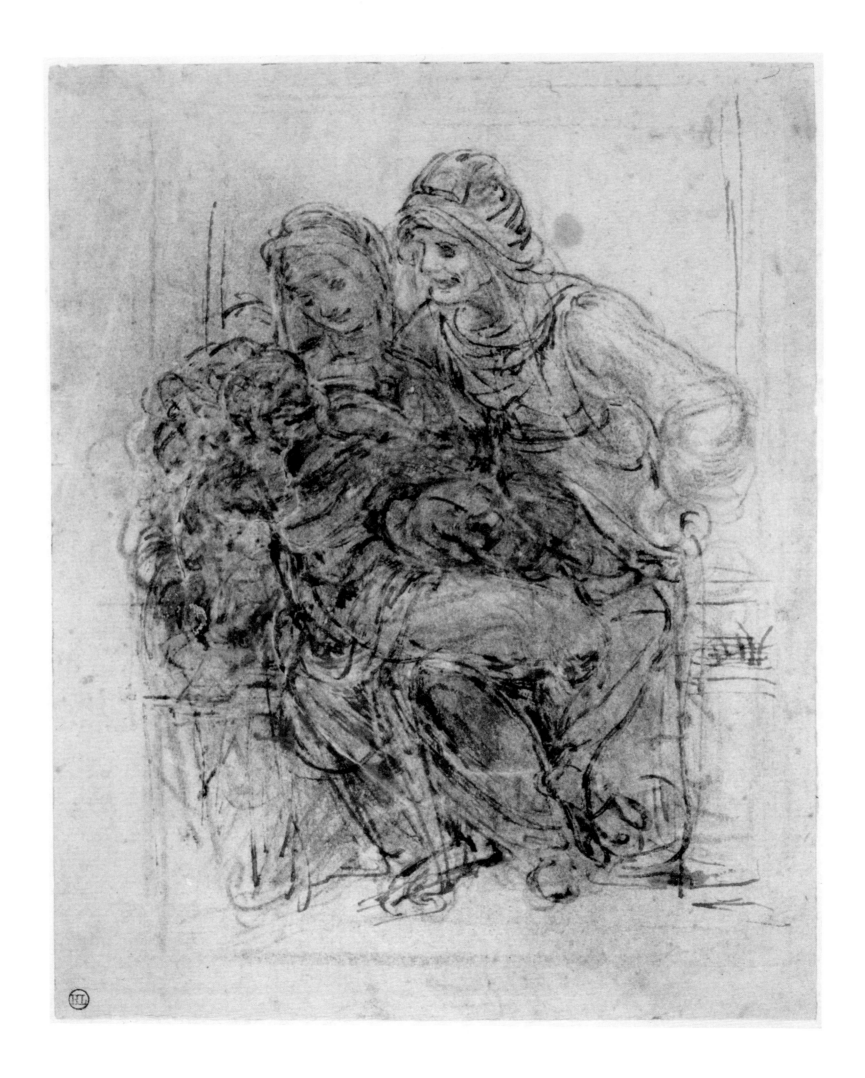

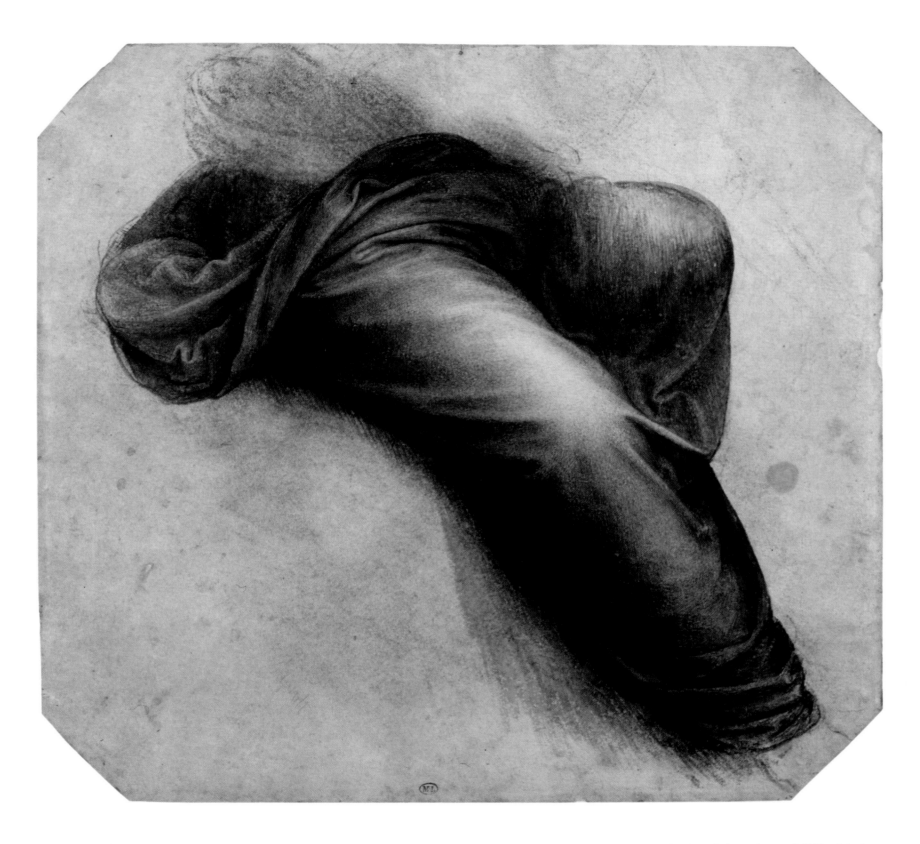

86 (opposite) Study of St. Anne, Mary and the Christ
Child, ca. 1503–1510
Charcoal, pen and ink on paper, 10 x 8.5 cm
Musée du Louvre, Cabinet des Dessins, R. F. 460, Paris

St. Anne is sitting facing to the left, Mary in her lap is
turning towards the right. The Christ Child is turning his
head to face St. Anne, while Mary is looking at her child in
a motherly fashion. With his right arm the boy is holding
some object that can no longer be identified. The sketch
was produced after the design in Venice (ill. 85) and, like
the design in London (ill. 84), dates from between 1503
and 1510.

87 (above) Study for *Madonna and Child with St. Anne*,
ca. 1503–1517
Black chalk, wash and white highlights on paper,
23 x 24.5 cm
Musée du Louvre, Cabinet des Dessins, Inv. 2257, Paris

The study of Mary's garment has been produced very
sensitively. Leonardo used blue and brown washes to give
the black garment an impressive delicateness. A second,
similarly skillful study in Windsor makes it clear just how
carefully he prepared this painting.

together. Their heads meet at the same height. This makes it possible for a close dialogue to develop between the two women, though Anne still radiates a serene dominance due to her central position. Hence, the *Burlington House Cartoon* varies the same theme as the 1501 cartoon. It also counts on being viewed by an observer familiar with Christian iconography. But independently of this theological dimension to the theme, Leonardo also created a picture showing a profound relationship between mother and child, apparently playful and spontaneous.

This increase of quality compared to the other compositions is the result of studies which Leonardo made during his years in Florence. He dissected corpses, increasingly extended his anatomical knowledge, and as he did so gained understanding of the connections between muscles and movement.

Above all, it was physical studies of movement and weight that would become important to him. Leonardo learned two principles that enabled him to reach a better understanding of the movement of the human figure. He recognized the importance of gravity for the statics of figures and the principle that each movement of the body had to have a compensating counter-movement if the person was not to lose balance. These insights had an effect on his perception of nature and ultimately enabled him to confidently give the figures in his pictures physiologically correct movements.

The theatrical staging of the figures, which was tuned more strongly towards the action, posture, gestures and interplay with the surface, was now enriched by a more complex understanding of movement, gravity and balance in the human body. Above all, the figure of Mary in the *Burlington House Cartoon* has been balanced sensitively. She is making a slight turning movement and, in the form of the Christ Child, who is bracing himself against it, she is holding a considerable weight which her body has to balance out by means of various movements. The necessary change of direction of movements to compensate for this can be seen in the joints. Their position creates a distribution of force and weight which maintains the body in a condition which is tense but stable for the moment.

"The musician claims that his art is equal to that of the painter, for it, too, is a body composed of many parts…" Leonardo wrote in his treatise on painting. Notes play the same part for the musician as limbs do for the painter, for they can be used to form a whole. The painter, like the musician, can create harmonies. This is true of the individual figure, and even more so of the entire picture. The lively interaction and the invigorating rhythm created by the changes of direction of the movements of the figures in the *Burlington House Cartoon* combine to form a living harmony. When combined with the dynamic narration of the states of mind of the individual figures, this cartoon can be seen to be one of the outstanding works of art of the Renaissance.

Leonardo worked on compositions with St. Anne until the end of his life (ill. 86). The painting in the Louvre (ill. 88) is the last work in the series for which,

shortly before his death, he produced detailed studies for Mary's garments (ill. 87). The composition convincingly reflects the elements which Leonardo had acquired during these years in Florence. Balanced bodies making extensive movements, a clear rhythm and inspired figures combined to form a painting of classic dimensions. The plasticity of the forms and the depth of space in the picture, with the mountains merging into the fog, are exemplary. The conception of the work dates to the time when he once more moved from Florence to Milan. At this time, Leonardo was working on the most demanding commission that the city of Florence was to award him.

PICTURE PROPAGANDA OF THE FLORENTINE REPUBLIC: THE *BATTLE OF ANGHIARI*

The Republic of Florence, which came into being in 1494, decided to create an assembly hall for their most important political committee, the "High Council", which was suited to the requirements and pretensions of the new republic. The majority of the construction work on the Sala del Gran Consiglio in the Florentine Palazzo Vecchio had been completed shortly before 1500. The pictorial program was to include two large wall paintings intended to express the self-confidence of the new republic. It was planned that two important victories from recent Florentine history should be depicted: the Battle of Anghiari and the Battle of Cascina. The choice of artist had to measure up to the importance of the commission, and the decision was made in favor of two of the most highly esteemed Florentine artists of the age, Leonardo da Vinci and the young Michelangelo.

89 (above) Leonardo (?)
Battle of Anghiari (Tavola Doria), ca. 1503–1505
Oil on panel, 85 x 115 cm
Lost (formerly private collection, Munich)

The panel is named after the collector Doria, who owned it until 1651. It shows the main scene of the design for the wall painting of the *Battle of Anghiari* for the Palazzo Vecchio in Florence. The familiar sources from the 16th century speak of a panel showing a group of horses; it could be this very painting. The painting is of indisputably high quality.

88 (opposite) *Madonna and Child with St. Anne*, ca. 1508–1518
Oil on panel, 168 x 130 cm
Musée du Louvre, Paris

Mary's gaze is melancholy. She has recognized that her son must suffer his future fate. Her body still seems to be showing the tension of the previous moment when she wanted to pull her child away from the lamb, the symbol of his future suffering. St. Anne is watching the events benevolently. The pyramidal composition is dynamic, yet harmoniously balanced. The colossal sense of depth created by the mountainous landscape gives the painting a perceptible peacefulness and greatness.

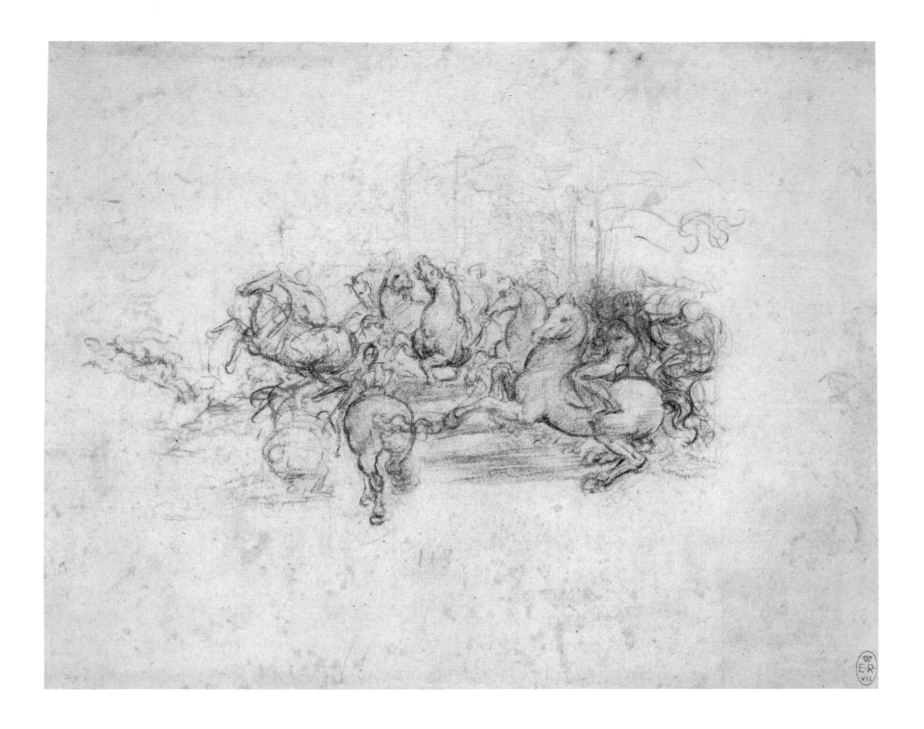

One of the many projects that Leonardo abandoned
during the course of his life was the plan to create a
monumental battle painting in the Sala del Gran
Consiglio in the Florentine Palazzo Vecchio. The theme
was the Florentine victory at Anghiari in 1434. The
master's wall painting soon disappeared, however, as it
remained unfinished; the composition with the whirling
hosts of cavalry was known only to artists. Peter Paul
Rubens (1577–1640) not only created a brilliant version
of it, but also applied what he could learn from Leonardo
to his paintings.

Neither of the two artists completed his work and we
only know of their projects indirectly by their being
mentioned in documents, or in the form of copies or
sketches that have been associated with the project.

Leonardo left the service of Cesare Borgia in the
autumn of 1503 and returned to Florence, where he
probably began working immediately on the commis-
sion for the wall painting of the *Battle of Anghiari*. As early
as 24 October 1503, he was given the keys to the Sala del
Papa and other rooms in the monastery of Santa Maria
Novella to use as his workshop and living quarters. The
lighting conditions in the hall of the Palazzo Vecchio,
given its impressive dimensions, must have been so bad
that there was no getting around the need to create at
least four additional windows, as we learn from a proof
of payment dated 30 June 1504, in the wall opposite that
where the planned paintings were to appear. This delayed

the start of the work. In addition, Leonardo spent
November and December in Piombino in order to give
his expert opinion on the town's fortifications.

The contract with the Signoria forced Leonardo to
either present the finished cartoon, or begin work on the
wall painting, by February 1505. Leonardo decided in
favor of the second option, for proofs of payments exist
which were made for the construction of the newly-
developed mobile scaffolding. This was an exceptional
technical feature and was presumably meant to enable
the artist to move freely along the wall. For Leonardo
intended to lay out the painting as a whole and then
work out the details across the entire surface at the same
time. For that reason, as in the *Last Supper*, he had to
test a method of painting other than the fresco
technique, which would have only enabled him to
produce the picture in separately completed sections.

91 (right) Study of battles on horseback and on foot, 1503/1504
Pen and ink on paper, 16 x 15.2 cm
Gallerie dell'Accademia, Inv. 215, Venice

The upper small sketch shows the turmoil of battle in a scene the dynamism and harmony of which is an intimation of the final composition of the *Battle of Anghiari*, the fight for the standard. Here, however, a furious battle on horseback is still shown. The later solution condenses the events to a close combat fight. Beneath this, in several sketches of figures, Leonardo tested fighting movements that can be regarded as studies for foot soldiers.

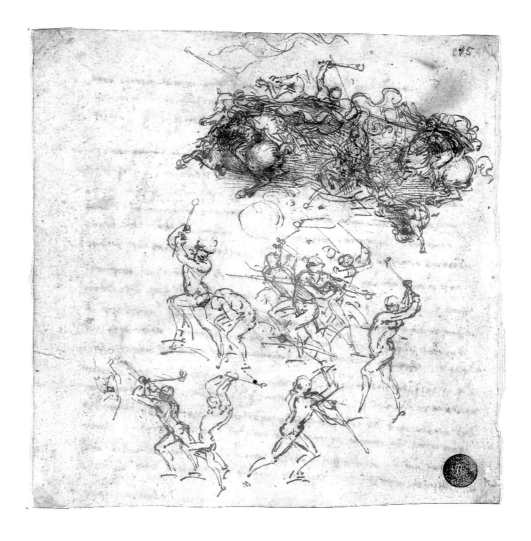

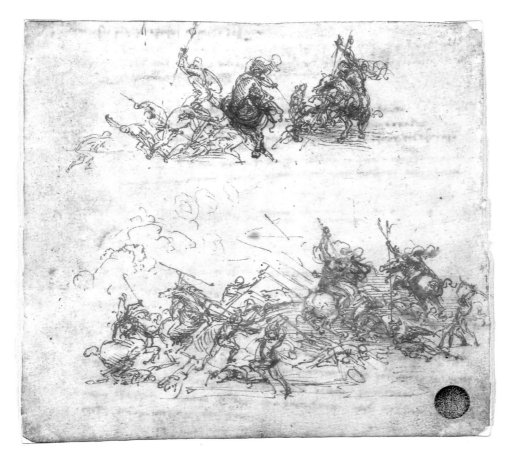

92 (left) Study of battles on horseback and on foot, 1503/1504
Pen and ink on paper, 14.5 x 15.2 cm
Gallerie dell'Accademia, Inv. 215A, Venice

Leonardo tried out mixed battle groups in connection with the *Battle of Anghiari*. At the top it is mainly foot soldiers who are fighting, while at the bottom a mixture of riders and foot soldiers is depicted whose furious battle has raised a cloud of dust.

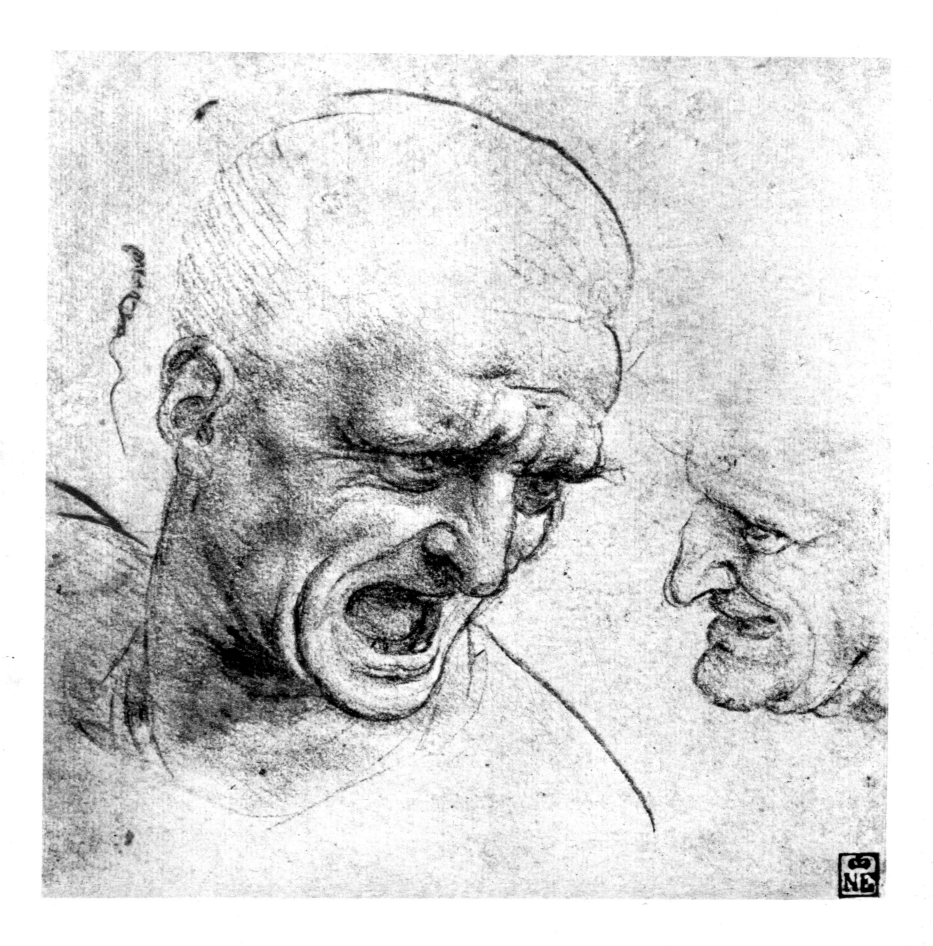

93 *Head studies*, ca. 1503–1505
Metalpoint, black chalk and red chalk on paper,
19.1 x 18.8 cm (facsimile)
Galleria degli Uffizi, Gabinetto dei Disegni e delle
Stampe, Florence

The two head studies show two different facial
expressions of soldiers who are experiencing the same
moment of the greatest possible effort: the decisive battle.
One of them is screaming because of the effort, the face of
the other is distorted. Both studies belong to figures that
were used in the final plan for the *Battle of Anghiari*.

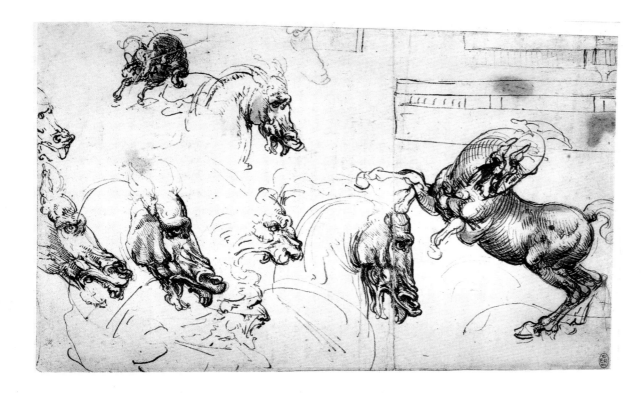

94 Study of horses for the *Battle of Anghiari*, ca. 1503/1504
Traces of black and red chalk, pen and ink, wash on paper, 19.6 x 30.8 cm (facsimile)
Galleria degli Uffizi, Gabinetto dei Disegni e delle Stampe, Florence

The horses' heads have been given expressions of aggressive savagery. The comparative studies of a lion and a man helped Leonardo to understand the characteristic of the facial expressions necessary for this expression. On the right another rearing horse is shown.

From documents we know that he had students and assistants helping him.

On 6 June 1505, Leonardo finally started work on the wall, as we know from one of his own notes. He mentions a bad omen for the work, for at the precise moment when he was about to start work with his brush, a heavy thunderstorm started which also damaged the cartoon. Another misfortune interfered with the project, for sections that had already been completed, and which Leonardo was attempting to dry by lighting fires, ran down the upper part of the painting, as an anonymous Florentine reported before the end of the first half of the 16th century.

After this second stroke of bad luck, Leonardo does not appear to have carried on working with any concentration on the *Battle of Anghiari*. On 30 May 1506, he was officially relieved of the commission, as the French king had in the meantime required Leonardo's services in Milan – a demand that the Republic of Florence was not in a position to refuse. In 1507, nevertheless, Leonardo had to pay a fine of 150 florins for breach of contract. After that, no further work was done on the project.

In 1549, Leonardo's "horses and riders" were still described as "something wonderful" by a visitor to the Palazzo Vecchio. What was really still visible of Leonardo's wall painting in 1557, when Vasari started redecorating the hall, is impossible to say with any certainty. It is possible that only sections of the cartoon and a small panel, showing the main scene and described as the "plan for the group of horses" (ill. 89), were placed on view.

It is not possible to reconstruct Leonardo's work in all its details, even though we know the main scene in his design quite well. As in the case of the *Last Supper* before it, Leonardo appears to have based his composition on actual texts. He chose as his main scene a particular

episode during the course of the battle that had been written about, namely the battle of a few riders around a standard. This was on the one hand suited to demonstrating all the horrors of the tumult of battle, and on the other hand, the small number of figures meant it would remain clear (ill. 91). In this way Leonardo complied with the demand he had made in his treatise on painting: "Compositions should not be made cumbersome and unclear by too many figures."

On the other hand, the battle around the standard could be understood as the key scene in a battle, for keeping or losing it was a symbolic sign of victory or defeat. For that reason, it can be assumed that the embattled standard belonged to the enemies of Florence, and to heighten the drama the military leaders of each side were involved in the battle. According to the sources, the names of the Florentine leaders were Ludovico Scarampo and Piergiampaolo Orsini, and those of the Milanese Niccolò and Francesco Piccinino. While the figural composition of the main group can be reconstructed quite reliably, it is only possible to conjecture about the remainder of the painting based on our present knowledge.

An early reference to the work dating from 1510 calls Leonardo's work "the horses of Leonardo." This presents us with the same phenomenon as we have already encountered in the naming of the Sforza equestrian monument: the riders are not identified. It is possible that the horses were depicted so impressively that here, as in the case of the equestrian monument, they were able to represent the entire work. Looking at copies of the scene also makes it quite clear that the concept of imitating men of action and making their state of mind recognizable through their movements was, in this case, extended to the horses (ills. 94, 95). The senseless violence with which the furious horses are fighting and

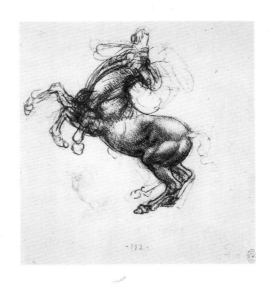

95 *Rearing horse*, ca. 1503/1504
Red chalk and pencil, 15.3 x 14.2 cm (facsimile)
Galleria degli Uffizi, Gabinetto dei Disegni e delle Stampe, Florence

The rearing horse was produced in the context of the first designs for the main scene in the *Battle of Anghiari* in the two Venice sheets (ills. 91, 92). It is an individual study that unites various nature studies of a rearing horse in order to achieve an expressive posture. The impression of movement is created by means of the sequence of forms that are composed of a mixture of roughly sketched head postures and the barest indication of the presence of a rider.

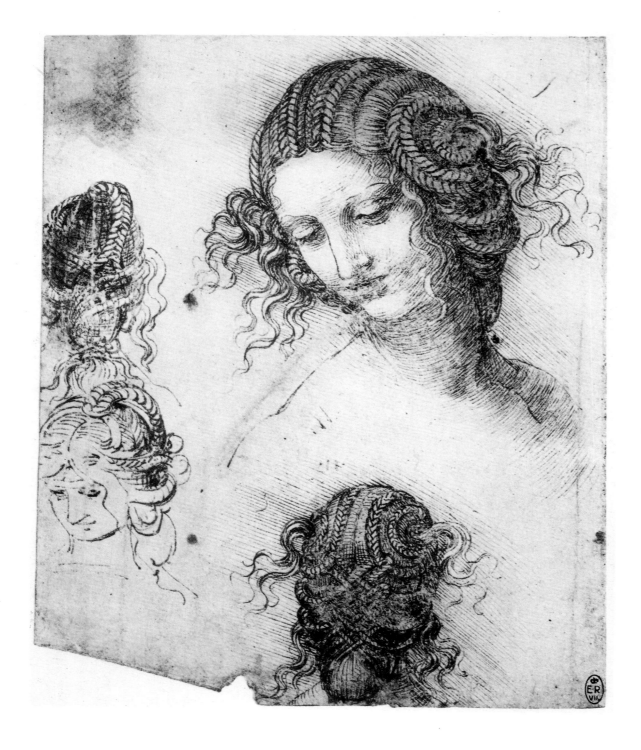

96 (left) *Head of Leda*, ca. 1503–1507
Black chalk, pen and ink on paper, 17.7 x 14.7 cm
Royal Library, RL 12516, Windsor

The skillfully plaited hair is probably a hairstyle invented
by Leonardo. The study of Leda's head and hairstyle
shows a head and neck modelled by means of hatchings
along the lines of the form. Leonardo gradually
introduced this technique into his drawings shortly before
1500. Previously he had predominantly used parallel
hatchings.

97 (below) Study for a kneeling Leda, ca. 1503–1507
Black chalk, pen and ink on paper, 12.6 x 10.9 cm
Boijmans Van Beuningen Museum, Inv. 446, Rotterdam

Leda, the wife of the king of Sparta, was seduced by Zeus
in the form of a swan. She gave birth to two eggs from
which hatched Helen, Clytemnestra, Castor and Pollux.
This and a second compositional plan in Chatsworth
show the kneeling Leda gently embracing the swan. With
her right hand she is pointing to the children.

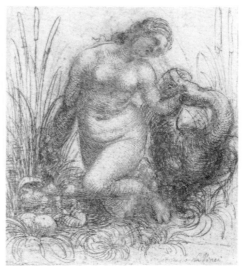

biting each other translates the madness of battle to a
bestial dimension in which reason has been utterly
extinguished by the heat of the moment.

"When you, poet, depict a bloody battle, is one con-
fronted by murky air, darkened by the terrible smoke of
murdering machines, which mix with the dense dust
that shrouds the sky in gloom, and in the midst of fleeing
wretches, frightened by gruesome death? In such a case
you are surpassed by the painter, for your pen will have
been worn out before you have fully described what the
painter, using his science, can place directly before your
eyes."

This passage from Leonardo's treatise on painting is
enlightening in two respects. First of all, it clarifies the
analytical distance between the artist and his subject.

The horrors of war which he describes serve principally
as an argument in the debate on the supremacy of the
arts. Secondly, the quotation suggests something that
the Codex Madrid, which was rediscovered in 1965,
confirms. In this painting, Leonardo was increasingly
occupied with the problem of aerial and color per-
spective, which he could use to create a sense of depth
even without a vanishing point. Aerial perspective is the
term used to describe the increasing loss of detail in
objects as distance increases, up to the point where form
dissolves. He used the term *sfumato* to describe the
desired blurring between the surroundings and the hard
outline of the subject depicted. This term would from
then onwards play its part in the history of painting.
Color perspective is characterized by the proportionally

98 (opposite) School of Leonardo
Leda, ca. 1508–1515
Oil on panel, 130 x 77.5 cm
Galleria degli Uffizi, Florence

Leda is looking at her twins hatched from one egg while
with her arm she is lovingly embracing Zeus, the father of
her children, in the form of a swan. Three paintings, in
the style of Leonardo, of the standing Leda are known
which can be closely connected to a cartoon produced by
Leonardo which has not been preserved. It is uncertain
when this cartoon was created and when the versions
dependent on it were produced.

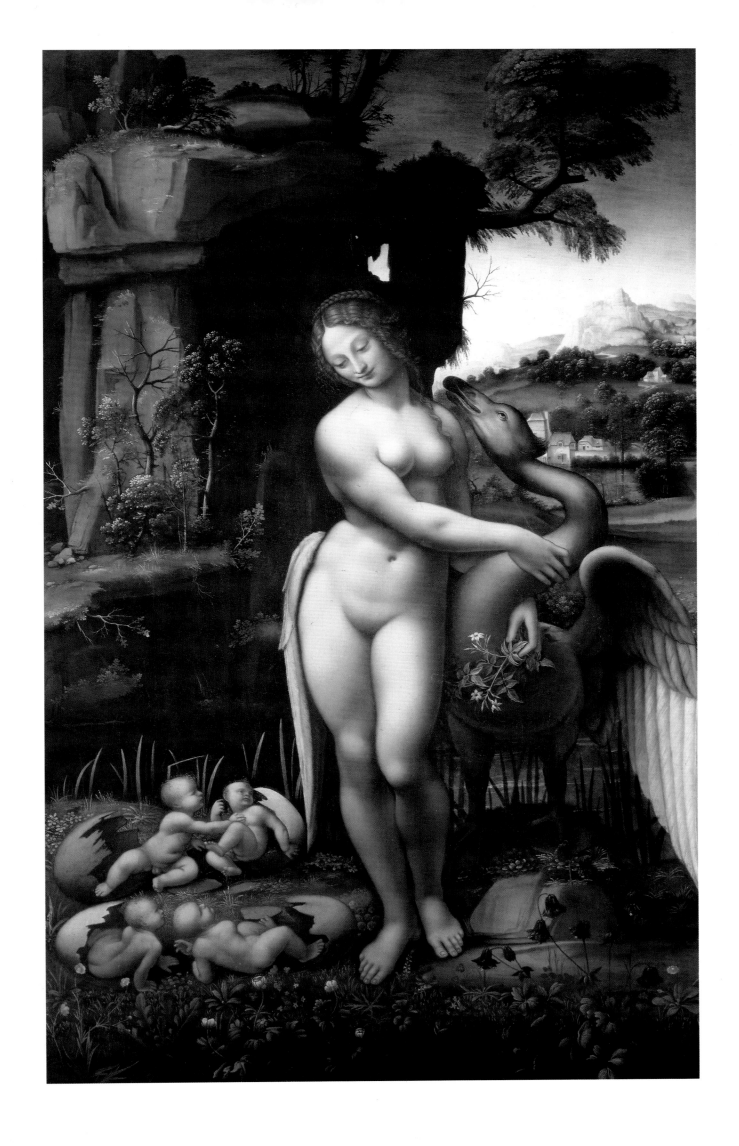

99 (below) School of Leonardo
Leda: twins and egg shells (detail ill. 98), ca. 1508–1515

In contrast to other variations of this theme in which
Leda is a proud mother presenting her children to the
swan, the process of birth has only just occurred in this
painting. The cracked eggs which the pairs of twins have
just hatched out of lie on the ground on either side of
Leda, and they are gazing at their mother.

The details depicted here show the difference between
works by the School of Leonardo and the few Leonardo
originals.

100 (opposite) School of Leonardo
Leda (detail ill. 98), ca. 1508–1515

The composition of the upper part of the group is
determined by a play of curves and contrasting turns, and
the contrapposto motif of the standing Leda develops
from this: the swan has turned his head up towards Leda,
full of desire; her body is turned towards him and she is
embracing him with her arm, but her head is to one side,
looking at her children. In a manner comparable with the
Mona Lisa (ill. 119), the position of the corners of her
mouth suggest she is smiling, and in the case of Leda this
can be interpreted as a shy agreement to what is
happening.

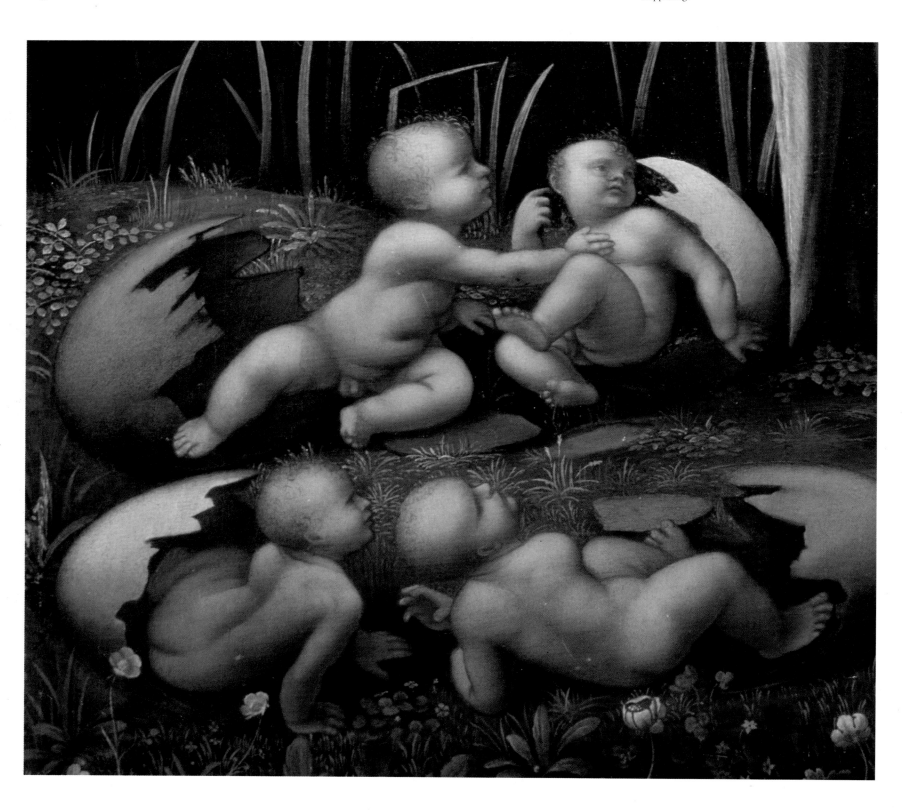

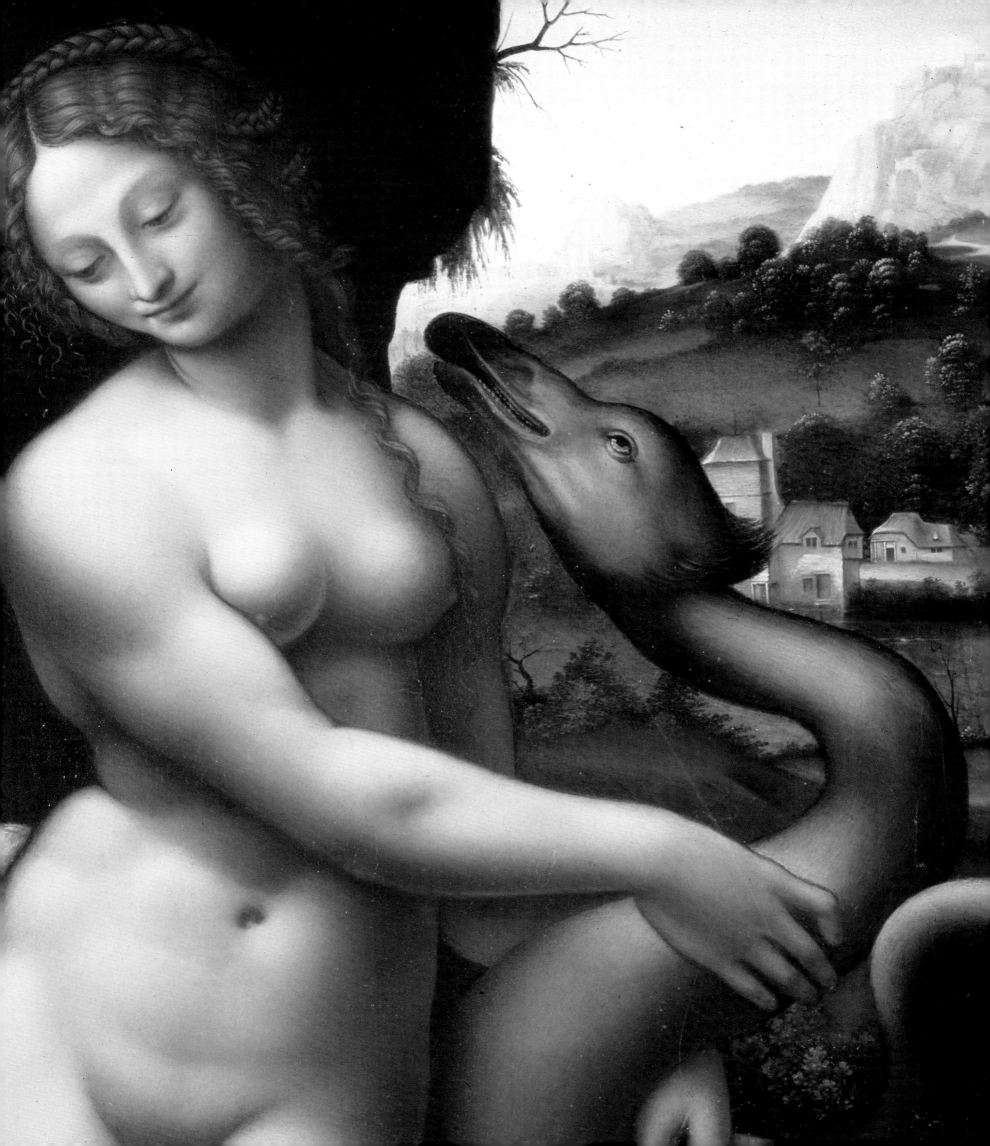

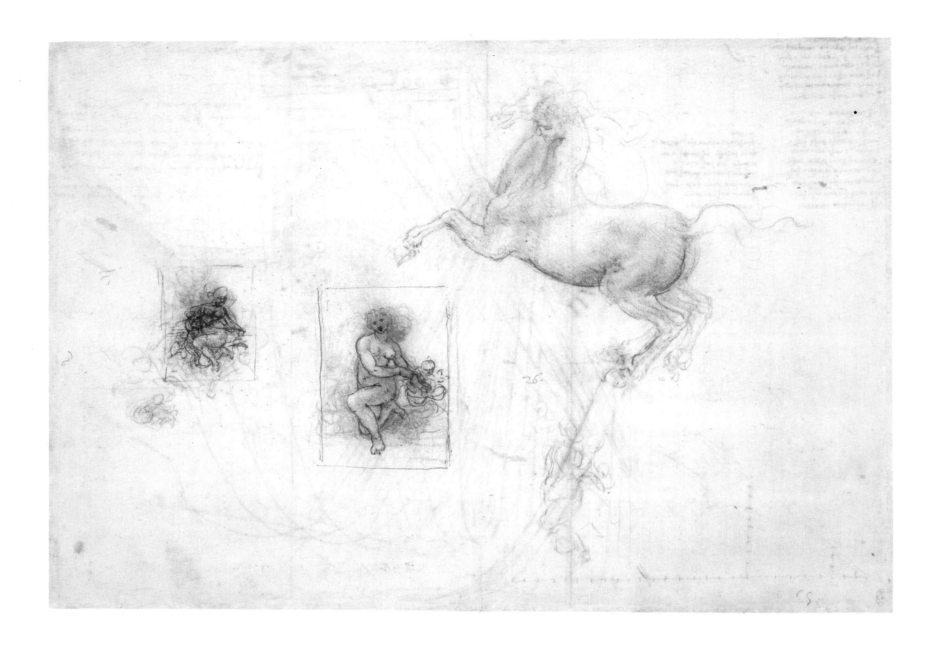

101 (above) Studies of Leda and a horse, ca. 1503–1507
Black chalk, brush and ink on paper
Royal Library, RL 12337r, Windsor

The sheet shows several stages in the development of the
composition of the kneeling Leda. The drawing on the
left was recently interpreted as a sketch that is actually a
composition showing St. Anne, Mary, the Christ Child,
St. John and a lamb. It is by no means impossible that
Leonardo would have transferred figures designed for a
Christian to a mythological pictorial theme. The horse
study provides the means for dating the theme of the
kneeling Leda to the same period as the *Battle of Anghiari*.

102 (opposite) Female head *La Scapigliata*, ca. 1508 (?)
Oil on panel, 27 x 21 cm
Galleria Nazionale, Parma

The face of *La Scapigliata* is more powerfully executed
than that of the standing Leda (ill. 98), though her head
is bowed in a similar manner. Given the lack of
accessories, it is possible that this face with its thoughtful
gaze belongs to a Madonna. The effectively placed
powerful brushstrokes in the hair are unusual for
Leonardo and possibly a later addition.

decreasing intensity of colors as distance increases.
Leonardo did not appear to feel that geometric
perspectival construction was suited to depicting a
landscape and, in addition, not particularly helpful
given the actual spatial conditions in the Sala del Gran
Consiglio, as the distance between the observer and the
wall painting was very small, and a geometrical con-
struction would, upon viewing, have automatically
created stronger distortions at the edges of the picture.

The sketches that were produced in connection with
the *Battle of Anghiari* also include other designs. Of
particular interest within the framework of Leonardo's
activity as a painter is a sheet which shows several
versions of both a rearing horse and a kneeling naked
woman with small children (ill. 101). When compared
with another study the kneeling woman can be
identified as *Leda* (ill. 97).

She was the queen of Sparta who was seduced by Zeus
in the form of a swan; she then gave birth to two eggs
from which hatched the twins Castor and Pollux as
well as Helen and Clytemnestra. The legend is not

unambiguous, however, so that the number of children
produced by the union varies, being either two, three or
four. The Leda on the Rotterdam drawing is a proud
mother presenting two children to the swan (ill. 97),
while a design at Chatsworth shows four children. Leda
is kneeling in order to be in a better position to face Zeus
in the form of the swan. One of Leonardo's circle
produced another variation of the Leda composition
(ill. 98), in which the problem of the varying body sizes
is solved by placing the swan on a small stone. The
picture of the standing Leda has a contrapposto motif
in which the entire body weight is placed on an engaged
leg and the free leg merely appears next to it. This motif,
so popular in classical sculpture, only appears in its
classic form in Leonardo's work in this design.

As was the case with the *Madonna with the Yarnwinder*
(ill. 83), which only exists in the form of "workshop
originals", it is not certain, where the Leda pictures
are concerned, when these paintings were produced,
whether Leonardo himself worked on them or whether
they were produced by students in his workshop

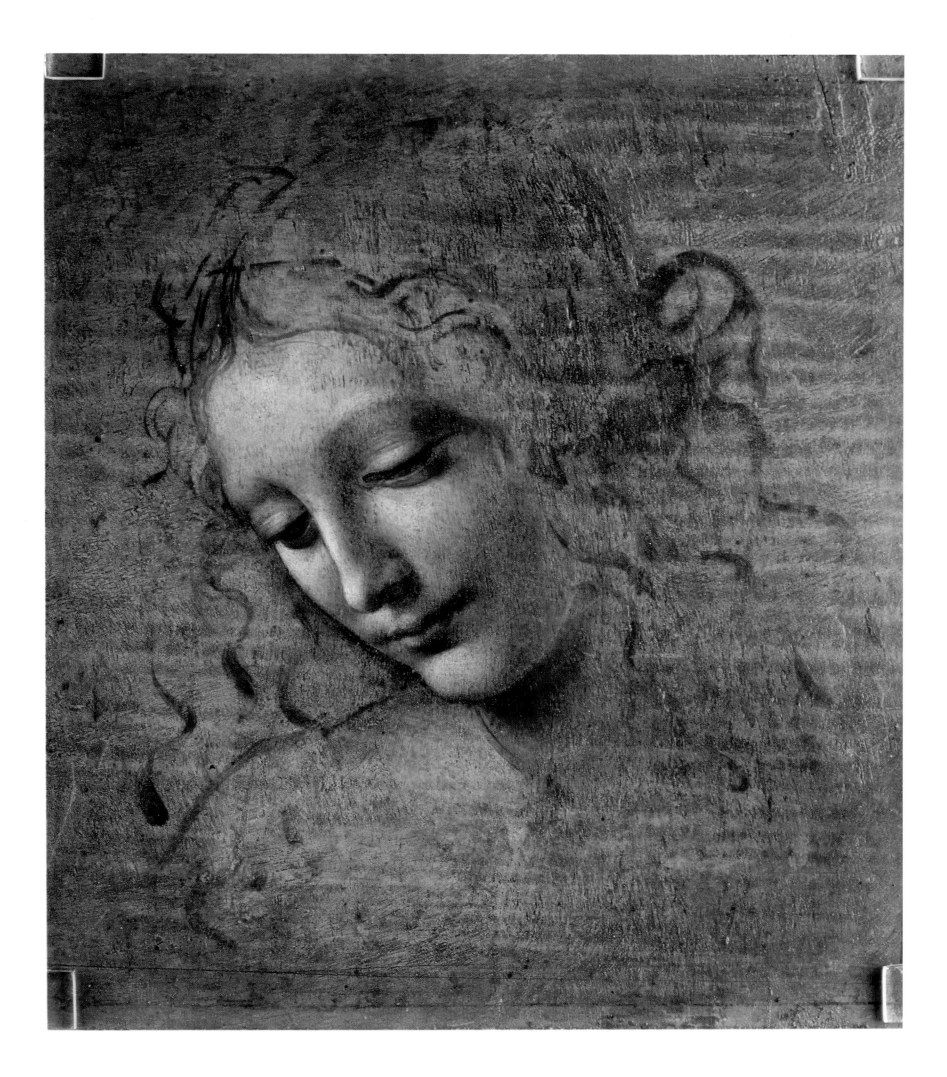

103 (left) Design for *St. John in the Wilderness*,
ca. 1508–1515
Red chalk on paper, 24 x 18 cm
Formerly Museo del Sacromonte, Varese

In its seated motif, the figure of St. John the Baptist is
reminiscent of classical sculptures. The clear gesture made
with the right hand, the rhetorically slightly bowed head
and the way it is turned towards the observer suggest
Leonardo to have been the author of this drawing,
especially as the head is more vivid than that in the
painting in the Louvre. In 1974, the drawing was stolen
from the museum and has disappeared, making it difficult
to judge nowadays.

104 (opposite) School of Leonardo
St. John in the Wilderness (Bacchus), ca. 1508–1515
Oil on panel transferred to canvas, 177 x 115 cm
Musée du Louvre, Paris

The Baptist, crowned with a laurel wreath, wearing a fur
garment and carrying a staff, is with his left hand possibly
pointing to a spring and holding a bunch of grapes. The
fur and staff can be interpreted as attributes of the
Baptist, and the fruit and laurel wreath as ones belonging
to the classical god of wine. Given the poor state of
preservation of the work, it is difficult to decide whether
the laurel wreath and grapes were actually part of the
original composition. There is at any rate a text that
equates St. John with Bacchus: the "Ovide moralisé" by
Pierre Bersuire, dating from the 14th century. A design
for the painting shows the naked St. John, though
without the attributes of Bacchus (ill. 103). This painting
was presumably produced by Francesco Melzi in
Leonardo's workshop.

working from drawings and compositional ideas he had created. There was probably never an original version by Leonardo, though a study of the *Head of Leda* (ill. 96) still exists. Here it is possible to make out very nicely how Leonardo's comprehensive requirements of painting should be understood: while only the frontal view of this woman's head would appear on a painting, he wanted to make sure that the arrangement of the complicated braids at the sides was depicted properly, and therefore also made a drawing of the back view of the hairstyle in order to completely clarify the position of the plaits.

It is not absolutely clear where the Leda compositions were produced. While works on this theme are on sheets relating to the *Battle of Anghiari* (ill. 101), in May 1506, the artist was summoned away from the rather unfortunate beginnings he had made in the Palazzo Vecchio, to go to Milan and work in the service of Charles d'Amboise there. During the six years he stayed in Milan, he appears to have been less involved in painting; at any rate there are scarcely any sources telling us of such work. In just one letter does Leonardo mention that he is currently working on two Madonnas for the French king. It has been suggested that the unfinished woman's head of *La Scapigliata* (ill. 102) in Parma is associated with this.

With regard to the way the head is bowed, this woman's head can be linked with the standing Leda compositions (ill. 98), though the shoulders do not match with those of Leda. The face could equally well be associated with the Madonna paintings (ill. 51). This work is probably an individual work as it cannot conclusively be attributed to any group of works and, for the same reason, can also not be dated more precisely.

105 (left) *Star of Bethlehem and other plants*, ca. 1505–1507
Pen and ink over red chalk on paper, 19.8 x 16 cm (facsimile)
Galleria degli Uffizi, Gabinetto dei Disegni e delle Stampe, Florence

Leonardo's depiction of the "Star of Bethlehem" plant has moved away from a previous nature study and stylizes the structure of the plant. The flowers are growing out of a draped ring of leaves. This plant appears in both studies of the kneeling Leda. Growth and birth were not merely the theme of the Leda compositions, but reflected the more general interests of Leonardo during this period.

106 (opposite) *Storm over a landscape*, ca. 1500
Red chalk on paper, 20 x 15 cm (facsimile)
Galleria degli Uffizi, Gabinetto dei Disegni e delle Stampe, Florence

We can see over a plain with a town into a valley above which is a low rain cloud, from which rain is pouring forth. The drawing appears to be based on a direct observation and was either produced at the location or from a sketch drawn at the location. Its narrative character suggests it dates from around 1500. Later landscapes are characterized more strongly by other interests connected with Leonardo's projects or scientific studies.

107 *Landscape near Pisa*, ca. 1502/1503
Red chalk on paper, 21.1 x 15 cm
Biblioteca Nacional, Codex 8936, fol. 7v, Madrid

This drawing depicts a precisely identifiable range of hills in the Pisa mountains near Cascina. This topographical record should be regarded as a preparation for a map of a canal project which Leonardo developed for the Florentine Signoria. The intention was to create a navigable trade route from Florence to the ocean.

NATURE STUDIES

During classical times, plants were studied mainly because of their healing powers, but during the Christian Middle Ages a symbolic dimension was added to this. For example, the lily appears as a symbol of the purity of Mary in paintings of the Annunciation. This is the context within which a drawing by Leonardo which he produced in connection with his early panel of the *Annunciation* (ill. 25) must be seen. Even in the *Madonna of the Rocks* (ill. 51), he was still using symbolic plants to extend the visual syntax. Not until the 1490s in Milan does his awakened interest in anatomy and proportion, visible in his studies of horses (cf. ill. 57), also appear to have fundamentally altered his study of botany.

In order to understand the processes of genesis and growth, Leonardo moved his attention from the appearance of the shape and began to investigate the influences on plants of light, earth and water. During the course of this he observed that plants turn to the light when growing. This perception proved to be a law

which, amongst other things, enabled him to draw botanically accurate treetops. Furthermore, he grew to realize the importance of water for the nutrition of plants and, in addition, was able to explain the various shapes of roots in terms of the varying capacity of soils to store water.

His scientific insights were also useful to Leonardo in his paintings. The drawing of the *Star of Bethlehem and other plants* (ill. 105) is an eloquent example of the artist's method of working. The red chalk drawing which was first made on the paper may reproduce an observed plant, but the artist goes over his work with pen and ink. He drew a formalized crown of leaves from whose center the flowers shoot out. Botanical accuracy is contrastingly combined with the artistic principles of composition such as rhythm and proportion. Consequently, the finished drawing is not a copy of reality, but combines decoration and liveliness in order to present both the botanist and the art lover with a sheet of great beauty.

The function of the drawing of the *Birch Copse* (ill. 109) is uncertain. It almost certainly comes from

108 (left) *Bernina Alps*, ca. 1511
Red chalk on red primed paper, 15.8 x 23 cm
Royal Library, RL 12414, Windsor

The sheet is part of the so-called "red series" that derives its name from the red coloring of the paper. The form of the two mountain chains suggests that they are part of the landscape around Lake Como. The hand-written notes are on the treatment of vegetation, which is also a subject discussed in the treatise on painting.

109 (below) *Birch copse*, ca. 1500
Red chalk on paper, 19.3 x 15.3 cm (facsimile)
Galleria degli Uffizi, Gabinetto dei Disegni e delle Stampe, Florence

The drawing is a nature study showing a stretch of observed mixed woodland, carried out in red chalk, a soft drawing medium suited to reproducing light and shade. The format of the page and the placing of the drawing and the text on the rear side suggest that the sheet was originally part of a notebook. Sketches of trees can also be found in the Paris Manuscript L dating from 1498 to 1502. The sketch on sheet 81v is very closely related to this drawing in terms of style.

110 (below) *Deluge over a city*, ca. 1517/1518
Black chalk on paper, 16.3 x 21 cm
Royal Library, RL 12385, Windsor

The forces of nature are descending on a city with considerable force. The theme of the Deluge may have been suggested by reports of the catastrophe in Bellinzona in 1515. "For in our own age something similar has been seen, a mountain fell seven miles across a valley, closed it off and created a lake," as Leonardo noted in connection with a discussion about the creation of the Red Sea.

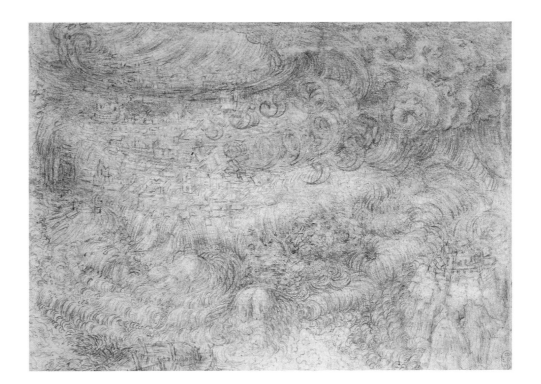

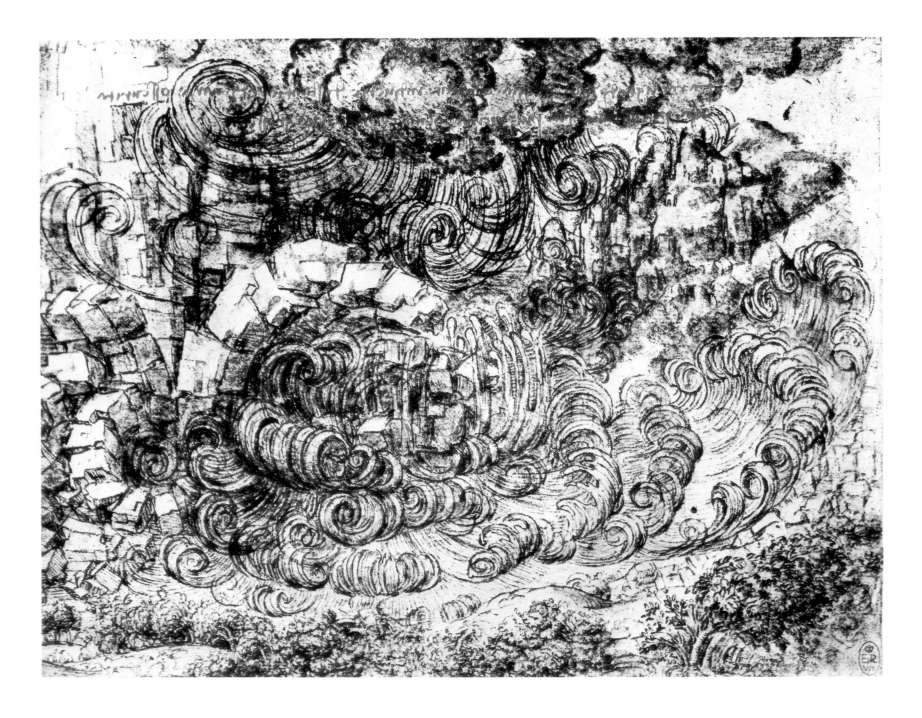

111 *Natural disaster*, ca. 1517/1518
Black chalk, pen and ink on paper, 16.2 x 20.3 cm
(facsimile)
Galleria degli Uffizi, Gabinetto dei Disegni e delle
Stampe, Florence

The formalized depiction of a natural disaster continues
what Leonardo had begun in his diagrammatical
depictions of water. He depicted the forces at work in
water and in the air, the results of his own basic research.
Here the artist had become a scientist. The drawing
proves Leonardo's advanced knowledge in this field.

one of the numerous codices which Leonardo kept from
his time in Milan onwards. On the one hand, it may be
an observed piece of woodland, on the other hand,
it might also have been intended as an illustration for
a treatise. Given its almost impressionistic character,
the sheet may equally have been an exercise for
panel painting. For in contrast with Sandro Botticelli
(1444/45–1510), who in Leonardo's words created
landscapes by enthusiastically throwing a sponge soaked
in paint against the wall, Leonardo himself in his treatise
on painting required a painter who took his profession
seriously to study the landscape with the same care that
he devoted to his figures.

In that respect, the sheet showing a *Storm over a
landscape* (ill. 106) is unusual, because it goes beyond
the character of a nature study. It must surely have been
an interest in the phenomenon of meteorology that was
the decisive factor in its creation. But its compositional

unity and careful formulation bring the sheet closer
to the status of an autonomous drawing. From Vasari
we know that, while Leonardo was still alive, collectors
were already gathering his studies. Its narrative and
descriptive individuality differs from later landscape
sketches which were created in connection with other
projects. For example, the *Landscape near Pisa* (ill. 107),
which is sketched with just a few strokes, was created by
Leonardo in connection with the ambitious project of
the Florentine republic to free itself of its dependence
on Pisa's harbor by building a navigable canal with its
own access to the sea.

Leonardo dealt with themes that had been considered by engineers before him and usually also written about in treatises. His flying machines are part of a tradition which appears to be as old as the dream of flying itself. Nonetheless, Leonardo the engineer remains an extremely exciting figure, for his method of developing machines is one that can still be called exemplary today.

Leonardo's starting point was what today would be considered the rather naive idea that one only needed to imitate the wing beats of birds with a machine in order to be able to take to the air. The power of the human body was to provide the energy to achieve this. Starting with older ideas on how a flying machine must function, he searched for a good solution as to how the power of man could be transferred to a functioning mechanism in such a way that the machine would simulate the beating of wings (ill. 117).

Leonardo made an important developmental step forward between 1503 and 1506, when he started to make a systematic study of the flying movements of birds and investigated the anatomy of the wing. This method of finding solutions for a technical problem in nature is now the basis for a separate branch of science, known as bionics.

At the beginning of the 16th century, Leonardo also studied general forms of movement in nature and understood that motion was the result of force and counterforce. A bird's wing had to meet with resistance in order to be able to create movement. That is why he also wanted to study the element of air. As air is not visible, however, he resorted to an astonishing thought: "The science of the winds can be recognized in the movement of water, and such a science provides us with a measure for the behavior of flying bodies in the air and the wind."

Such analogous thought was at first not anything exceptional, for an important principle of the understanding of the world before the modern era depended on treating man as a microcosm, a universe within himself, and the outside universe, the macrocosm, as equivalents. For example, Leonardo had begun by equating the circulatory system in man with the Earth's water cycle. However, his nature studies did not confirm this naive analogy when it came down to concrete questions such as the reason why water and blood flowed. There were several possible causes of the first principle of life, motion, and Leonardo got to know them from classical treatises, understood them by means of his observations and experiments and comprehended their universal validity. It was not until he had this understanding of the laws of nature that he was, after 1500, able to conceive a mechanistic conception of the world that saw laws of nature at work in the entire universe.

Leonardo conducted extensive studies of water. As a canal engineer (ill. 116), he built canals, bridges and locks and therefore had to understand the effects of forces such as whirlpools, surface eddies and rates of flow, as these had an effect on the direction of flow (ill. 114). Comparable phenomena can also be observed in the air,

112 (above) Detail of *Skis with which one can walk on water*, ca. 1480
Metalpoint, pen and ink on paper
Biblioteca Ambrosiana, Codex Atlanticus, fol. 7r, Milan

Leonardo frequently sketched ideas that represented technical applications of known laws. The counterpressure of the water makes it possible to walk on water with a type of ski. The sticks are meant to stabilize the man and enable him to move forwards by using the power of his arms.

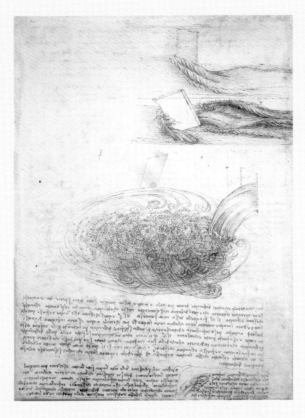

113 (far left) Study of water, ca. 1513
Pen and ink on paper, 15.4 x 21.6 cm (facsimile)
Galleria degli Uffizi, Gabinetto dei Disegni e delle Stampe, Florence

Even when Leonardo was working on technical subjects, he never lost sight of his interests as a painter: the water studies, and the note in which he comments on similarities between the fall of the hair and the movements of the water, appear to have been expressed visually in the hair of the *St. John the Baptist* in the Louvre (ill. 123).

114 (left) Studies of water, ca. 1509–1511
Pen and ink on paper, 29 x 20.2 cm
Royal Library, RL 12660v, Windsor

The study shows surface currents, whirlpools and eddies such as those created when a jet of water pours into a quiet pool. At the top of the page Leonardo examined the eddies created in flowing water if a board was held in the water by either its narrow or wide side. These studies were part of his basic research and enabled him to develop his projects for the construction of canals. He did, however, recognize that similar eddies and vortices are created in the air when cold and warm winds or layers of air meet each other.

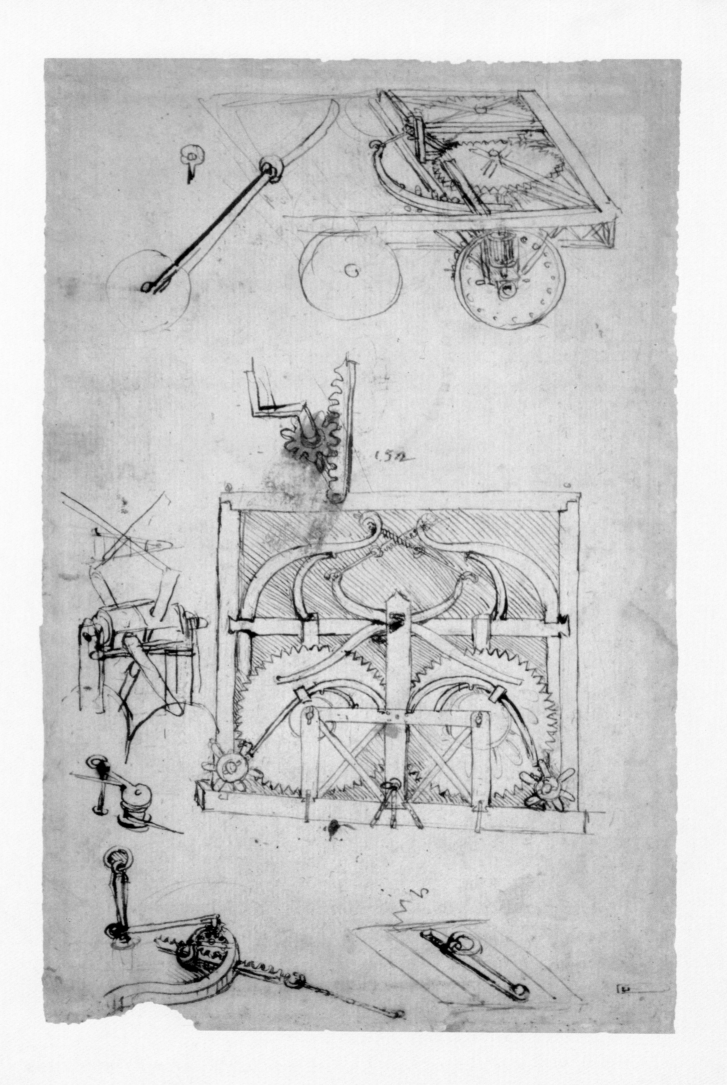

115 (opposite) *Automobile*, ca. 1478–1480
Metalpoint, pen and brush on paper, 27 x 20 cm
Biblioteca Ambrosiana, Codex Atlanticus, fol. 812r,
Milan

The automobile that Leonardo attempted to power with a
modified clockwork mechanism is one of his best-known
inventions. It was not, however, an invention in the strict
sense of the word, for other engineers before him had also
made attempts to produce a self-powered vehicle. It is
probable that Leonardo was familiar with these studies,
though it is remarkable how intense Leonardo's research
of this technical phenomenon was.

116 (above) *Canal bridge*, ca. 1495
Pen and ink on paper, 27 x 20 cm
Biblioteca Ambrosiana, Codex Atlanticus, fol. 126v,
Milan

On this sheet, Leonardo designed a canal bridge crossing
over a second water course flowing beneath it. A lock
would be used to enable a ship to pass from one to the
other despite the height difference.

117 (right) *Manuscript page on a flying machine*,
ca. 1487
Metalpoint, pen and ink on paper, 23.5 x 17.6 cm
Institut de France, Codex B, fol. 180r, Paris

Next to the car, the flying machine was one of mankind's
great dreams and it is, therefore, not surprising that the
inventive Leonardo should have devoted himself to this
problem as well. His flying machines underwent several
developmental stages. The machine illustrated here was
meant to be powered by the muscle power of a man
standing upright. He had to move the pairs of wings, that
beat crosswise on top of each other, up and down like
those of a bird. If built, the machine would have been so
heavy that it would have been completely unsuitable for
flight. Leonardo recognized this problem and attempted
to reduce the weight by using lighter materials.

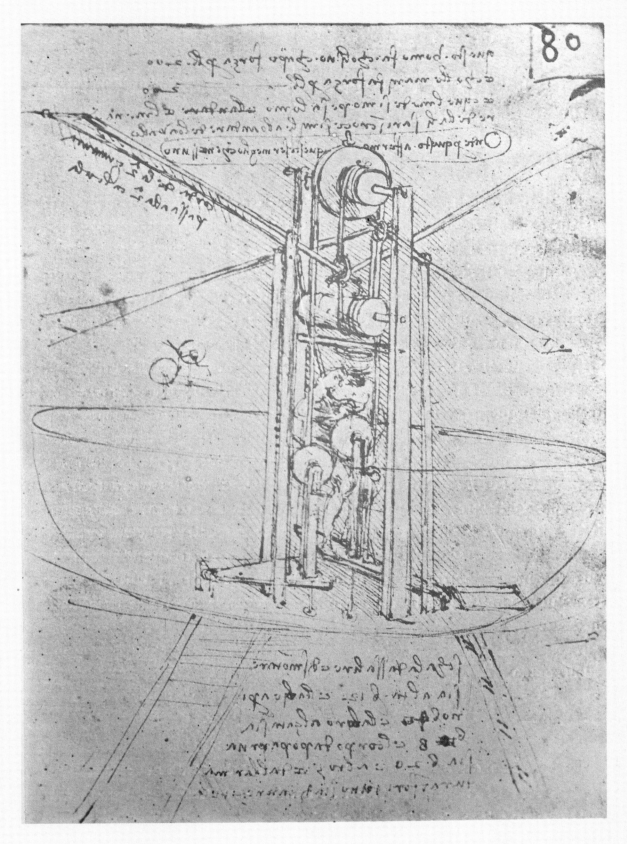

when for example warm and cold air meet, mix and create
eddy-winds and vortices. The science of winds, which
Leonardo studied by observing water, helped him to
understand air thermals. In the end he was convinced
that, like the large birds, one had to use air thermals in order
to fly.

Leonardo therefore independently developed the naive
conception of flying as a "beating of wings" by means of
a systematic investigation right to the principle of gliding.
Nonetheless, he was not to fulfill his dream of flight, for he
could find no way of transporting his flying machines to
those areas where one could make use of thermals.

OCCUPIED MILAN AND THE ROME OF POPE LEO X 1506–1516/17

118 Studies of the Villa Melzi and anatomical study, 1513
Pen and ink on paper
Royal Library, RL 19077v, Windsor

The page of anatomical studies bears the date 9 January 1513 and also contains architectural studies of the Villa Melzi in Vaprio d'Adda, where Leonardo stayed in 1513. The estate belonged to the family of Leonardo's student Francesco Melzi. The note "Room in the tower in Vaprio" and the plan of the layout of the fortress of Trezzo prove that he stayed in Vaprio, as does a group of drawings of river landscapes kept in Windsor, which depict stretches of the Adda river that can still be identified.

Leonardo was summoned from Florence because the French king required his services in Milan. Charles d'Amboise, the French governor in Milan, commissioned him to design a villa, but his sudden death in 1511 ended the project.

In nearby Pavia, Leonardo and Marcantonio della Torre, the professional anatomist at the University of Pavia, started dissecting corpses. Although Leonardo had continually studied the structure of the body in order to be able to depict the human figure properly, this collaboration raised his research to a higher scientific level that showed itself in the quality of his drawings (ill. 118). A single sheet deals with various stages of dissection, and next to them are schematic drawings which clarify the functional connection of muscles or tendons (cf. ill. 4, top right). In these studies it is no longer merely a question of discovering what physically exists; instead, the interplay of bones, muscles and tendons comes to the fore.

Leonardo made the following note with regard to a planned publication of his studies (ill. 4): "Power is created by mental movement. For while this movement is running through the limbs of sensitive creatures, they cause their muscles to swell; for that reason, these swelling muscles become shorter and tighten the sinews which are connected with them, and this creates power in human limbs." (Codex Arundel, fol. 151).

The studies of embryos (ill. 126) is one of Leonardo's most impressive anatomical drawings. It is certain that Leonardo did not dissect a pregnant corpse; instead he applied his examinations of animal embryos to humans. The function and structure of the unborn child was more important to him than the possible reproductive nature of the uterus.

As an autopsy always destroy layers in order to reveal the tissue beneath, Leonardo developed a method of showing the results of several dissections in a drawing "in an instant" (ill. 118). Leonardo increasingly viewed the drawing as a scientific instrument and from that time on devoted himself more and more to something he had already started in his landscape maps: combining measurement and explanatory depictions in his drawings. He produced landscape drawings showing the course of the River Adda. They combined artistic

interests with optical and engineering investigations. His studies of water, which he intensified in Milan, led him to produce depictions showing something that actually happens, but cannot be perceived in that way by the human eye (ills. 113, 114). Now Leonardo had finally achieved what he required of an artist: that the hand should be guided by understanding.

After anatomist Marcantonio della Torre died of the plague in 1511, Leonardo's practical opportunities for pursuing an intensive examination of corpses probably diminished, but the structure of the human body continued to interest him in his drawings (ill. 118). This sheet proves in an impressive manner how many fields of knowledge the artist was familiar with: thus, for example, drawings of the interior of the abdominal cavity appear side by side with architectural notes.

Leonardo had already studied architecture in the 1490s, even though at the time these were deliberations of a more theoretical nature, such as a new town plan of Milan. Only written sources and sketches still exist of the plan of the dome for Milan Cathedral, produced in competition with Bramante, and they do not give any information about the precise appearance of his design. It was probably not until he worked on the villa for Charles d'Amboise that his study of architecture took on a more concrete form. Whether the plans for the alterations to the Villa Melzi in Vaprio d'Adda in any way corresponded to the wishes of the family, or whether the drawings should be seen merely as a creative examination of the place Leonardo was living in at the time, is not known. At any rate, the project was not carried out either there or at the villa of the French governor.

The most exceptional development in Leonardo's painting took place after he returned to Milan. The portrait of the *Mona Lisa* (ill. 119) and the half length figure of *St. John the Baptist* (ill. 123) were created. They were prepared by means of optical studies in which Leonardo investigated vision with two eyes. There are notes on this subject in Manuscript D, a treatise on optics kept in Paris, as well as an anatomical sheet in Windsor.

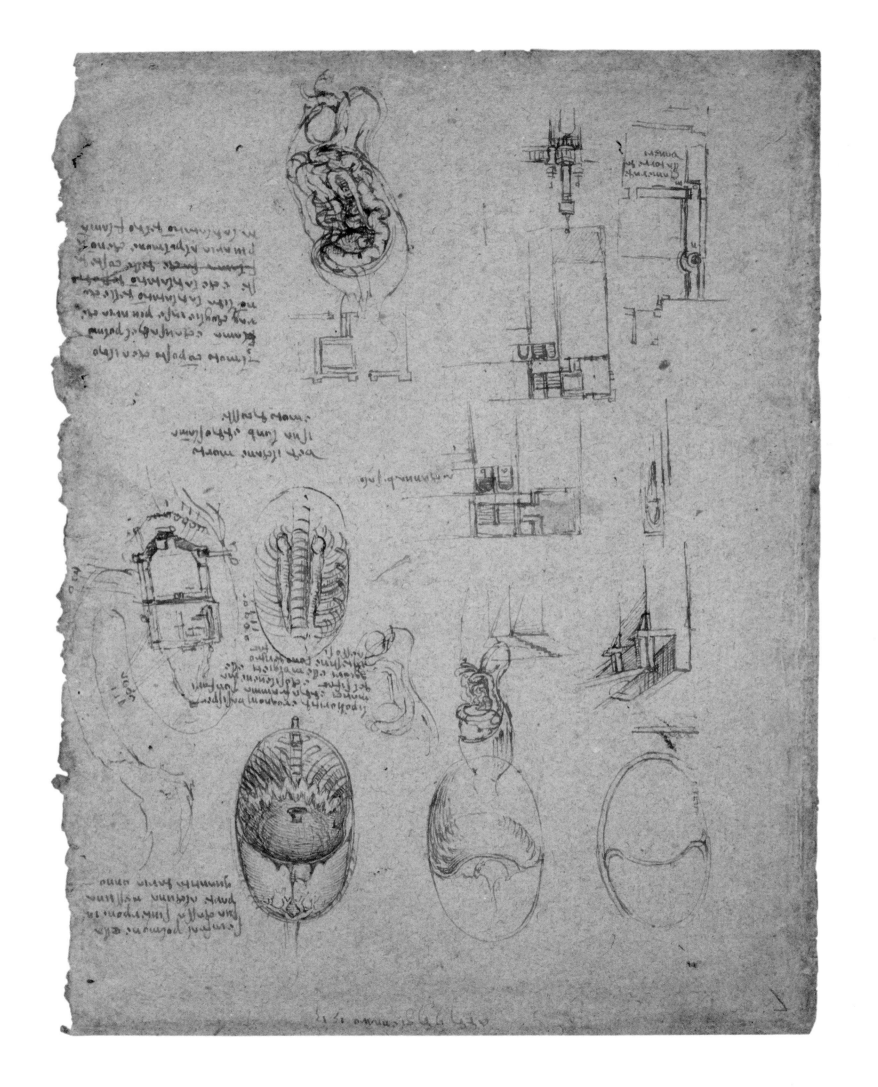

THE MOST DEMANDING IMITATIVE PORTRAIT IN THE HISTORY OF PAINTING

No other picture in the history of European painting is as well known and has whetted people's imaginations as much as Leonardo da Vinci's *Mona Lisa* (ill. 119). Her enigmatic smile has repeatedly given rise to speculation and during the course of the years has become a topos for the magical dimension of a work of art. The exceptional position of the painting has been achieved not least by its technical mastery, which is as admired as its polished composition. But it is also the case that no other work of art has been exploited to such a degree to further a certain conception of art, and nowadays the original almost seems to disappear behind the countless reproductions. After the First World War, Marcel Duchamp was still able to increase people's awareness of the work of art by declaring a Mona Lisa with a mustache to be his work of art. But in 1963, Andy Warhol in his own way criticized the urge to duplicate the Mona Lisa by his silk screened image of her with countless repetitions, and thus posed questions about the original. While it was possible for a Florentine craftsman to steal the panel from the Louvre in 1911 for patriotic reasons, it is now protected from attacks behind armored glass.

The expression of the unknown woman is depicted as softly and sensitively as the flowing of her garment. The naturalness and sensuousness with which her hands are lying on the back of the chair, and their subdued color, create a peculiar and yet harmonious atmosphere that contrasts with the unusual landscape. Beyond this, in this painting Leonardo was attempting to produce something unique: he was simulating "two-eyed vision". It is not only the mysterious smile of the portrayed woman that makes this one of the most famous paintings in the world.

An attentive observer will find the most diverse peculiarities in this painting. First of all, the figural composition is reminiscent of the pyramidal form which was noticeable in both the *Adoration of the Magi* (ill. 46) and the *Madonna of the Rocks* (ill. 51). Here, however, it is produced by just one single figure, and the arms and hands define the spatial base of this pyramid. The three-dimensional appearance of the figure is linked in several ways with the contrastingly flat seeming background. On the one hand, Leonardo continues the arch-like rise of the veil across the left shoulder into the landscape emphasizing the bridge. On the other hand, the curving path on the left is an ornamental pattern that is emphasized in the cloth on both sleeves as a border of light, thus subtly connecting the flat and three-dimensional structures. However, it is really Leonardo's famous *sfumato* which unites the plastic convex figure with the enormous perspectival depth of the mountainous landscape, creating a harmonious whole picture. The unusual rise in the height of the horizon between the left and right sides intensifies the puzzling character of the landscape, which disappears into the diffuse light. Leonardo is a long way from simply painting nature. The refinement and special features of the composition

once again show that a painter who wants to present nature as deceptively as possible does not have to depict it in an identical manner, but has to deceive the observer into regarding what he is seeing as being identical with nature.

The very first question asked when attempting to decipher the painting, regarding the identity of the portrayed young woman, cannot be answered. In his description of the picture, Giorgio Vasari said that the portrayed woman was Mona Lisa, the wife of Francesco Giocondo. However, he cannot have ever seen the picture himself. An anonymous predecessor of Vasari's, in his biography of Leonardo, referred to a portrait of Francesco Giocondo, who was a relatively unimportant silk merchant living in Florence, and whose third wife was Lisa. There are, however, various arguments against the painting having been produced during Leonardo's time in Florence, one being that while he was working on the *Battle of Anghiari* he even turned down a commission from Isabella d'Este, and for that reason it is scarcely likely that he was working for an ordinary merchant. Another is that the depiction of the unusual landscape in the background suggests the work has a later date.

The optical studies, which mainly take on tangible form in the Manuscript D kept in the Paris Institut de France and which cannot have dated from before 1508, are linked to the unusual manner in which the woman in the picture is presented. Leonardo's studies of "two-eyed" vision would not have progressed far enough for the creation of such a portrait to be feasible until he had returned to Milan. This eliminates the possibility that the portrayed woman can be identified as Mona Lisa del Giocondo. It equally rules out the identification as an androgynous being or a disguised self-portrait of Leonardo himself, as has been suggested. It is not certain whether identifying the person involved would indeed be of any assistance in understanding the painting and its visual references any better, for Leonardo's requirements in this painting seem to have gone beyond creating an individual portrait. It is probably the most demanding conception of an imitative portrait in the history of painting.

The technique of creating an object from a combination of the views of the right and left eyes is, for practical reasons, limited to objects that are constructed symmetrically, so that both views can be depicted on the symmetrical axis without creating particularly great displacements. Man is constructed almost symmetrically, and his rounded head is particularly suited to simulating the phenomenon of "two-eyed" sight. The portrait of the *Mona Lisa* was the first occasion on which Leonardo made use of this technique in order to achieve a heightened level of *rilievo* (ill. 119). He first portrayed the lady with his right eye and decided that this view should be the main one, or in other words, he did not place the line of intersection along the center of the nose, but used the entire view of the nose. The shortened left view of the *Mona Lisa* had, therefore, to be trimmed at the center before being added. The distortion thus created can be recognized at the point of transition from

119 *Mona Lisa*, ca. 1510–1515
Oil on panel, 77 x 53 cm
Musée du Louvre, Paris

From the darkness of the foreground, the bust of a woman in a dark garment emerges, culminating in a gentle face that is turned towards the observer. A smile flits across her face, but her gaze suggests a more serious atmosphere. A slight twisting of her neck compared to the three-quarter profile of her bust creates a tension to the outline of her neck, her head is just a little more in profile and almost imperceptibly more vertical. A plain garment swirls about her body, but the fall of the material shows its value. The light is flashing gently across transparent veils. Her only ornaments are a decorative border at her low neckline which is accompanied by a plaited ornament – one of Leonardo's favorite patterns – and the delicate pleats of the valuable material. The woman needs no jewelry, necklace or rings to emphasize her exceptional quality, her natural elegance is enough. Behind her a low wall with two carved columns accentuates the middle distance in order to enable one to gaze into a peculiarly low lying quiet landscape. Only a road snaking to her right and a bridge on the other side show that people have had a formative effect on this inhospitable mountain range.

The woman is sitting on a chair, leaning forward slightly so that her weight when sitting is also spread onto her left lower arm, which is resting heavily on the back of the chair. Her right arm emerges from the depths of the picture, passes through the space and its hand takes its place elegantly on top of her left arm. Its little finger is pressed down by the weight of the relaxed hand, and one can directly sense the gentle tactile experience of the outer fingertip of her ring finger touching the wooden chair back (ill. 122). Her left hand, in contrast, is active and her fingers are grasping the chair back, each finger in a different manner; the little finger has a special role, it is elegantly extended. Gentle light plays on the skin sections and models them so three-dimensionally that they appear alive, surrounded by an atmosphere that thickens increasingly towards the depths of the landscape.

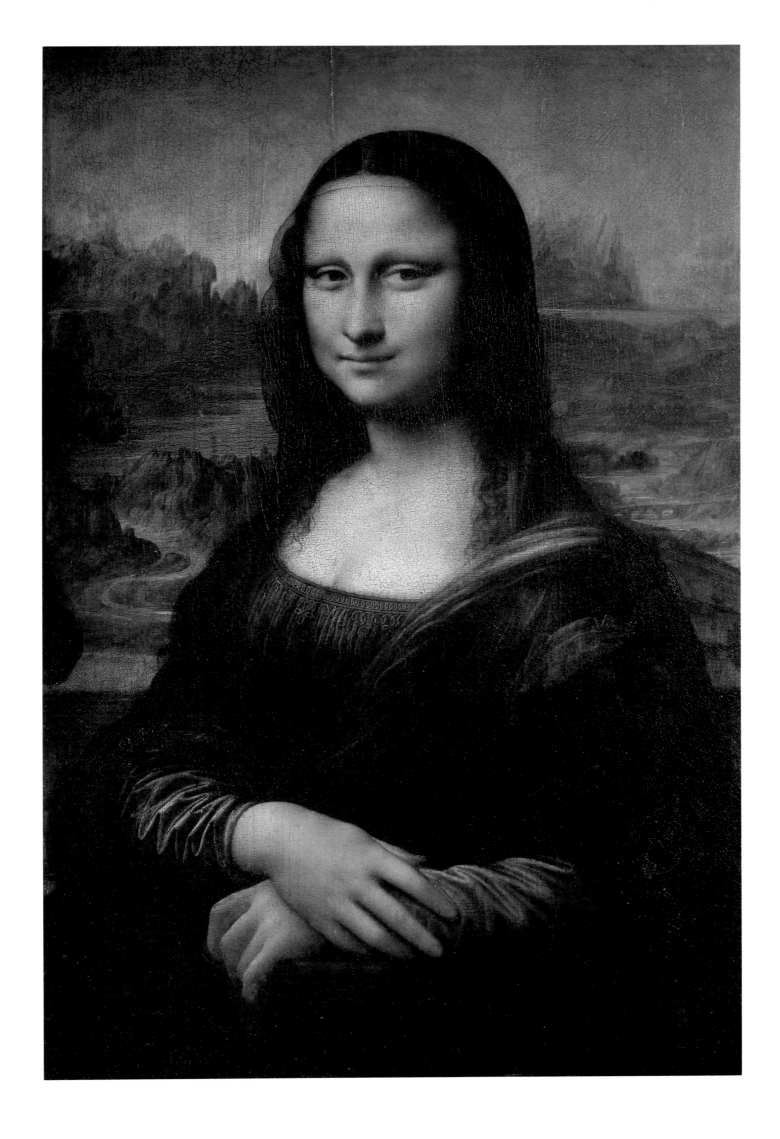

120 (above) *Mona Lisa*: landscape and bridge (detail ill. 119), ca. 1510–1515

In his treatise on painting, Leonardo wrote that in a good painting contours had to become more blurred the further into the background they were. This creates his famous *sfumato*, which makes all things look as if they were seen through a veil. There was nothing new in depicting landscapes as decorative or symbolic backgrounds to portraits, but Leonardo's skill lay in his ability to combine both pictorial elements into one harmonious whole by linking them to each other in various ways. The bridge, for example, is nothing more than a continuation of the archlike rising veil draped across the Mona Lisa's left shoulder.

121 (opposite) *Mona Lisa* (detail ill. 119), ca. 1510–1515

There is a suggestion of a smile both in the Mona Lisa's eyes and on the lips and in the corners of her mouth; it appears unfathomable and mysterious and during the course of the centuries has given rise to any number of interpretations. Giorgio Vasari, writing about the arts, provided an amusing explanation: Leonardo wanted to depict the lady in a happy mood and for that reason arranged for musicians and clowns to come to the portrait sittings. This anecdote was ingeniously supported by the name he gave the portrayed woman: "La Gioconda", which means nothing less than "the merry one".

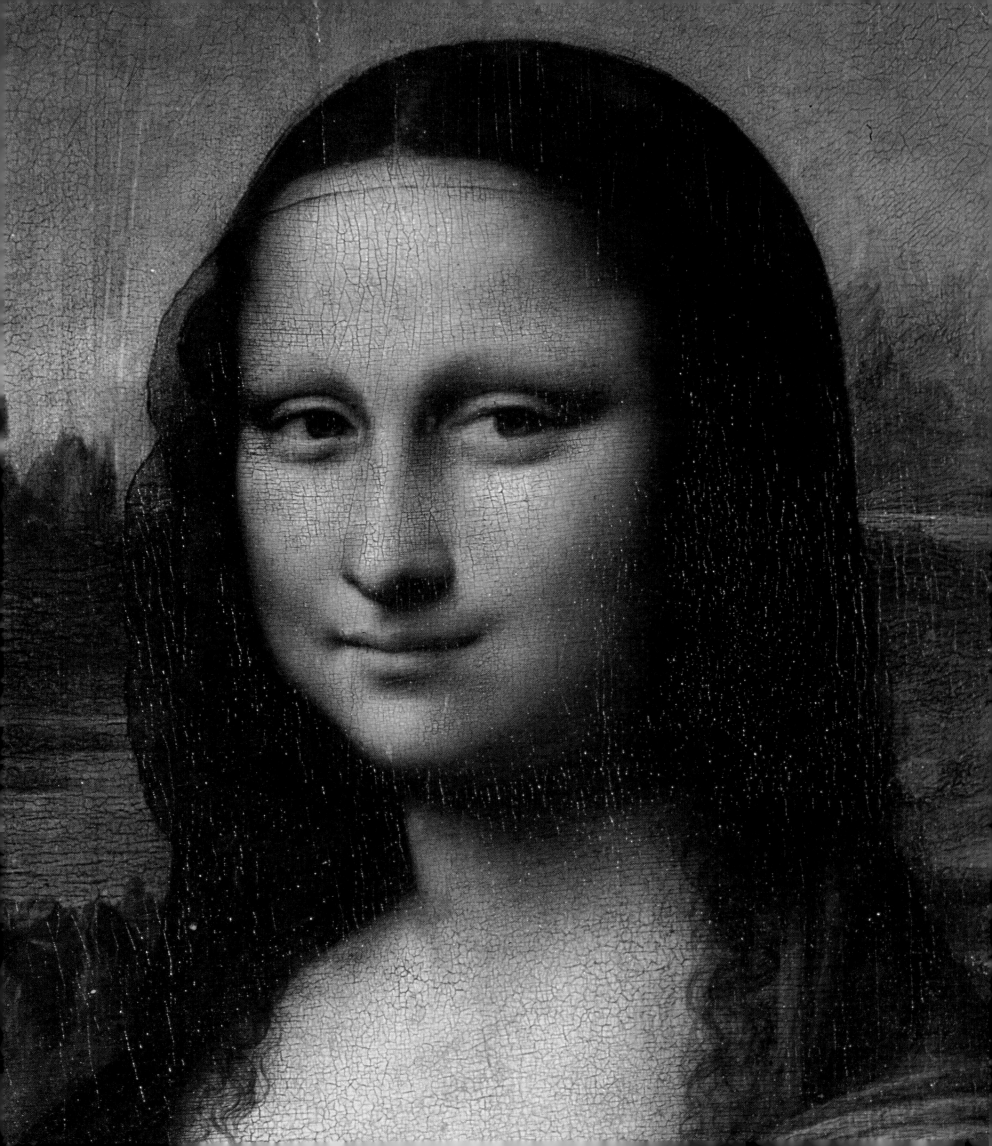

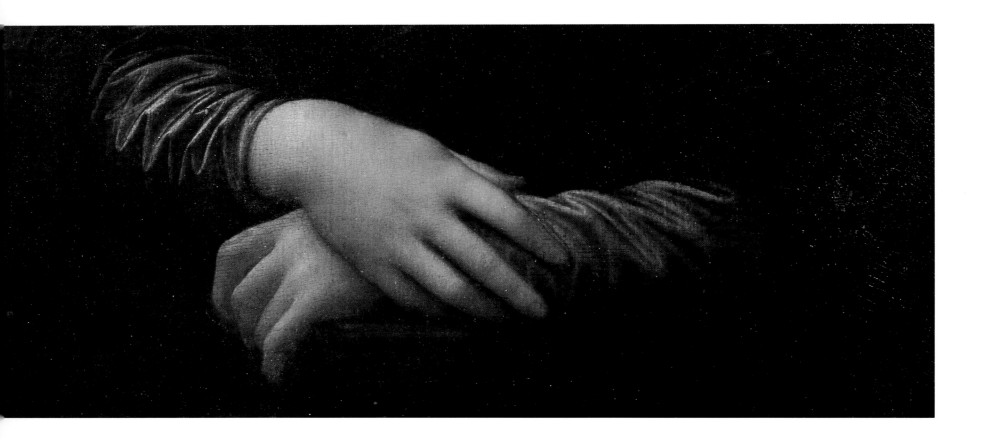

122 *Mona Lisa*: hands (detail ill. 119), ca. 1510–1515

The sensuous quality of the picture is shown particularly well by the hands. The right is resting relaxedly on the left which is gripping the chair back. In his description of the *Mona Lisa*, Giorgio Vasari also praised its vividness, saying that "one could swear that the pulses were beating".

the nose to her right eyebrow, and also on the right side of her mouth that, when looking at the right half of her head in isolation, appears to be foreshortened (ills. 119, 121).

In addition, both the dating of the painting and the place it was created are open to debate; it may have been started from 1508 on in Milan, or later from 1513 in Rome. The picture certainly never left the artist's workshop during his lifetime. In France it was seen in Leonardo's studio by a traveller who thought it depicted a Florentine friend of Giuliano de' Medici. Giuliano's sudden death would explain why the portrait remained with the artist.

After Leonardo's death, the picture disappeared from written records; it may have passed into the ownership of Francis I or, less likely, gone to Milan with Leonardo's servant Salai as an heirloom. There are, however, Italian sources indicating that Francis I owned the picture. The only query is whether he bought it directly from Leonardo or whether it was purchased for him at a later date in Milan.

Vasari was evidently mistaken in his identification of the young woman and the dating this suggested. But his explanation of the enigmatic smile of the Mona Lisa has at least a striking and ingenious persuasive power where its play on words is concerned. The art historian wrote that Leonardo "employed singers and musicians or jesters to keep her full of merriment." In a sophisticated literary manner, this amusing anecdote ties in with the name which he gave the portrayed woman, for "la Gioconda" means "the merry one".

Irrespective of whether this major work was produced during his time in Milan or later in Rome, the work

situation in Milan was definitely very bad for Leonardo. The unstable political situation would certainly have contributed to this to an extent. On a sheet dated 18 December 1511, showing the surroundings of the villa belonging to the Melzi family, the drifts of smoke caused by war are visible in the background. They refer to the retreat of the Swiss troops after attacking Milan on 14 December 1511, and another drawing of a fire on the same sheet relates to a battle that took place two days later.

In 1513, Leonardo turned his back on these uncertain conditions and obeyed the call of his new patron, Giuliano de' Medici, to come to Rome, where the powerful Florentine family of bankers had gained a foothold and from 1513 had provided a pope in the form of Leo X. There is also no evidence of paintings dating from this time, though the artistic climate of the city, and above all the presence of Raphael, will have kept Leonardo's interest in painting alive. At least one painting by his workshop would have been produced during his time in Rome, *St. John in the Wilderness* (ill. 104). The preparatory drawing (ill. 103) can unfortunately, since it was stolen in 1974, only be judged from pictures of it, and in addition, its state of preservation is poor. A youth is sitting on a rock and, with his right hand, is pointing to the spring bubbling up next to him. In his left hand he is holding a staff. The spring can be interpreted as an allusion to baptism, the shepherd's staff identifies St. John the Baptist as a hermit. As in the earlier *Leda*, this is a combination of designs on classical and Christian themes, as the Christian hermit St. John the Baptist is presenting himself naked like the classical god of wine, Bacchus.

In the drawing, the youth's posture is the allusion to classical sculptures, but in the painting by the student attributes such as grapes and a laurel wreath are added in order to underline the ambiguity (ill. 104). Whether they were part of the original conception or were added at a later date can no longer be ascertained by a technical examination of the painting, as the work has been transferred to canvas.

The friendly expression of *St. John the Baptist* (ill. 123) is not quite as puzzling as the smile of the *Mona Lisa*, though the history of its creation is just as shrouded in mystery. Like the picture of *St. John in the Wilderness* (ill. 104) painted in his workshop, Leonardo's own picture is linked to the commission by a Florentine brotherhood of St. John, but like the *Mona Lisa* (ill. 119) it never left the artist's workshop.

St. John is depicted as a half-length figure, turning his upper body to the left while his head is pointing straight at the observer. His face, shoulders and right arm are lit up, and his raised hand is pointing to the staff with the Cross. His left hand is coming from the darkness behind the entire figure into the foreground of the picture, creating an impression of spatial depth. The diagonal line of the picture is formally emphasized by the left hand, where only the fingertips are lit up; this is joined by the way his head is leaning, and at the same time, the fingers are increasing the tactile nature of the leopard-skin which the Baptist is wearing in an unusual manner. The figure is not determined by any tangible line, it blurs as it were in front of its background; the varnish increases this impression of unsharpness. The shoulder-length hair of St. John probably comes closest to demonstrating drawing ability; the treatment of the highlights on his curls is reminiscent of the whirlpools in his studies of water (ill. 113). He is connected to the *Mona Lisa* both by his smile and his gaze, without the same expression having been striven for.

The opportunity of depicting several views in a picture, something that the eye is not capable of achieving simultaneously in the real world, is something that Leonardo began to make use of in characterizing the figures in his paintings. This becomes clear in the picture of *St. John the Baptist* (ill. 123). His right eye is looking at and addressing the observer directly, attracting his attention to him. If, however, one concentrates on his left eye, one gets the impression that this eye is looking diagonally upwards. This gaze is extremely irritating, for St. John appears to have a squint. The figure explains itself to the observer by means of its gazes and gestures.

Visual references guide the observer through the painting. All the things one needs a sequence of words to describe are shown in an instant: "I am St. John the Baptist, God's prophet, who has heralded the coming of Jesus Christ." Thus, the gesture pointing to his chest relates to the eye fixed on the observer, meaning: "I am talking to you." The attribute of the staff with the cross clearly identifies the figure as St. John. The other eye corresponds to the way his finger is pointing upwards, implying that: "He who will save mankind by dying on the Cross will come from heaven."

123 *St. John the Baptist*, ca. 1510–1515
Oil on panel, 69 x 57 cm
Musée du Louvre, Paris

St. John the Baptist is looking at the observer impressively and declaring his identity by means of gestures and gazes. The picture is probably one of the three works which Antonio de Beatis saw in Leonardo's studio in Clos-Lucé in 1517. It is the last painting to be produced by Leonardo himself, and was probably already completed in Rome. The Pinacoteca Ambrosiana in Milan owns a further version that depicts St. John in a landscape, which is related to the painting of the *Madonna and Child with St. Anne* in the Louvre.

124 Studies of embryos: diagram (detail ill. 126), 1509–1514

Next to the impressive drawings of embryos, in a corner of the sheet, is a note which proves Leonardo's study of "two-eyed vision".

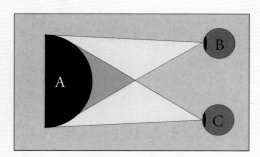

125 Diagram of binocular vision

The perceived surface of an object is smaller than that seen by the combination of the right (B) and left (C) eyes. Leonardo recognized this phenomenon and used it in order to give his figures a greater degree of *rilievo*, as two eyes are able to see further around an object than one, meaning that they see it more three-dimensionally. He probably drew the two views onto a glass plate and then transferred the combined drawing to a different medium.

A simple experiment can make it understandable how spatial sight works. If one holds a finger about 20 cm in front of one's eyes and then looks with both eyes at the space behind it, one can see the entire space behind the finger. If one only looks with one eye, the finger will always conceal some of the background. Leonardo carried out such and similar experiments himself and wrote down his observations. From the 1490s, Leonardo had been familiar with the principle of spatial sight, and knew that the spatial impression created in that way could not be simulated in painting. The important effect, that with two eyes one can see things that are behind an object, cannot be represented in the flat art of painting, for a painted object conceals everything behind it. The painter can only imitate nature using a "one-eyed" vision.

Leonardo's interest in optics and the task of the portrait can be seen in the second decade of the 16th century mainly in the form of two paintings: the so-called *Mona Lisa* (ill. 119) and the half-length figure of *St. John the Baptist* (ill. 123). During these years, Leonardo attempted to understand how a perceived object was transmitted in the eye and turned into a perception. During the course of this, Leonardo stumbled across another phenomenon of spatial sight: both eyes are looking at an object from a slightly different angle. This creates an effect that blurs objects slightly for us, which can be seen most clearly along the contours of the perceived objects. With only one eye, in contrast, one can see the contour line clearly. The lack of sharpness of "vision with two eyes", created by the varying angle of perception, decreases the further away an object is. But the further away the object is, the less the detail that can be made out on it.

The paintings of the *Mona Lisa* and *St. John the Baptist* have an extreme lack of sharpness, the cause of which is generally explained in terms of Leonardo's *sfumato*. *Sfumato* is explained by means of the phenomenon of unsharpness created by aerial perspective, which for example causes the mountains in the background of the *Mona Lisa* to dissolve into a haze. But this does not explain how *sfumato* should be created in a face seen close up.

During his study of optics, Leonardo recognized a further phenomenon of binocular vision that led him to a method of depiction that was to become unique in the history of painting. This phenomenon applies to that part of the object that can be depicted in painting. If one is standing in front of a sphere and looking at it with just the right eye, one can see more of the right side of the sphere than if one looks with just one's left eye, and vice versa: on the left side one can see more with the left eye. If one combines the view of the right eye with that of the left, one can see further around the object (ill. 125). As a result, the spatial impression created by the combined view is stronger. As both views are, however, produced from a slightly different angle of vision, they have to blur to form one picture. The result is that sharp lines can no longer exist in the picture.

This appears to explain the origins of the lack of sharpness in Leonardo's pictures.

It was Leonardo's intention to use the simulation of spatial or "two-eyed" sight to give the object more *rilievo*, in other words to make it appear more three-dimensional and thus bring the perception of the painting closer to the perception of nature. Leonardo recognized that the "two-eyed" vision of a relief could be approximately simulated by the combination of the views of the right and left eyes. A relief also does not make it possible to look at the space behind an object, and painting can even surpass a relief as it is not subject to real lighting conditions. For example, a three-dimensional body creates shadows that, in a relief body, are not equally distributed and strong. Painting, in contrast, can use the shadows created by the three-dimensional body as a model and depict them.

Leonardo's reflections on optics led him to attempt to depict "two-eyed" vision of an object in painting. By dividing it into two one-eyed views, which he recombined on the painted surface, he discovered the possibility of simulating a phenomenon of natural spatial sight in painting. In that way, he had added a further technique to his repertoire of illusions that was able to provide a partial solution for a basic problem in imitative painting, namely that of creating a convincing illusion of the three-dimensional world on a two-dimensional painted surface. Until that point, in addition to *rilievo* that creates the plastic appearance of objects, linear perspective and the aerial and color perspectives investigated by Leonardo were the most important techniques at his disposal in order to create a three-dimensional effect in a picture.

126 (opposite) Studies of embryos, ca. 1509–1514
Black and red chalk, pen and ink wash on paper, 30.5 x 22 cm
Royal Library, RL 19101r, Windsor

The sheet includes studies from a number of years. The note "book on water to Mr. Marcho Ant" refers to the anatomical expert Marcantonio della Torre, who died in Pisa in 1511 and with whom Leonardo carried out dissections of human bodies. This drawing of the fetus was the result of knowledge rather than direct observation of nature. Leonardo had examined the fetus of a cow and allowed his observations of the placenta to influence this drawing.

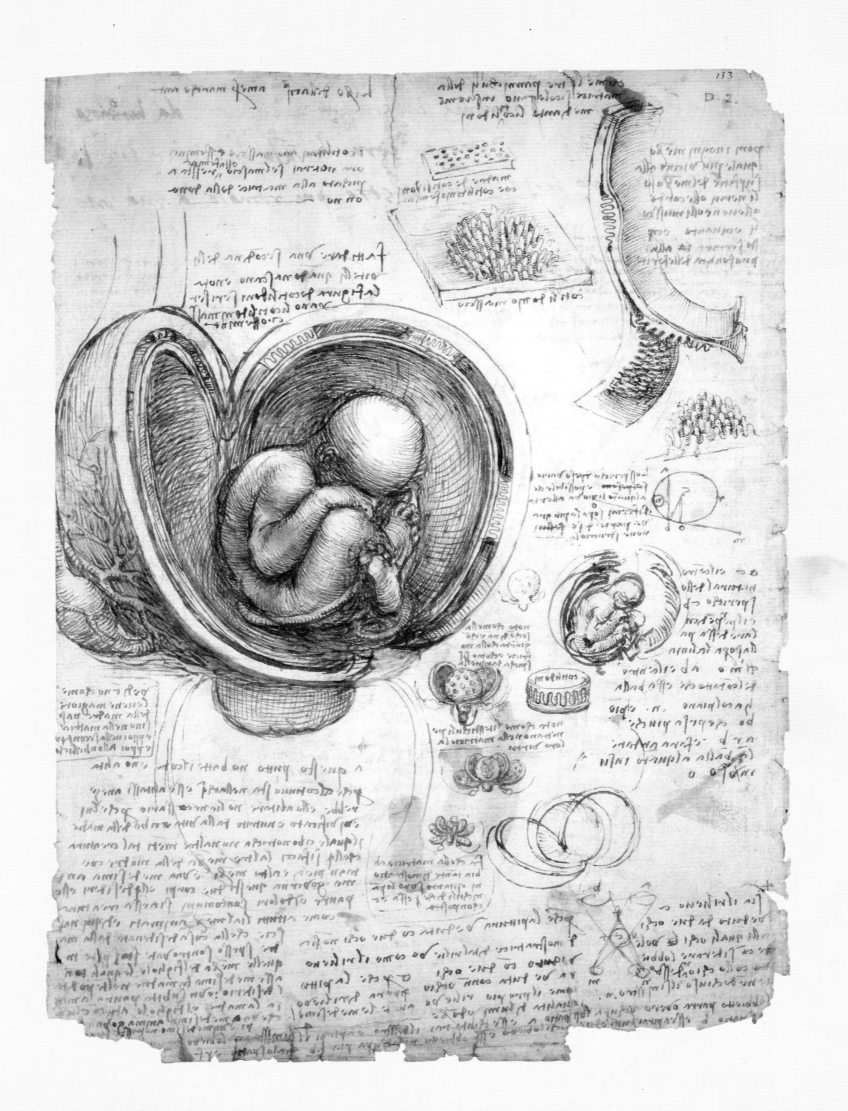

THE FINAL YEARS IN AMBOISE
1517–1519

127 Francesco Melzi (1492–ca. 1570)
Flora, ca. 1517–1521
Oil on panel, transferred to canvas, 76 x 63 cm
Hermitage, St. Petersburg

The painting of the Roman goddess of flowers, Flora, is directly connected to the Berlin painting of *Pomona and Vertumnus.* Both reflect the same model by Leonardo, namely the figure of Mary in the *Burlington House Cartoon* (ill. 84). The painting appears to have remained in the royal collection in France, at least until the mid-16th century. It is possible that a cartoon of the half-length figure also existed, for in addition to some copies at least two almost identical versions of the painting still exist.

When Leonardo was made "first painter, engineer and architect" by the French king Francis I, he was already 65 years old, a considerable age at the time. Like so much in the artist's life, it is not known how he came to be appointed. He had been in direct contact with the French royal family since his second stay in Milan at least – Francis I had reconquered the duchy of Milan in 1515 when he was victorious over the Swiss army at Marignano – and he probably met the king for the first time in 1515 in Bologna. Whatever the case, from 1517 Leonardo stayed in the castle of Clos-Lucé with his servant Salai and Francesco Melzi, who was to become particularly important.

Deeply admired by the king, towards the end of his life Leonardo once more performed the function of an artist and engineer in the service of a royal court. As he had done for the Sforzas in Milan, he designed costumes for a masked ball, but his principal activities were as the king's architect. He drew architectural designs for the castle of the queen's mother in Romorantin, which despite their sketchiness already anticipate the great palaces of the absolute monarchs. As in so many of his projects, Leonardo attempted to start by understanding the problem thoroughly so that he could then develop comprehensive measures for improvement. In this case also, Leonardo not only planned the extension of the residence, but also included observations on town planning in order to make sure that the infrastructure of the new residence town to be built was suited to the requirements. Thus he planned not merely to border the castle with an artistic network of canals, but to link it with the Loire via a navigable canal so that the town would be connected with the existing trade and travel routes.

No doubt the French king would also have desired the famous artist to produce paintings, but Leonardo was suffering from paralysis. The illness was probably so advanced that he was no longer able to use his brush himself: "And it is true that no more good can be expected of him [Leonardo], because his right side is paralyzed. He has enlisted the aid of a student from Milan who works quite well, and although Master Leonardo can no longer paint with the delicacy one expects of him, he still draws and teachers others," wrote

Antonio de Beatis after visiting Leonardo's studio in Clos-Lucé, in an entry dated 10 October 1517 in his journal. This student of Leonardo's was Francesco Melzi, who was his companion during the last stage of his life. He was also the one who completed Leonardo's treatise on painting after his death. Melzi appears to have shared the master's knowledge, and Leonardo developed his last works together with him. He made him his main heir and left him his workshop together with all his notebooks and drawings. An ambassador from Ferrara wrote the following about Melzi in 1523: "[Melzi] was the student and is the heir of Leonardo da Vinci, and possesses many of his secrets, and all his opinions, and also paints very well, as far as I can judge, and in his thoughts he shows discernment and is a very friendly young man."

It was very probably the paralyzed Leonardo who composed the painting of *Pomona and Vertumnus* which Francesco Melzi produced (ill. 129) and which in a certain sense can be considered the artist's painted legacy. It narrates an episode from Ovid's "Metamorphoses": Vertumnus enters Pomona's grove in order to convince her of his love. Because she had always run away on previous occasions when he came, he has cunningly dressed as an old woman on this occasion. By telling her about the allegory of the grapevine and elm, he is able to convince her of the importance of togetherness, for the grapevine needs something it can climb up and the elm, when considered on its own, is useless. Persuaded, Pomona gives in to love and her innermost longings and they become a couple.

Vertumnus is a composite figure who represents various moments in time and historical elements in his various parts. His face is that of an old man, only the bonnet identifies him as an old woman. The feet and hands are those of a young person. This makes his transformation visible. The motif of his gait, due to which his garments are still fluttering, shows that he has just arrived. At the point where his right wrist is bent, the grapevine is entwined around the elm. The gentle touch of her shoulder with his youthful hand depicts the moment at which he reveals himself to her. Pomona's eyes are still lowered longingly while he is already gazing at her passionately.

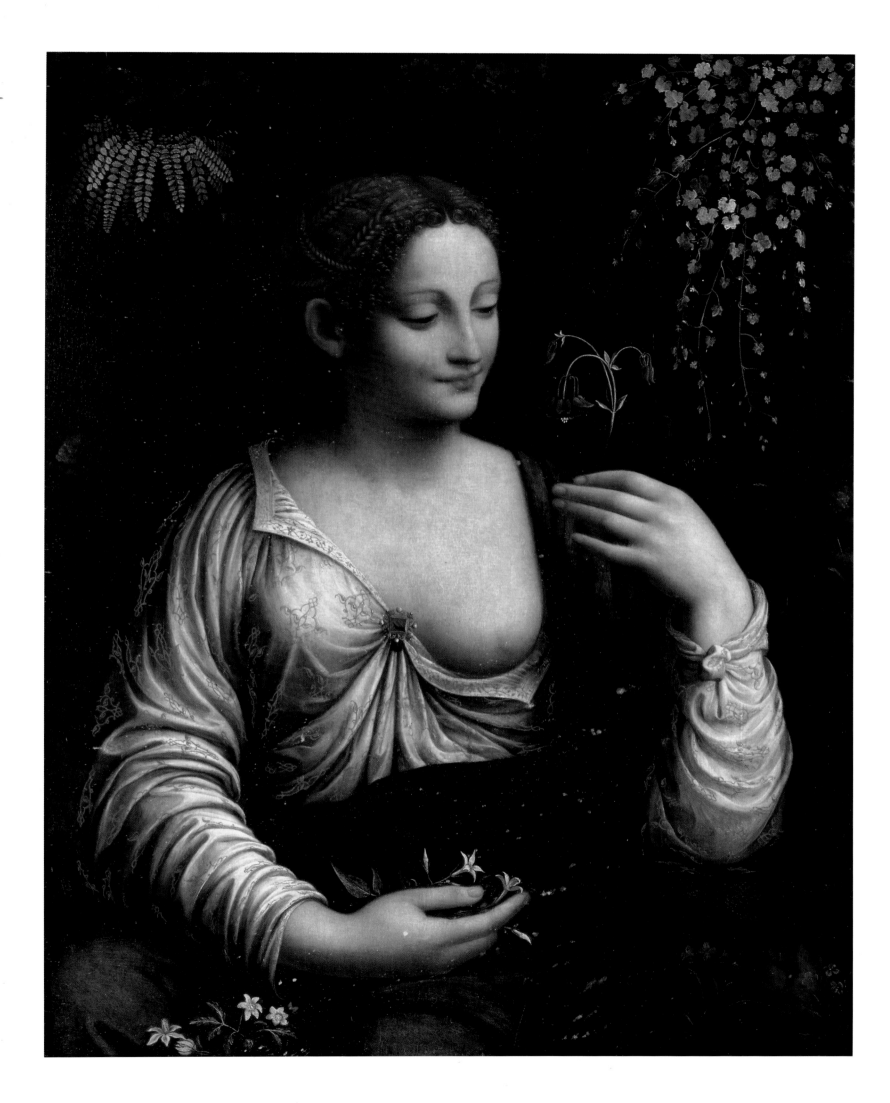

128 (below) and 129 (opposite, condition during restoration) Francesco Melzi (1492–ca. 1570)
Pomona and Vertumnus, ca. 1517–1520
Oil on panel, 185 x 134 cm
Staatliche Museen zu Berlin – Preußischer Kulturbesitz, Gemäldegalerie, Berlin

Pomona, the classical goddess of fruit, and Vertumnus, the god of transformation, are the main figures in an episode in Ovid's "Metamorphoses" which is depicted here. Until very recently, the attribution of the painting was disputed. This changed in 1995, when the author was able to prove the existence of a documented signature by Melzi, which an art dealer removed in the 18th century in order to be able to sell the picture as a work of Leonardo's.

Due to its poor condition, the painting was not taken seriously for a long time. It was only once it was restored that its similarity to Leonardo's works became evident.

Leonardo had developed a form of pictorial narrative that differed from that in the *Last Supper* (ill. 72) in that every element in the picture now played an independent role in the narrative, while in the *Last Supper* the production was tuned to the effect of entire figures and staged in a more theatrical manner. At first glance, the painting only appears to narrate a single moment in time, but when one looks at the picture more closely the various temporal planes within which the individual figures operate unfold.

Little attention has been paid to the portrait of Francis I – in a private collection in the USA – which the king must surely have commissioned his first court painter and his workshop to produce. Melzi seems to have also produced this portrait which displays both the "divided" vision of St. John and Leonardo's own general idiosyncrasy of characterizing figures by means of visual references. If the later inscription is to be believed, it was created in about 1518.

It was probably at the request of Francis I that Leonardo continued working on drawings for the painting *Madonna and Child with St. Anne* in the Louvre (ill. 88). He produced wonderful detail studies, but the painting was never completed by him. As in the picture of *Pomona and Vertumnus*, the pictorial narrative played a central role in his ideas for the painting of *St. Anne*.

His last drawings from the period in France are almost entirely executed using black chalk, pen and ink. He no longer appears to have used red chalk. The surviving drawings are characterized by an astonishing ease in the use of lines. In addition to drawings of horses and designs for costumes, there also remains the *Deluge* series, chalk drawings of the cosmic destruction of the world (ills. 110, 111). They are amongst the most impressive drawings to have ever been produced in this technique. These drawings were probably inspired by a real catastrophe which took place in 1515 in Bellinzona, when there was an enormous landslide which flooded villages. But they were created at the end of the artist's life, which means that it is feasible to interpret them in the sense of an apocalyptic view of the world in Leonardo's later years. Vasari, though without the benefit of more precise information about the artist, also spoke of a resignation towards the end of Leonardo's life. In accordance with Leonardo's scientific orientation, it ended not with the christological iconography of the last days, but with a deluge unleashing the forces of nature, which in turn should be given a moral value. The symbolic landscapes could with equal right be seen without a moral background as scientific drawings in which the forces that come into play during a natural catastrophe are clearly shown. It is possible that they were planned as illustrations for a book. At any rate, the remaining sketches and workshop pieces indicate that his creative urges continued without interruption until shortly before his death.

According to a legend that once again derives from Vasari, Leonardo is said to have died in a dignified manner on 2 May 1519, in the arms of the French king Francis I, though the latter, according to contemporary sources, was staying far away from Amboise in the castle of Saint-Germain-en-Laye at the time. Francesco Melzi informed Leonardo's oldest brother Giuliano and his relatives in his homeland of the death of their relative with the following words: "I believe you already know about the death of your brother, Master Leonardo, who was like the best of fathers to me, and for whose death it would be impossible for me to express the grief I have felt …"

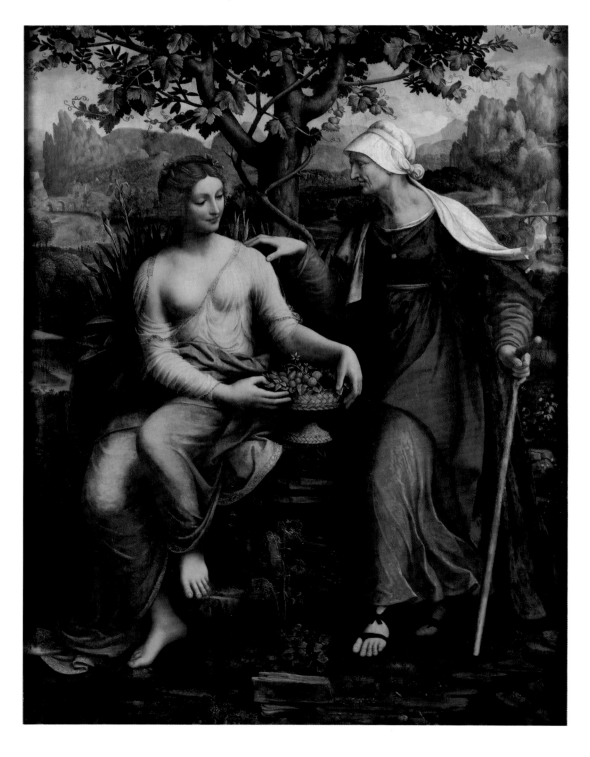

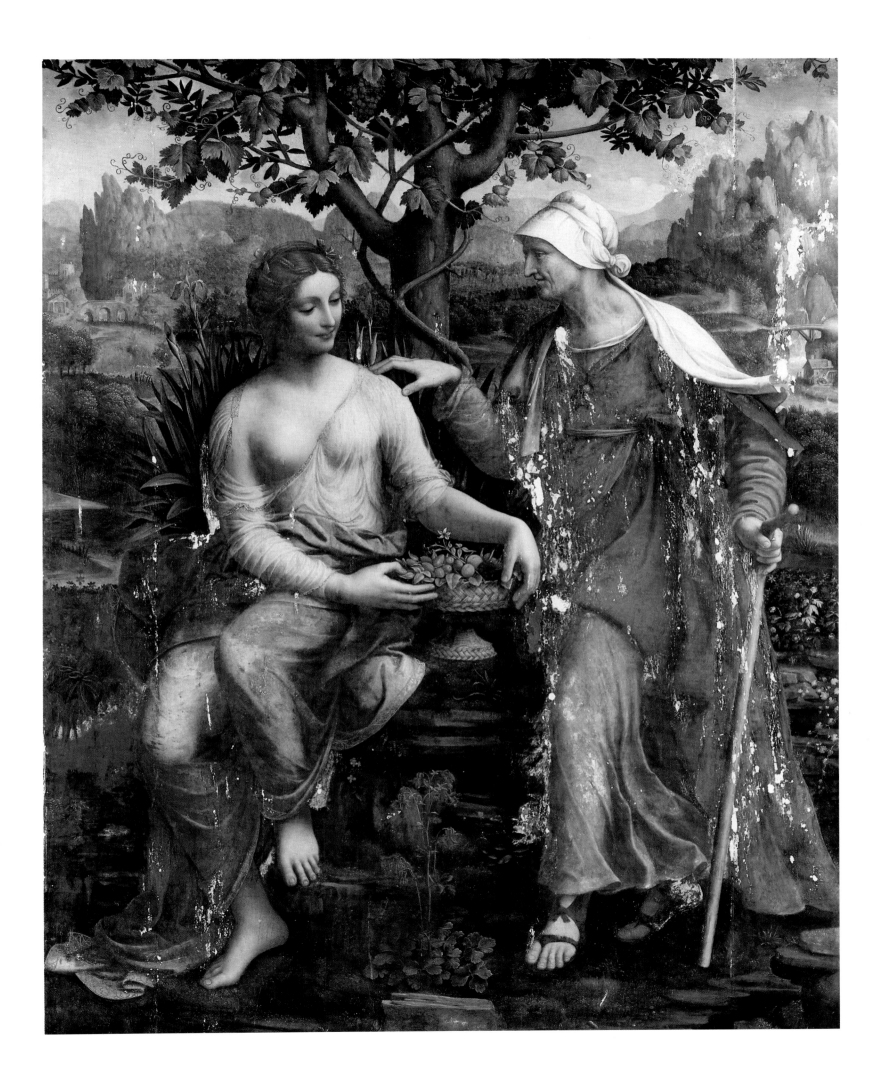

PAINTING BECOMES A SCIENCE

"Perhaps there is throughout the world no second
example of such a comprehensive, inventive genius that,
incapable of being satisfied, longed so greatly for
infinity, was so naturally sophisticated and so advanced
beyond his own century and the following ones."

Hippolyte Taine, "Travels in Italy", 1866

The 67 years of Leonardo's life corresponded to one of
the most varying and, at the same time, most creative
eras in history. During the course of these years,
supported by the intellectual current of humanism,
many fundamental principles were created from which
the modern age was to develop. The invention of the
printing press and the discovery of the New World and
the sea route to the East coincided with the life and work
of Leonardo, whose exploratory urge was limitless – no
matter whether he was trying out new techniques in
painting, testing new principles of composition or new
possibilities presented by the visual idiom or the
characterization of a portrait's subject, whether he was
conducting anatomical studies, studying the laws of
optics, investigating sculpture and the techniques of the
work process, or developing hydraulic installations and
designing machines.

Even Leonardo's own contemporaries felt his uni-
versality to be so unusual that the writer and painter
Benedetto Varchi (1502–1566), on the occasion of
his public funeral oration (1564) for Michelangelo,
Leonardo's younger rival, went so far as to list Leonardo's
varied talents, an extremely unusual act given the
circumstances. He honored him as the founder and
completer of the third and highest method of painting,
the *maniera moderna*, and as an arithmetician, musician,
geometrician, cosmographer, astrologer and astron-
omer, as a writer of verses and poetry, philosopher
and metaphysician, who had also excelled in anatomy,
medicine, botany, mineralogy and many other fields.

The roughly 20 known paintings – about another 20
are suggested by various sources – and hundreds of
drawings demonstrate in a most impressive manner that
Leonardo did not consider science and art to be two
different things, but felt that they were linked to each
other in the most fruitful manner. It was his conviction
that the artist had to use the methods of the scientist,

and the scientist the tools of art. A scientist who could
not draw lacked the means of conveying his knowledge
in a vivid manner. An artist, in contrast, had to master
the laws of geometry in order to be able to construct a
system of perspective or establish the proportions of
humans and animals. For him, painting occupied the
highest position amongst the sciences as it possessed a
significance and power of communication that went
beyond all the other sciences. For it did not need to be
translated into other languages, like literature for
example, and did not fade away the moment it was
created as music did. As he wrote in his "Treatise on
Painting" (ill. 6): "With its principle, in other words
drawing, painting instructs the architect to make
his building pleasant to the eye; it teaches the makers
of the most diverse vases; the goldsmiths, weavers,
embroiderers; it has found the letters with which the
various languages are expressed; it has given the
arithmetician numbers; it has taught geometry to depict
figures; it teaches painters in perspective, astrologers,
mechanical engineers and master builders."

Although Leonardo's works were frequently stigma-
tized due to being unfinished, they turned his name into
a legend. The *Last Supper* (ill. 72) and the *Mona Lisa*
(ill. 119) are two of the most famous pictures in the
history of painting. It was Leonardo who brought about
a decisive advance in painting. During his stay in
Florence he matured into an artist who showed signs of
considerable promise, and Leonardo internalized the
Albertian tradition according to which painting, in
imitation of classical rhetoric, was seen as a means of
communication.

According to Alberti, history painting was the most
worthy genre in painting and should be staged in such
a way, as a readable pictorial narrative, that the observer
could envisualize a story in the way it had artistically
been put into practice. To achieve this, the painter
should use both traditional methods of visual language
and newly developed attributes and symbols as well as
characteristic accessories, which the observers of the
time were able to read like words.

A further task which Alberti posed artists was also
drawn from the classical body of thought, namely the
idea of painting as a deceptive imitation of reality. He

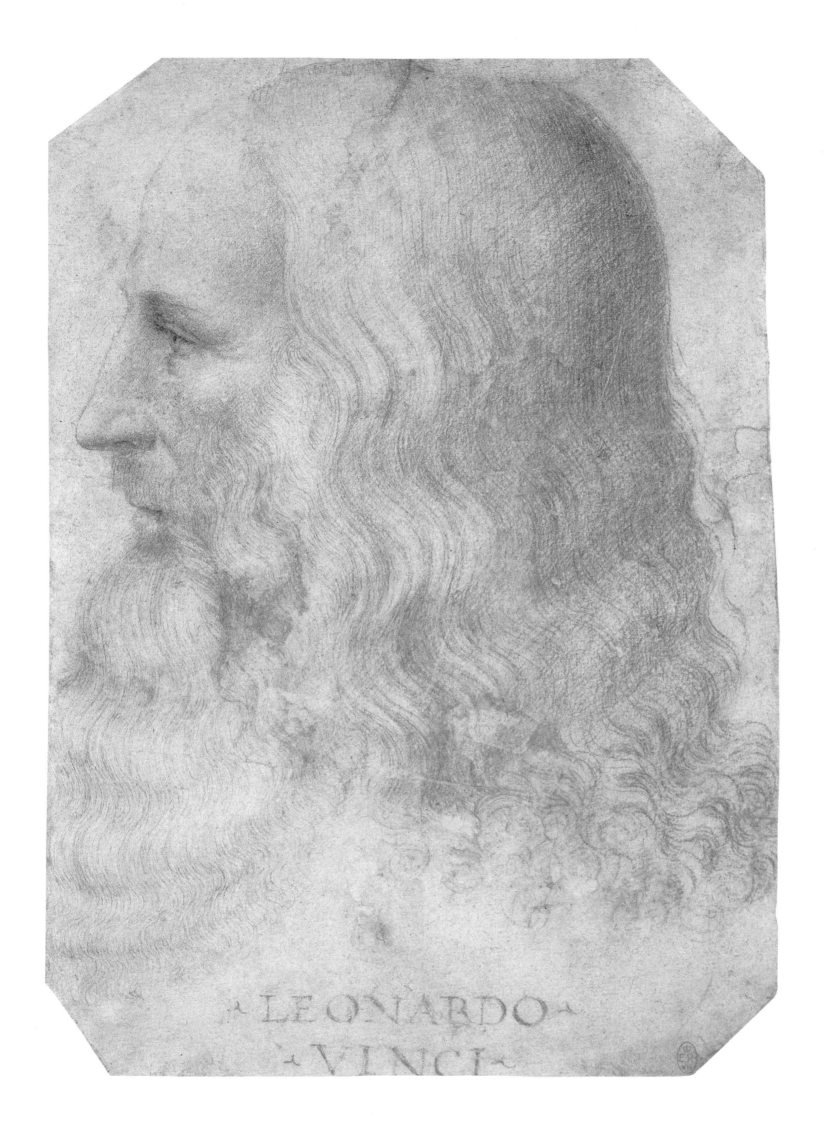

LEONARDO
VINCI

131 (above) *Treetrunks with branches, roots and rocky soil*, 1498
Brush drawing on prepared paper, fragments
Castello Sforzesco, Sala delle Asse, Milan

All that remains of Leonardo's decorations in the Milan
Castello Sforzesco are these fragments in the Sala delle
Asse which were, when discovered towards the end of the
19th century, restored in such a way that it is scarcely
possible any more to make out their original appearance.
Only the fragment depicted here was covered up and then
revealed again in 1954. It reveals Leonardo's plan to cover
the vaulted ceiling of the Sala with a complicated network
of twigs and leaves growing from the tree trunks painted
on the side walls which, together with the blue of the sky
in-between, create the illusion of a jumble of branches
beneath an open sky.

132 (opposite) *Coat of arms of the Sforza family*, 1498
Brush drawing on prepared paper, fragments
Castello Sforzesco, Sala delle Asse, Milan

The restoration undertaken by Luca Beltrami from 1901
to 1902, on the basis that little of the original remained,
was very extensive and in parts also quite arbitrary, so that
it is no longer possible to decide to what extent the dense
and regularly overlapping branches correspond to the
original. The center of the decorations in the vault,
however, where Leonardo placed the coat of arms of the
Sforza family like a boss is undisputed.

134 (left) *Map of Tuscany and the Chiana Valley,*
ca. 1502
Black chalk, pen, ink and color on paper, 33.8 x 48.8 cm
(facsimile)
Galleria degli Uffizi, Gabinetto dei Disegni e delle
Stampe, Florence

This general map of Tuscany and the Chiana Valley
probably dates from the time when Leonardo was in the
service of Cesare Borgia. It is presumably a strategic map
produced for Borgia, for the place and river names have
been recorded carefully. It may also have been produced
in connection with Leonardo's plans to build a canal from
Florence to the sea. Damming Lake Chiana was meant to
guarantee a sufficient water supply for the canal, even
during the dry season.

considered the greatest achievement to be to create a work that depicted painted persons or objects in such a way as if they were alive or real. Leonardo accepted these challenges like no other painter and in his paintings achieved what he had since the 1490s been attempting to define, in his "Treatise on Painting", as the fundamental purposes of painting. For Leonardo, the highest artistic goal of painting was to imitate reality. In the painter's opinion, though, this could not be achieved solely by copying nature, but only by outwitting the observer. But if it was his task to deceive an observer, then spatiality, plasticity and people that acted in a psychologically accurate manner had to be depicted.

Leonardo achieved the first through his studies of perspective, specifically aerial perspective. In order to realize the second requirement, he investigated the influence of light and shade in the production of *rilievo*, and his anatomical and physiognomic studies relate to the third point. In addition to this, he recognized the importance of the process of perception on the part of the observer for creating an illusionary effect, and his painting by definition strove to achieve this. The attempt to simulate binocular vision was to be one of the last great challenges for Leonardo the painter.

His methodical awareness that the clearly defined nature of a science determines its goal and this in turn decides the method used to reach that goal, and that the results achieved at any stage have to be measured against the defined goal, turned painting, which had long been regarded as a craft, into a true science. This made Leonardo one of the first rationalists in a modern sense, though only a few of his contemporaries absorbed and understood his concepts. It is not, therefore, surprising that his achievements in the history of ideas are only gradually being recognized today, especially as the complications connected with gathering his writings for a long time made it impossible to gain an overall perspective of the entire work of this fascinating person. A history of the influences of his writings has yet to be written.

With regard to his paintings, the debate over the authorship, attribution and dating is not over yet. In contrast, Leonardo the artist is held in universal respect. This feeling is probably not expressed better anywhere than in the writings of Vasari, where he cites the words of praise of Giovanbatista Strozzi:

"Vince costui pur solo
Tutti altri, e vince Fidia, e vince Apelle
Et tutto il lor vittorioso stuolo."

"Da Vinci alone vanquished all others,
He vanquished Phidias and Apelles,
And all their victorious followers."

Brigitte Hintzen-Bohlen
Peter Hohenstatt

133 (opposite) Codex on the flight of birds
Pen and ink on paper, 21 x 15 cm
Biblioteca Reale, fol. 6, Turin

In order to develop his flying machines, Leonardo
systematically studied the flight of birds. On this sheet he
recorded the observation that birds made use of varying
winds when gliding, and he noted this down in small
sketches on the margin.

CHRONOLOGY

1452 On 15 April, Leonardo di Ser Piero da Vinci is born in the Tuscan town of Vinci.

1468 Leonardo is still living in his father's house in Vinci.

1469 Leonardo's father is the procurator for the convent of San Martire in Florence. The family moves from Vinci to Florence in this year. This is presumably the point at which Leonardo starts work in Andrea del Verrocchio's workshop.

1471 Verrocchio completes the dome lantern for the Florentine cathedral of Santa Maria del Fiore by mounting the copper sphere.

1472 Leonardo is recorded as a member of the Florentine guild of painters.

1473 The first dated work by Leonardo, the landscape drawing of 5 August on *Santa Maria della Neve* (ill. 14).

1476 Leonardo and others are accused of homosexuality and given a suspended sentence.

1477 Antonio, Leonardo's oldest half-brother on his father's side, is born.

1478 The first pages of the so-called Codex Atlanticus are written, and will form part of a collection of drawings and notes from all phases of Leonardo's work. The British Museum has in its possession the Codex Arundel which, similarly to the Codex Atlanticus, contains a chronologically and thematically mixed collection of Leonardo's works.

Leonardo notes that he is working on two Madonnas. Commission for work in the Chapel of San Bernardo in the Palazzo Vecchio.

1481 Leonardo signs a contract for an altar painting (ill. 46) with the monks of San Donato in Scopeto.

1483 Contract for an altar painting (ill. 51) for the Chapel of San Francesco Grande in Milan.

1485 Possible commission to paint a Madonna for Matthias Corvinus, the king of Hungary.

1487 Leonardo starts work on Manuscript B and Ashburnham. The Codex Trivulzio in the Biblioteca Trivulziana in Milan and the Codex Forster II in the Victoria and Albert Museum in London also date from the years after 1487. Leonardo takes part, alongside Bramante, in a competition to produce the dome lantern for Milan Cathedral.

1489 Ludovico il Moro asks Lorenzo de' Medici for bronze founders for the Sforza monument. Leonardo starts his book "On the Human Figure" on 2 April.

1490 Leonardo creates the decorations for the "Festa del Paradiso" on the occasion of Gian Galeazzo Sforza's marriage to Isabella d'Aragon. He withdraws his model for the dome lantern from the competition. The Manuscript C of the Institut de France in Paris begins with the note: "on the 23rd of April 1490 I began this book and recommenced the horse." Giacomo Salai enters his household at the age of ten. In June, Leonardo visits Pavia with Francesco di Giorgio di Martini, who has been summoned as an expert for the planned construction work on the cathedral.

1491 Leonardo notes down that "Gian Antonio having left a silver stile on one of his drawings, this Giacomo [Salai] stole from him."

1492 Giuliano da Sangallo spends a short time in Milan. Leonardo begins the Manuscript A of the Institut de France. He makes short journeys to Como, into the Valtellina and Valsassina, to Bellagio and Ivrea.

1493 The Codex Madrid I is begun on 1 January. He starts work on the third section of Manuscript H in the Institut de France. The clay model of the Sforza equestrian monument is to be finished for 30 December, and on 20 December the decision is made to cast the horse lying and without a tail. Bellincioni calls Leonardo the "Apelles of Florence". He makes notes on Chiaravalle's clock. A certain Caterina, possibly his mother, arrives on 16 July and is mentioned on two further occasions in 1494.

1495 Start of work on Manuscript M of the Institut de France. Presumably commissioned to produce the *Last Supper* in the refectory of Santa Maria delle Grazie. He decorates "rooms" in the Castello Sforzesco.

1496 Drawings for "De divina proportione" by Luca Pacioli. Dispute with Ludovico il Moro over the decoration of the rooms in the Castello Sforzesco. Leonardo applies for the commission to produce the bronze cathedral doors in Piacenza.

1497 Work is started on the Institut de France's Manuscripts I and L. Design of the Casa Guiscardi. Leonardo draws a portrait of Lucrezia Crivelli, the new favorite of Ludovico il Moro.

1498 In March, Leonardo is in Genoa to give expert advice on the harbor. He

completes the work in the Sala delle Asse. Ludovico il Moro gives Leonardo a vineyard in October.

1499 On 14 December, Leonardo sends money to Florence.

1500 With Luca Pacioli and students, Leonardo is a guest of the Gonzagas in Mantua while on his way to Venice. He creates a portrait of Isabella d'Este. On 13 March, Leonardo is in Venice. He plans a defensive structure in Friuli to counter an imminent Turkish invasion. On 24 April, Leonardo is in Florence. In the Codex Atlanticus there is a note to the effect that he intends to go to Rome, Vinci and Naples with the Frenchman Ligny. The note "casa d'Adriana" suggests that he managed to get at least as far as Tivoli near Rome.

1501 On 3 April, he is definitely back in Florence. Isabella d'Este asks for a replica of her portrait. Pietro da Novellara provides us with important notes on the work on a *St. Anne* and a *Madonna with the Yarnwinder* for Robertet, the secretary to the French king.

1502 At the request of Isabella d'Este, Leonardo gives his expert opinion on vases from the collection of the deceased Lorenzo de' Medici. On 18 August, Leonardo receives a permit from Cesare Borgia which allows him to inspect all the defensive structures of cities ruled by the Borgias as the "senior military architect and general engineer." This is probably when the designs for a bridge over the Bosphorus, a map of Imola (ill. 11) and maps of Tuscany, Umbria, the Chiana Valley (ill. 134), the Castiglion Fiorentino and the hydrographic system in Tuscany were produced. Manuscript L in the Institut de France documents the tour of inspection he made for Cesare Borgia, stopping at cities such as Urbino, Cesena and Rimini.

1503 Studies for a project to divert the Arno which would cut Pisa off from the ocean. Landscape drawings of the Monte Verruca and the Pisa mountains are created. In October, the Sala del Papa in the Florentine convent of Santa Maria Novella is put at his disposal, and he uses it as a studio while working on the commissioned *Battle of Anghiari*.

1504 The Manuscript K of the Institut de France is created. Leonardo is asked for his opinion on where Michelangelo's *David* should be located, and he suggests the Loggia dei Lanzi. Isabella d'Este requests a small *Christ Child* if she is not to receive her portrait in colors. Leonardo makes a note about "my world map, which Giovanni de' Benci has." On 9 July, Leonardo receives news that his father has died. On 20 November, Leonardo is in Piombino and presents his designs for town planning and military equipment. On 30 November, he notes that he has squared the circle.

1505 The duke of Ferrara would like to buy a *Bacchus* from Leonardo that is already promised to the cardinal of Rouen. Start of work on the wall painting in the Palazzo Vecchio: "On Friday 6 June 1505, at precisely three o' clock, I started to paint in the palace…" Entries in both the Milan Codex Atlanticus and the Codex Arundel in the British Museum on the existence of nothing, and in the Codex Forster I in the London Victoria and Albert Museum. Entries in the Turin Codex on the flight of birds, though it is possible these were not made until 1506.

1506 Leonardo is called to Milan by Charles d'Amboise, the French king's governor in Milan. On 30 May, Leonardo leaves Florence, but is forced to sign a document agreeing to return within three months. On 18 August and 16 December, Charles d'Amboise requests a delay on behalf of Leonardo.

1508 Leonardo dissects an old man and a woman in Santa Maria Nuova in Florence. On 22 March, he is a guest in the Florentine house of Piero di Braccio Martelli and supports the sculptor Rustici in his project concerning a bronze group for the Baptistery in Florence. On 12 September, he is definitely in Milan once more and starts on Manuscript F of the Institut de France. Plans for a villa for Charles d'Amboise.

1509 City plans for Milan, projects for a canal and studies of water.

1510 Together with the anatomist Antonio della Torre, Leonardo conducts dissections at the university of Pavia. In October, he takes part in preparatory talks for stables for Milan Cathedral. In December, Leonardo believes that he will shortly complete his book on anatomy.

1511 Leonardo notices fires that the Swiss troops have lit outside Milan; it is likely that at this time he was in Vaprio in the villa belonging to the family of his student Francesco Melzi. During the following period he created plans for an extension to this villa.

1513 On 9 January, Leonardo is definitely in Vaprio. On 24 September, he leaves for Rome with Francesco Melzi, Salai and a certain Lorenzo.

1514 "Finished on the seventh day of July at the twenty-third hour at the Belvedere in the studio given me by Il Magnifico (Lorenzo de' Medici)." On 25 September, Leonardo is in Parma. Studies on the harbor of Civitavecchia. Project for draining the Pontine Marshes. On 8 October, he is elected a novice of the "Arciconfraternita di San Giovanni dei Fiorentini" in Rome.

1515 On 9 January, Leonardo notes that Giovanni de' Medici has left Rome. Leonardo is expelled from the hospital of San Spirito, where he had wanted to continue his anatomical studies, on suspicion of practicing black magic. Leonardo creates plans for Giovanni de' Medici's stables and for a new Medici palace in Florence. Francis I reconquers Milan. Leonardo probably takes part in the meeting between the Medici pope Leo X and the French king Francis I in Bologna.

1516 His patron dies on 17 March. In August, Leonardo is in Rome and surveys the church of San Paolo fuori le Mura.

1517 On 2 May, Leonardo is in Amboise, Francis I's royal residence, and is made the king's first painter, engineer and architect. He is paid a salary of 2,000 scudi; the nobleman Melzi received 800 and Salai 100. On 10 October, the cardinal of Aragon and his secretary Antonio de Beatis visit Leonardo's studio.

1518 On 24 June, he is in Clos-Lucé near Amboise.

1519 On 23 April, he draws up his will. Leonardo dies on 2 May 1519 in Clos-Lucé near Amboise.

GLOSSARY

aerial perspective, a way of suggesting the far distance in a landscape by using paler colors (sometimes tinged with blue), less pronounced tones, and vaguer forms. In Leonardo's works, the term refers to the increasing loss of detail to the point where the whole form of objects dissolves as distance increases.

altar painting, a painting that stands on or behind an altar. Early altar panels were made to stand alone; gradually they came to form the central work of elaborate altarpieces that combined several panels within a carved framework.

anatomy (Gk. *anatemnein,* "dissect"), in medicine anatomy is the term applied to knowledge about the construction of the human organism gained by dissection; in the fine arts, anatomical compositions were derived from precise studies of nature and nudes, as well as the desire to achieve a deeper understanding of the individual bodily functions that determine a person's external appearance. The Renaissance developed a special scientific interest in proportioning individual body parts in an anatomically precise manner, and reproducing faithfully to life the movements of muscles.

Annunciation, based on Luke 1:26–38, it shows the moment at which the angel Gabriel gives the Virgin the message that she will give birth to Christ. In the Middle Ages and the Renaissance, the Annunciation was one of the most frequently used themes in the European fine arts.

Apelles (ca. 330 BC), Greek painter and one of the most celebrated artists of the classical world.

a secco (It. "on dry"), a fresco which, unlike true fresco, is painted on plaster that has already dried. *A secco* painting is generally less durable than true fresco.

attribute (Lat. *attributum,* "added"), a symbolic object which is conventionally used to identify a particular saint or deity, usually portraying a characteristic moment from the person's life.

Augustinians, in the Roman Catholic Church, a mendicant order founded in 1256 under the rule of St. Augustine (AD 354–430). The order became widespread in the 14th and 15th centuries, renowned for its scholarship and teaching. Under the influence of humanism during the Renaissance, Augustinians played a leading role in seeking Church reform.

balustrade, a rail supported by a row of small posts or open-work panels.

bust, a sculpted portrait consisting of the head and shoulders. Developed in ancient Greece and widely used in ancient Rome, the bust was revived in 15th-century Italy.

Byzantine art, the art of the Byzantine Empire, which had its capital in Constantinople (Byzantium), from the 5th century to the fall of Constantinople to the Turks in 1453. Based largely on Roman and Greek art, Byzantine art also absorbed a wide range of influences, notably from Syria and Egypt. Byzantine art was essentially a spiritual and religious art, its forms highly stylized, hieratic and unchanging (central images were thought to derive from original portraits). It also served to glorify the emperor. Among its most distinctive products were icons, mosaics, manuscript illuminations, and work in precious metals. The strong influence of the Byzantine style on medieval Italian painting can be seen in the works of Cimabue, Duccio, and Giotto.

Carmelites (Lat. *Ordo Fratrum Beatae Mariae Virginis de Monte Carmelo,* Brothers of Our Blessed Lady of Mount Carmel), a Roman Catholic order of contemplative mendicant friars. Founded in Palestine in the 12th century, the Carmelites were originally a group of hermits. In the 13th century the order was refounded as an order resembling the Dominicans and Franciscans. An order of Carmelite Sisters was founded in the 15th century, and reforms introduced by St. Teresa of Ávila in the 16th century led to the creation of the Barefoot (Discalced) Carmelites.

cartoon (It. *cartone,* "pasteboard"), a full-scale preparatory drawing for a painting, tapestry, or fresco. In fresco painting, the design was transferred to the wall by making small holes along the contour lines and then powdering them with charcoal in order to leave an outline on the surface to be painted.

central perspective, scientific and mathematical method of perspectival depiction developed by Brunelleschi at the beginning of the 15th century. From the observer's point of view, all the lines leading into the background meet at a single vanishing point in the center of the composition. On the two-dimensional picture surface, the three-dimensional illusion is made possible by the precise foreshortening and proportioning of the depicted objects, landscapes, buildings and figures, according to their position in the space.

central-plan building, a building whose parts are of equal proportions, with a ground plan that is normally a circle, ellipse, square, rectangle or Greek cross. Models for centrally-planned buildings in the Italian Renaissance included the ancient Roman Pantheon and other classical architecture.

chiaroscuro (It. "light dark"), in painting, the modelling of form (the creation of a sense of three-dimensionality in objects) through the use of light and shade. The introduction of oil paints in the 15th century, replacing tempera, encouraged the development of chiaroscuro, for oil paint allowed a far greater range and control of tone. The term chiaroscuro is used in particular for the dramatic contrasts of light and dark introduced by Caravaggio. When the contrast of light and dark is

strong, chiaroscuro becomes an important element of composition.

classical, relating to the culture of ancient Greece and Rome (classical antiquity). The classical world played a profoundly important role in the Renaissance, with Italian scholars, writers, and artists seeing their own period as the rebirth (the "renaissance") of classical values after the Middle Ages. The classical world was considered a golden age for the arts, literature, philosophy, and politics. Concepts of the classical, however, changed greatly from one period to the next. Roman literature provided the starting point in the 14th century, scholars patiently finding, editing and translating a wide range of texts. In the 15th century, Greek literature, philosophy and art – together with the close study of the remains of Roman buildings and sculptures – expanded the concept of the classical and ensured it remained a vital source of ideas and inspiration.

codex (Lat. "wooden writing board"), a manuscript, especially of the Scriptures, a holy work or one of the classics.

color perspective, the proportionally decreasing intensity of colors as distance increases.

condottiere, pl. condottieri (It. "leader"), in Italy from the 14th to the 16th century, a leader of mercenary soldiers.

contrapposto (It. "placed opposite"), an asymmetrical pose in which the one part of the body is counterbalanced by another about the body's central axis. Ancient Greek sculptures developed contrapposto by creating figures who stand with their weight on one leg, the movement of the hips to one side being balanced by a counter movement of the torso. Contrapposto was revived during the Renaissance and frequently used by Mannerist artists, who developed a greater range of contrapposto poses.

copperplate engraving, a method of printing using a copper plate into which a design has been cut by a sharp instrument such as a burin; an engraving produced in this way. Invented in south west Germany in about 1440, the process is the second oldest graphic art after the woodcut.

Dominicans (Lat. *Ordo Fratrum Praedictatorum*), order of mendicant monks founded by St. Dominic in Toulouse in 1216, to spread and extend the faith by preaching and teaching. The Dominicans were the most influential medieval order, and were put in charge of the Inquisition by the pope in 1232.

Eucharist (Gk. *eucharistia*, "giving of thanks"), the sacrament of the Last Supper with bread and wine, the climax of the Christian service.

Franciscans, a Roman Catholic order of mendicant friars founded by St. Francis of Assisi (given papal approval in 1223). Committed to charitable and missionary work, they stressed the veneration of the Holy Virgin, a fact that was highly significant in the development of images of the Madonna in Italian art. In time the absolute poverty of the early Franciscans gave way to a far more relaxed view of property and wealth, and the Franciscans became some of the most important patrons of art in the early Renaissance.

fresco (It. "fresh"), wall painting technique in which pigments are applied to wet (fresh) plaster (intonaco). The pigments bind with the drying plaster to form a very durable image. Only a small area can be painted in a day, and these areas, drying to a slightly different tint, can in time be seen. Small amounts of retouching and detail work could be carried out on the dry plaster, a technique known as *a secco* fresco.

glaze, color applied so thinly that the base beneath it is visible through the layer.

grisaille, painting in gray monochrome, often used in painting to imitate stone sculptures.

Guild of St Luke (It. Compagnia di San Luca), the painters' guild in Florence (named after St Luke because he was believed to have painted a portrait of the Virgin Mary).

hatching, in a drawing, print or painting, a series of close parallel lines that create the effect of shadow, and therefore contour and three-dimensionality. In cross-hatching the lines overlap.

historia (Lat. "story"), in Renaissance art theory, the story or incident to be painted or sculpted. It was thought the subjects depicted should be morally, intellectually, and spiritually uplifting, so the two main sources of subjects for artists were the Bible and Christian stories on the one hand, and classical literature and mythology on the other.

history painting, genre of painting whose subject is the depiction of historical, legendary, biblical or mythological figures and events.

humanism, an intellectual movement that began in Italy in the 14th century. Based on the rediscovery of the classical world, it replaced the medieval view of humanity as fundamentally sinful and weak with a new and confident emphasis on humanity's innate moral dignity and intellectual and creative potential. A new attitude to the world rather than a set of specific ideas, humanism was reflected in literature and the arts, in scholarship and philosophy, and in the birth of modern science.

icon (Gk. "image, likeness"), in Byzantine art, a religious image painted on a panel. Icons were painted in a formal, highly stylized way. See **Byzantine art.**

iconography (Gk. "description of images"), the systematic study and identification of the subject-matter and symbolism of art works, as opposed to their style; the set of symbolic forms on which a given work is based. Originally, the study and identification of classical portraits. Renaissance art drew heavily on two iconographical traditions: Christianity, and ancient Greek and Roman art, thought and literature.

illusionism (Lat. *illusio*, "derision, deception"), method of painting in which perspective and other pictorial devices are used to create the impression of a three-dimensional space.

lantern (Lat. *lanterna*, "lamp"), in architecture, a small turret that sits at the top of a dome or roof. Fitted with windows or openings, the lantern provides light to the space below.

lectern, a reading stand or desk, especially one at which the Bible is read.

Leda, in Greek mythology, a princess who was seduced by the god Zeus, who had taken the form of a swan. She bore two children, the twins Castor and Pollux, great warriors who became immortal as the star constellation Gemini. According to some legends, she is also the mother of Clytemnestra and Helen.

liturgy (Gk. *leitourgia,* "a service performed by a priest"), the public rituals and services of the Christian Churches; in particular, the sacrament of Holy Communion.

lunette (Fr. "little moon"), in architecture, a semicircular space, such as that over a door or window or in a vaulted roof, that may contain a window, painting or sculptural decoration.

Maria lactans (Lat.), a depiction of the Virgin breast feeding the infant Jesus.

Medici, a Florentine patrician family which ruled Florence from 1434 to 1737 with brief interruptions, and held Tuscany from 1569. Lorenzo I, the Magnificent (1469–1492), was one of the most influential Medicis who was a particular patron of the arts and sciences and gathered leading humanists at the Florentine Academy. His son Giovanni de' Medici (1475–1521) was Pope Leo X in Rome from 1513 to 1521.

Medusa, in Greek mythology, a once beautiful woman who, having offended the goddess Athena, had her hair turned to snakes and her face made so hideous that anyone looking at her was turned to stone.

metalpoint, a method of drawing using a thin pointed rod of metal on parchment or paper that has been coated with an opaque white ground. Metalpoint produced a fine, grayish line. Developed in the Middle Ages, it was popular throughout the Renaissance; it began to be replaced by graphite pencil in the 17th century.

Silverpoint was one of the most widely used forms of metalpoint.

oil paint, a painting medium in which pigments are mixed with drying oils, such as linseed, walnut or poppy. Though oils had been used in the Middle Ages, it was not until the van Eyck brothers in the early 15th century that the medium became fully developed. It reached Italy during the 1460s and by the end of the century had largely replaced tempera. It was preferred for its brilliance of detail, its richness of color, and its greater tonal range.

Ovid (Publius Ovidius Naso), classical Roman poet. He wrote the "Metamorphoses", a work which concerns all the transformations recorded in Greek and Roman mythology and legend from the creation of the world up to the time of Augustus.

palazzo (It. "palace"), a palace, large town house or mansion. The palazzo played an important role in the Renaissance, both in architectural design, and also in fresco painting.

Palazzo Vecchio (It. "old palace"): city palace in Florence, the seat of the city government (Signoria).

panel painting, a portable painting on a rigid support (usually wooden boards) rather than canvas. It was not until the 15th century that canvas began to replace wooden panels.

paragone (It. "comparison"), a rivalry between painting and sculpture during the Renaissance as to which of the two arts was the more important. The debate this encouraged helped to define the nature and role of both arts.

Parrhasius (ca. 420 BC), Greek painter of the late classical period (ca. 400–300 BC), and one of the most famous artists of the classical age.

passio (Lat. "suffering"), the suffering of a martyr; the suffering of Christ in His Passion.

Passion cycle, depictions of the leading up to and including the death of Christ. The main scenes depicted are: Christ's entry into Jerusalem; the Last Supper; the agony in the garden; the betrayal by Judas; Peter's denial; Christ before Pilate; the flagellation and the mocking of Jesus; the road to Calvary; the crucifixion; the deposition; and the entombment. Outstanding examples of the Passion cycle are Giotto's frescoes in the Arena Chapel in Padua, and Duccio's *Maestà.*

perspective (Lat. *perspicere*, "to see through, see clearly"), the method of representing three-dimensional objects on a flat surface. Perspective gives a picture a sense of depth. The most important form of perspective in the Renaissance was linear perspective (first formulated by the architect Brunelleschi in the early 15th century), in

which the real or suggested lines of objects converge on a vanishing point on the horizon, often in the middle of the composition (central perspective). The first artist to make a systematic use of linear perspective was Masaccio, and its principles were set out by the architect Alberti in a book published in 1436. The use of linear perspective had a profound effect on the development of Western art and remained unchallenged until the 20th century. See **aerial perspective**.

physiognomy (Gk. *physis*, "nature", and *gnomon*, "interpreter"), the external appearance of a person, in particular the face.

pigments, the coloring ingredients (usually powders) that are mixed with water, oils or other media to form paint. During the Renaissance they were obtained from organic, animal and mineral sources. For example, the semi-precious stone lapis lazuli was ground to make a blue that (largely because of its expense) was used to paint the Virgin Mary's garments.

plasticity (Gk. *plastikos*, "able to be molded, malleable"), in painting, the apparent three-dimensionality of objects, a sculptural fullness of form.

Pliny the Elder (Gaius Plinius Secundus, AD 23/ 24–79), Roman writer. The only one of his works to have been preserved is the "Historia Naturalis" (history of nature) in 37 volumes, a great encyclopedia covering all the known manifestations of nature and art.

predella (It. "altar step"), a painting or carving placed beneath the main scenes or panels of an altarpiece, forming a kind of plinth. Long and narrow, painted predellas usually depicted several scenes from a narrative.

proportion, the ratio between the respective parts and the whole in painting, sculpture and architecture. Of importance is the Canon of Proportion, a mathematical formula establishing ideal proportions of the various parts of the human body. The unit of measurement is usually the relationship of the head to torso; the golden section, a line C divided into a small section A and a larger section B, so that A:B are in the same relationship as B:C; quadrature, which uses the square as a unit of measurement; triangulation, which uses an equilateral triangle in order to determine important points in the construction; harmonic proportions, an analogy with the way sounds are produced on stringed instruments, for example an octave = 1:2 (the difference in pitch between two strings, one half the length of the other), a fifth = 2:3, a fourth = 3:4.

refectory, room where meals are served, especially in a monastery or school.

relief (Lat. *relevare,* "to raise"), a sculptural work in which all or part projects from the flat surface. There are three basic forms: low relief (*bas-relief, basso rilievo*), in which figures project less than half their depth from the background; medium relief (*mezzo rilievo*), in which figures are seen half round; and high relief (*alto rilievo*), in which figures are almost detached from their background.

Renaissance (Fr. "rebirth"), progressive cultural epoch originating in Italy and lasting from the 14th or 15th till the 16th century. The later period from about 1530 to 1600 is also called Mannerism. The term *rinascità* was coined by Giorgio Vasari (1511–1574) in 1550; Vasari meant it to refer to progress beyond medieval art. The culture of the Renaissance was primarily established by visual artists, scholars, philosophers and writers. They were inspired by humanism, which aimed for a new image of humanity, the world and nature and took antiquity as its model. The Renaissance evolved the concept of the *uomo universale*, the person of universal learning and all-round intellectual and physical capacity. The visual arts emerged from their status as crafts, and with their new independence artists found that their social status had risen too. The arts and sciences were closely tied and influenced each other, for example in the discovery of mathematical perspective and increasing anatomical knowledge. Renaissance architecture took its bearings from the theories of Vitruvius (ca. 84 BC) and adopted classical features; its major achievements were in palace and church architecture, and centrally-planned buildings were characteristic of the Renaissance.

rilievo (It. "relief"), in painting, the impression that an object is three-dimensional, that it stands out from its background fully rounded.

Sacra Conversazione (It. "holy conversation"), a representation of the Virgin and Child attended by saints. There is seldom a literal conversation depicted, though as the theme developed the interaction between the participants – expressed through gesture, glance and movement – greatly increased. The saints depicted are usually the saint the church or altar is dedicated to, local saints, or those chosen by the patron who commissioned the work.

Servites, in the Roman Catholic Church, a religious order founded in 1240 by a group of Florentines who had devoted themselves to the service of the Virgin Mary. They adopted the rule of St. Augustine.

Sforza, Italian noble family which ruled Milan and the majority of Lombardy from 1450 to 1535.

sfumato (It. "misty, softened"), in painting, a very gradual transition from light to dark, a subtle modelling of forms that eliminates sharp contours. Made possible by the introduction of oil paints, *sfumato* was largely developed by Leonardo da Vinci.

Signoria (It. "lordship"), from the 13th to the 16th century, the governing body of some of the Italian city

states. They were usually small groups of influential men presided over by the head of the city's most important family.

silverpoint, a method of drawing using a thin pointed rod of silver, on parchment or paper that has been coated with an opaque white ground. Silverpoint produced a fine, grayish line. Popular throughout the Renaissance, it began to be replaced by graphite pencil in the 17th century.

still life, also called *nature morte* or *natura morta*, a painting of artistically arranged inanimate objects such as flowers, fruits, books, containers and dead animals. Still life was used in paintings from the 14th century, as a result of closer attention to reality, but was not a separate genre of painting until the 16th century, reaching its high point in the Netherlands in the 17th century.

tectonics (Gk. *tekton*, "carpenter, builder"), the underlying structure or design.

tempera (Lat. *temperare*, "to mix in due proportion"), a method of painting in which the pigments are mixed with an emulsion of water and egg yolks or whole eggs (sometimes glue or milk). Tempera was widely used in Italian art in the 14th and 15th centuries, both for panel painting and fresco, then being replaced by oil paint. Tempera colors are bright and translucent, though because the paint dries very quickly there is little time to blend them, graduated tones being created by adding lighter or darker dots or lines of color to an area of dried paint.

topos, pl. **topoi** (Gk. "a commonplace"), in literature, figure of speech; in art, a widely used form, model, theme or motif.

tracing marks, tracing marks are created while a design is being transferred from a cartoon to the ground of a panel. First of all, the design is used to create a so-called cartoon which bears a full-scale drawing of the composition. Along its lines, at short intervals, holes are made. The cartoon is then laid on the primed panel and a fine colored dust is blown through the holes, creating the tracing marks. All one then needs to do is connect the dots in order to achieve a precise copy of the design.

Trecento (It. "three hundred"), the 14th century in Italian art. This period is often considered the "proto-Renaissance", when writers and artists laid the foundation for the development of the early Renaissance in the next century (the **Quattrocento**). Outstanding figures of the Trecento include Giotto, Duccio, Simone Martini, the Lorenzetti brothers, and the Pisano family of sculptors.

uomo universale (It.), the Renaissance "universal man", a many-talented man with a broad-ranging knowledge of both the arts and the sciences.

vanishing point, central point in a perspectival composition towards which a set of lines, which are actually parallel, appear to converge.

Vasari, Giorgio (1511–1574), Italian architect, painter and writer. His major achievement was the description of "The Lives of the Artists", and it is one of the most important sources in art history.

wash, the use of a wet brush to tint a pen drawing with ink, sepia or watercolor, in order to create light and shade or corporeality.

Zeuxis (ca. 425 BC), Greek painter from Herakleion. His illusory shadow painting was very highly regarded in Athens.

SELECTED BIBLIOGRAPHY

Beltrami, Luca: Documenti e memorie riguardanti la vita e le opere di Leonardo da Vinci, Milan 1919

Bode, Wilhelm von: Studien über Leonardo da Vinci, Berlin 1921

Brown, David Allen: Leonardo and the Ladies with the Ermine and the Book, in: Artibus et Historiae, 21/1990, p. 47–61

Bull, David: Two Portraits by Leonardo: Ginevra de' Benci and the Lady with the Ermine, in: Artibus et Historiae, 25/1992, p. 67–84

Cianchi, Marco: Die Maschinen Leonardo da Vincis, Florence 1988

Clark, Kenneth / Pedretti, Carlo: A Catalogue of the Drawings of Leonardo da Vinci in the Collection of Her Majesty the Queen at Windsor Castle, London 1968

Clark, Kenneth: Leonardo da Vinci. An Account of his Development as an Artist (original edition Cambridge 1939), with an introduction by Martin Kemp, London 1988

Clayton, Martin: Leonardo da Vinci. A Curious Vision, London 1996

Facsimile complete edition of Leonardo da Vinci, Giunti-Editore, Florence 1968–1996

Farago, Claire J.: Leonardo's Battle of Anghiari: A Study in Exchange between Theory and Practice, in: The Art Bulletin, June 1994, p. 301–330

Fiorio, Maria Teresia / Marani, Pietro C. (eds.): I Leonardeschi a Milano. Fortuna e Collezionismo, Milan 1991

Galuzzi, Paolo (ed.): Gli ingenieri del rinascimento da Brunelleschi a Leonardo da Vinci, Florence 1995

Guerrini, Mauro: Bibliografia leonardiana 1986–1989, in: Raccolta Vinciana, Milan 1989

Heydenreich, Ludwig H.: Leonardo-Studien, Munich 1988

Kemp, Martin: Leonardo da Vinci. The Marvellous Works of Nature and Man, London 1981

Lorenzi, Alberto/ Marani, Pietro: Bibliografia Vinciana 1964–1979, Florence 1982

Ludwig, Heinrich (ed.): Leonardo da Vinci. Das Malereibuch, reprint of the 1882 edition, Osnabrück 1970

Marani, Pietro C.: Leonardo, Milan 1994

Marinoni, Augusto (ed.): Gerolamo Calvi, I manoscritti di Leonardo da Vinci, Busto Arsizio 1982

Pedretti, Carlo: Leonardo da Vinci on Painting – A lost Book (Libro A), Berkeley, Los Angeles 1964

Pedretti, Carlo: Leonardo. A Study in Chronology and Style, London 1973

Pedretti, Carlo: The Literary Works of Leonardo da Vinci. Commentary, Berkeley and Los Angeles 1977

Pedretti, Carlo: The Codex Atlanticus of Leonardo da Vinci. A Catalogue of its Newly Restored Sheets, New York 1979

Pedretti, Carlo / Vecce, Carlo (eds.): Leonardo da Vinci. Libro di Pittura, Florence 1995

Pedretti, Carlo: Leonardo da Vinci Architekt (original edition Milan 1978), Stuttgart and Zurich 1980

Pedretti, Carlo (ed.): Achademia Leonardi Vinci, annual, Florence 1988–1997

Reti, Ladislao (ed.): Leonardo. Forscher Künstler Magier, Munich 1990 (original edition Lucerne 1987)

Articles in Raccolta Vinciana between 1905 and 1985

Shearman, John: Leonardo's Colour and Chiaroscuro, in: Zeitschrift für Kunstgeschichte, Berlin 25/1962, p. 13–47

Shell, Janice: Grazioso Sironi, Salai and Leonardo's Legacy, in: Burlington Magazine, 133/1991 [-1], p. 95–108

Suida, Wilhelm: Leonardo und sein Kreis, Munich 1929

Vasari, Giorgio: The Lives of the Artists, Oxford 1991

Veltmann, Kim H.: Studies on Leonardo da Vinci I, Linear Perspective and the Visual Dimensions of Science and Art, Munich 1986

Verga, Ettore: Bibliografia Vinciana 1493–1930, Bologna 1931

Vezzosi, Alessandro: Léonard de Vinci. Art et Science de l'Univers, Paris 1996

Wassermann, Jack: Leonardo da Vinci, New York 1975

PHOTOGRAPHIC CREDITS